FRENCH FURNITURE

FRENCH FURNITURE

From Louis XIII to Art Deco

Edited by Sylvie Chadenet

A BULFINCH PRESS BOOK

LITTLE, BROWN AND COMPANY

Boston New York London

First United States Edition

Library of Congress Cataloging-in-Publication Data
Tous les styles. English
French furniture: from Louix XIII to 1900/ edited by Sylvie Chadenet; [translated
from the French by John Goodman].—1st U.S. ed.
p. cm.
"A Bulfinch Press book."
ISBN 0-8212-2683-5 (pb)
1. Furniture—France—History. I. Chadenet, Sylvie. II. Title.
 NK2547.T6813 2001
 749.24'09'03—dc21 00-045539

Bulfinch Press is an imprint and trademark of Little, Brown and Company (Inc.)

Printed in Hong Kong

This work is based on the *Encyclopédie des Styles d'hier et d'aujourd'hui,* published by the
practical encyclopedias department of Culture, Art, Loisirs.

Text edited by Sylvie Chadenet
Drawings by Maurice Espérance
General editor Annie Morand

❖ *Contents*

Glossary

A

Acanthus: plant whose foliage is among the most widely used of all decorative motifs.

Accotoir (French): the supporting piece of a chair arm.

Alentour (French: "surround"): in tapestries, the decorative field between the border and the central motif (Régence, Louis XV).

Amati (French): see *maté*.

Anse de panier (French): literally, "basket handle"; used to designate arches with this profile.

Arabesque: scroll of flowers and foliage arranged without concern for symmetry.

Arbalète (en) (French): used to designate serpentine profiles suggestive of a strung bow.

Arcature (French): a series of small arches.

Armoire: tall cupboard or wardrobe.

Attributes: symbolic objects, often used in the eighteenth century; palm fronds are an attribute of victory, rifles and game are attributes of the hunt.

B

Baluster: short column swollen toward the middle and consisting of several parts: a base *(piédouche)*, a swelling known as the *poire* (pear) or *panse* (belly), a neck immediately above this, above which, in turn, is a culminating capital.

Barbeau (French): the cornflower, a motif widely used on Sèvres porcelain and in eighteenth-century marquetry.

Bâte (French): in silver, a consolidation molding around the neck, opening, edges, or base of an object. Also used designate the border on plates surrounding the rim.

Bibliothèque (French): literally, "library"; in furniture, bookcase.

Biscuit: unglazed, fired porcelain, usually left entirely undecorated.

Bombé (French): literally, "blown out"; used to describe the bulging forms frequent in Louis XV case furniture.

Boudin (French): see *torus*.

Bout-de-pied (French): the separate footpiece of a chaise longue.

Bruni (French): polished.

Bucranium: antique motif representing the skull of an ox.

Bulbe (French): turned element resembling a bulb.

Bureau (French): desk.

Bureau-plat (French): flat-top writing table, a furniture type introduced at the end of the seventeenth century.

Burl: abnormal excrescence on a tree that produces mottled or speckled patterns in the wood, much prized in veneers.

C

Camaïeu (en) (French): rendered entirely in muted shades of a single color.

Campane (French): see *lambrequin*.

Cannelures (French): fluting or short vertical grooves arranged side by side to form a frieze.

Carcase: the body or supporting armature of a piece of luxury case furniture before the addition of marquetry or lacquer panels.

Carderon (French): quarter-round molding.

Carreau (French): square detached cushion used in chairs or on the floor (seventeenth and eighteenth centuries).

Cartel clock: wall clock with an elaborate pointed base (eighteenth century).

Cartouche (French): escutcheon-like round or oval field (sometimes blank, some times inscribed) surrounded by an elaborate frame.

Caryatid: support shaped like a female figure.

Acanthus

Caryatid

Attribute *Baluster*

Bâte

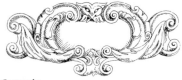

Cartouche

Doric capital

Ionic capital

Corinthian capital

Console

Arm support (console d'accotoir)

Die join

Stretcher

Interlace

Pediment mirror

Gadrooning

Ceinture (French): literally, "belt"; portion of a table or chair to which the legs are attached; in English, analogous to "seat rail" (chairs) and "frieze" (tables).

Chantournée (French; synonym of *contournée*, "twisted"): used to designate complex profiles composed of a series of curves and countercurves.

Chausson (French): see *sabot*.

Chiffonier: see *semainier*.

Chiffonnière (French): small, high table on legs and equipped with three drawers.

Chryselephantine: adjective designating an object made of gold and ivory.

Chute (French: "fall"): bronze fitting used to decorate the shoulders or knees of furniture legs, and occasionally furniture cases; there is no analogous generic term in English, although "pendant" is sometimes appropriate.

Cintre (French): the curve of an arch.

Ciselure (French): in furniture, the chasing of bronze and copper fittings.

Column: cylinder-shaped support consisting of (bottom to top) a base, a shaft, and a capital; there were five orders, or types, of ancient columns: Doric, Ionic, Corinthian, Tuscan, and Composite.

Commode: literally, "comfortable" or "convenient"; chest of drawers, a furniture type introduced toward the end of the seventeenth century.

Console: ornamental bracket with a compound curved outline; the French also describe the supports of chair arms as *consoles* and large, freestanding tables as *consoles de milieu*. A *console d'applique* is a console table designed to be placed against the wall.

Courtepointe (French): counterpane, a kind of bedcover.

Courtine (French): a kind of bed curtain.

Crête (French): 1) the cresting of a chair back; 2) lace curtain-edging.

Crosse (French): literally, crozier or crook; used to designate any element that scrolls at the end in a way analogous to the ends of these staffs.

D

Dé (French): literally, "die"; small cubic support sometimes placed below the feet of chairs or tables; in English, sometimes called a knuckle (eighteenth century).

Dé de raccordement (French): literally, "joining die"; cubic block of wood articulating the join between a leg or post and the adjacent rails, especially in seating.

Dentil: a rectangular cubic form, reminiscent of a tooth, aligned in rows with intervening spaces to form "dentil moldings," usually found below projecting cornices.

Dessus brisé (French): slope-front desk; also called a *dos d'âne* (donkey back).

Dormante (French): fixed vertical support between two hinged doors.

Dos d'âne (French): see *dessus brisé*.

Doucine (French): molding consisting of two quarters of a circle, one convex and the other concave; in English (depending on their relative disposition), cyma recta or cyma reversa.

E

Ébéniste (French): furniture-maker specializing in luxury case furniture incorporating marquetry of various kinds (late seventeenth and eighteenth centuries).

Églomisé (French): adjective designating an eighteenth-century technique for engraving and gilding glass; it derives from the name of the technique's inventor, Glomy.

Égoiste (French): small coffeepot intended for use by one or two people.

Enamel: vitreous substance, usually colored, fused to a metal surface under heat; a similar substance fused to glass is called a glaze. In French, *émail* designates both substances.

Encoignure (French): corner cupboard.

Entablature: the upper part of a classical order above the capital, consisting of the architrave, the frieze, and the cornice.

Entrejambe (French): space between the legs of a piece of furniture; by extension, the stretchers — often in H- or X-configurations — used to reinforce the legs.

Entretoise (French): see *entrejambe*.

Espagnolette: decorative motif consisting of a head and bust, usually female, emerging from a console, foliate, or fan motif; often used specifically to designate bronze fittings of this type on furniture corners (eighteenth century).

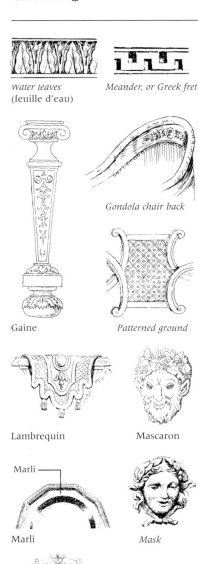

Water leaves
(feuille d'eau)

Meander, or Greek fret

Gondola chair back

Gaine

Patterned ground

Lambrequin

Mascaron

Marli

Marli

Mask

Rosette medallion

Estampille (French): stamp by which, beginning in the late 1740s, Parisian master *ébénistes* were obliged to certify their work. They were occasionally used before that time; the earliest surviving examples date from the 1720s.

F

Fauteuil (French): armchair (from the archaic *faudesteuil*), current until the mid-seventeenth century.

Feuille d'eau (French): "water leaf," a classical decorative motif resembling elongated laurel leaves arranged side by side; in furniture, found principally in chased moldings.

Floret: round, flower-like ornamental motif.

Foncer (French): French verb used to describe certain furniture surfaces. Examples: a cane-bottom chair is *foncé de canne*; a chair upholstered in leather is *foncé de cuir*.

Fret: 1) band of horizontal and vertical lines intersecting one another at right angles; the most common type is known as the meander or Greek key motif; 2) lozenge marquetry patterns.

Frieze: decorative or narrative composition in a horizontal band. Specialized furniture applications: 1) in armoires, the horizontal band between the cornice and the doors; 2) in tables, the horizontal band between the legs and the top (analogous to the French term *ceinture*).

G

Gadrooning: on silver, a band of identical, rounded convex forms disposed vertically or at an angle.

Gaine (French): support shaped like a pilaster but narrowing toward the base; in English, legs of this shape are sometimes called baluster legs or tapering legs.

Galuchat: treated sharkskin used to cover coffers, furniture panels, etc.

Garniture (French): the fabric covering an upholstered seat.

Girandole (French): crystal pendant adorning a chandelier, wall light, candelabrum, etc.; in English, an elaborate wall bracket or chandelier (eighteenth century).

Glaze: a vitreous coating fixed to ceramic by firing.

Gondola chair back: rounded chair back that curves forward to constitute the arms as well.

Gorge (French): literally, "neck"; semi-cylindrical concave groove.

Gradin (French): unit of progressively receding shelves placed on top of furniture for the display of prized objects.

Grotesque: ornamental composition of classical derivation combining *rinceaux*, fantastic animals, and human figures; named after similar wall paintings in the "grottos" (partially excavated rooms) of Nero's Golden House in Rome.

I

Interlace: decorative motif composed of intertwining bands.

J

Japoné (French): very thin faïence.

Joue (French): literally, "cheek"; in furniture, the part of an armchair between the arms and the seat rail when this is in-filled.

L

Lacquer: a colored resin applied to objects, paneling, furniture, etc.; by extension, objects coated with this resin.

Lambrequin (French): pendant ornamental motif terminating in scallops or "teeth" simulating swags of drapery with tassels.

Lambris (French): wooden wall panel, often carved.

Landier (French): high, narrow firedog.

Lit-de-bout (French): a bed perpendicular to the wall (also called a *lit-de-milieu*).

Lit-de-travers (French): a bed parallel to the wall.

Lobe: a form of convex profile.

Loupe (French): "burl"): abnormal excrescence on a tree that produces mottled or speckled patterns in the wood, much prized in veneers.

Ears oreilles)

Proto-cabriole leg (pied-de-biche)

Four-square leg (pied en façade)

Out-turned leg (pied en oblique)

Palmette

Small foot (piedouche)

Diamond point (pointe de diamant)

Pointe de gateau

Rat's tail (queue-de-rat)

M

Main (French): literally, "hand"; handle.

Maindron (French): the iron used to apply *estampilles*.

Marabout (French): in lace, a short, very thick fringe; in silver, a small bulbous teapot or coffeepot without feet.

Marli (French): in ceramics and silverware, the area of a plate or platter between the central recess and the outer edge.

Mascaron: the head of a fantastical man, woman, or animal.

Mask: a human face, frontally disposed and without caricatural exaggeration.

Maté (French): in silverware, an unpolished area left matte or dull.

Medallion: a round or oval decorative element containing a motif; by extension, a round or oval chair back.

Menuisier (French): furniture-maker specializing in frame furniture and solid-wood furniture (eighteenth and nineteenth centuries).

Modillion: small, upside-down console supporting a cornice.

Molding: a long ornamental element, either projecting or recessed, of continuous profile (flat, round, concave, convex, etc.). According to type, many have specific names: torus, cavetto, ove, cyma recta, cyma reversa, etc. In metalwork and furniture, each style has its own characteristic moldings.

N

Niello: delicate inlay of black enamel in a metal ground.

Nielloed: in ceramics, decorated with delicate designs executed in black, usually against a white ground.

Noix (French): carved element in the center of the X-stretcher of a table or console.

O

Oreille (French): literally, "ear"; in chairs, a projection extending forward from the top of the back to support the head; in metalwork and ceramics, an added piece used as a handle.

P

Palmette: decorative motif resembling a stylized palm frond.

Panse (French): literally, "belly"; the swollen portion of an object or piece of furniture.

Patterned ground: in furniture, a regular pattern, either carved or executed in marquetry.

Pediment: triangular element surmounting the entablature.

Pente or **Penture** (French): the curtain of a canopy bed (seventeenth and eighteenth centuries).

Pied-de-biche (French): literally, "doe-leg"; slender, slightly curved leg with a hoofed foot; transitional to the later cabriole leg, which has more pronounced curves.

Pied en façade (French): leg aligned with the sides of the piece it supports.

Pied en oblique (French): turned-out leg.

Piédouche (French): in metalwork and ceramics, the flared base or foot of an object.

Piètement (French): the portion of a piece of furniture consisting of the legs and frieze, or *ceinture*.

Pilaster: engaged pillar or low, flat projection, often fluted. Pilasters *en gaine* taper toward the bottom.

Placet (French): small tabouret, or stool.

Ployant (French): small folding tabouret, or stool.

Pointe de diamant (French): diamond point, or projecting decorative motif shaped like a pyramid.

Pointe de gâteau (French): projecting decorative motif composed of several irregular pyramids arrayed around a center like the slices of a cake.

Poire (French): see *panse*.

Polychrome: of several colors.

Psyché mirror: large portrait-format mirrors set into a frame and supported by a stand with two side posts (resembling columns or balusters) and a large base. It usually pivots along the central horizontal axis.

Q

Quadrilobe: a geometric motif composed of four lobes.

Quarter-round: convex molding resembling a quarter circle in section.

Rinceau

Rosette Cabling
(rudenture)

Linenfold
(serviette
plissée)

Tas de sable

Triglyph

Trompe-l'oeil plate

Facing volutes
(volutes affrontés)

Tripod stand

Quenouille (French): literally, "distaff"; in furniture, tall bedpost culminating in a feather panache and resembling a distaff.

Queue-de-rat (French): literally, "rat's tail"; attenuated point in relief on the back of a silver utensil linking its functional end with its handle.

R

Rafraîchissoir (French): small chest equipped with two wine coolers and resting on four legs.

Rechampis (French): molding picked out in a color different from that of the adjacent area.

Régulateur (French): long-case clock.

Religieuse (pendulum clock *à la*; French): cubic pendulum clock surmounted by a dome; so named because its profile resembles that of a church porch (*religieuse* means "nun").

Rinceau (French): decorative motif composed of scrolling foliage.

Ronde-bosse (French): sculpture executed in high relief and readily distinguishable from the rest of the piece of furniture it adorns.

Rondin (French): a bolster-shaped cushion; in modern French, a *traversin*.

Rosette: ornamental motif in the shape of a star or rose.

Rudenture (French): small rod set into fluting; known in English as cabling; if the cable insets terminate in leaf-bud motifs, they are known as *asperges* or *chandelles*.

S

Sabot (French): metal "shoe," protective as well as ornamental, on the feet of a piece of furniture.

Semainier (French): high and narrow chest with six to eight drawers; after *semaine*, French for "week," as these pieces sometimes have a different drawer for each day of the week.

Servante (French): a kind of commode (chest of drawers) resembling a pantry table meant to be set against the wall; ancestor of the modern dessert table.

Serviette plissée (French): linenfold motif, or carved motif resembling a folded napkin.

Shaft: the portion of a column situated between the base and the capital.

Singeries (French): decorative motifs and/or compositions incorporating monkeys dressed as humans. Of Far Eastern derivation, they were much used by Berain and his students.

T

Tambour: used to describe a sliding door or desk cylinder made of wooden slats glued to canvas or some other textile.

Tas de sable (French): projecting decorative motif shaped like a hipped roof.

Term: vertical pedestal tapering toward the bottom *(en gaine)* and surmounted by a bust or decorative figure.

Tors (French): decorative motif consisting of twisted foliage, ribbon, or strings of pearls.

Torus: projecting molding shaped like a half-circle in section; also called a *boudin*.

Triglyph: a projecting block (originally used in Doric friezes) with two grooves running down the center and two half grooves along the outer edges.

Trilobe: a clover form, much like a spade (in cards).

Tripod: three-footed base.

Trompe l'oeil: illusionistic perspective representation.

Trophy: see *attributes*.

Trumeau mirror: mirror set into the woodwork between two windows or doors; in modern French usage, any mirror above a mantel or console table with a frame of high quality.

V

Vantail (French): door.

Verdure (French): tapestry consisting wholly or largely of vegetal and floral designs.

Verseuse (French): coffee pitcher.

Violoné (French): used to designate chair backs shaped like the body of a violin; analogous to the English "fiddleback."

Volute: spiral scroll; in furniture, often found in console motifs and terminals of various kinds. Also, *Volutes affrontées* (French): two adjacent upright volutes oriented in opposite directions.

The Medieval Style

1300-1500

Linenfold panel

Authentic pieces from this period — also known as the Gothic — are quite rare (expensive and fragile), but it is useful to know something about them, for they are the ancestors of all subsequent French furniture; their forms and ornament are constant reference points in the history of furniture.

Medieval furniture is characterized first of all by exceptional formal *stability:* from the eleventh century to the end of the fifteenth century, its shapes and lines scarcely changed. There is some compensation for this uniformity in the rich *diversity* of its ornament. This seeming contradiction is easily explained:

• On the one hand, furniture from this period was responsive to social and economic conditions that were the same throughout Europe.

• On the other hand, because of the difficulty and slowness of contemporary means of transport, such pieces have decoration reflective of regional traditions, both in their motifs and their technique.

Materials. Oak was used almost exclusively until the end of the fifteenth century, when walnut began to replace it. In all likelihood, pine was also used for many basic pieces (trestle tables, beds, benches); the mediocre quality of this wood would explain why so few of such pieces have survived.

Aside from wood, the only material used in furniture was wrought iron. Used for hinges, door braces, locks, handles, and upholstery studs, it is usually visible and sometimes carefully worked.

Ornament. This was painted or carved. Many pieces from this period were entirely polychromed. Their panels, whether painted or carved, were designed to stand out against colorful framing elements.

Inlay and marquetry work were not unknown, but were used rarely, and only in Italy and southern Spain. The fronts and ends of pieces featuring such decoration were divided into numerous fielded panels, each sometimes containing a single motif or image; these panels are not always perfectly symmetrical, which makes for awkwardness.

• All ornamental themes on medieval furniture are of religious inspiration.

• The decorative motifs and architectural forms — rosettes, lancet arches, crocketed pinnacles, interlace — evoke Gothic churches.

• The figure compositions depict scenes from the Gospels or from the vast corpus of saints' legends.

The furniture

Beds are known to us primarily through paintings and manuscript illuminations.

The most common doubtless consisted of a high wooden stand supporting a rudimentary mattress and covered with

an ample bedcover falling as far as the floor. They had only one headboard, carved or painted. A large canopy *(ciel)* surrounded by curtains was fixed to the ceiling above.

Seating was very rudimentary in this period:

Benches, simple planks of oak fixed to the top of two or three trestles, were the most common type of seating. Some have low backs, occasionally carved or painted, and armrests the same height as the back.

Small benches or stools consist of two plank supports linked at the top by another plank serving as the seat, which can be either square or rectangular.

Some stools from the period consist of round seats supported by three inclined legs.

Chairs were regarded as prestige furniture. Some rest on feet that formed a kind of lancet gallery, while others — the most common type — consist of a chest (with a richly decorated front panel) surmounted by a high back with a rectangular or curved top rail and two arms. Some of the backs are coved.

Armoires — few survive from this period — consist of two or even three superimposed units, each with two hinged doors. Their panels are painted or carved; sometimes they are perforated so that air can circulate within. The iron hardware is sometimes very richly worked.

Chests, the most characteristic pieces of the medieval period, are rectangular receptacles mounted on four or six smooth feet. The front panels are often richly decorated, those on the ends much less often.

The lids are fixed to the rear panel by three or four large hinges, and they generally feature locks, occasionally quite large, set into the upper center of the front panel. The lids are usually flat and smooth, but painted, carved, and bow-top examples were produced in some regions (Alsace, Bavaria, northern Italy).

Chest

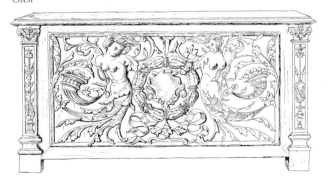

Caquetoire

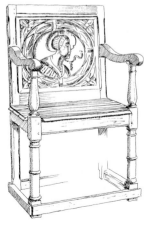

The Renaissance Style
1500-1610

THE STYLE OF THE FRENCH Renaissance does not differ markedly from that of contemporary Italy, of which it is a relatively faithful translation. In any case, although it evokes the classical architectural vocabulary and incorporates much ornament of pagan inspiration, it has a few distinguishing features.

Sculpture is the predominant form of ornament. French Renaissance pieces are likely to feature carved decoration, as opposed to the painted and inlaid ornament pervasive in Italy.

The buffet is the most characteristic furniture type. The French style also gave pride of place to a furniture type that was rare in Italy during this period: the buffet, which, dubbed the Henri II buffet, became fashionable again at the end of the nineteenth century. Quite large, these pieces consist of two superimposed units and often culminate in low pediments or cornices; sometimes there are one or two drawers toward the bottom. Each unit has two richly carved doors (typically decorated with mirrors, medallions, garlands, and *rinceaux*), while the support posts often take the form of pilasters or, more often, caryatids. The feet are generally short and squat, but sometimes these are replaced by a low socle or platform.

This type of buffet was often imitated and mass-produced between 1860 and 1900, but it remains one of the most characteristic of French Renaissance furniture types.

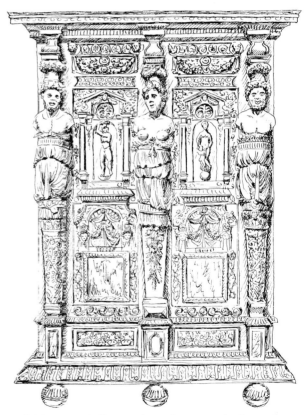

Much like Henri II buffets, French Renaissance armoires feature the rich sculptural ornament (niches, pediments, pilasters, caryatids) characteristic of much French furniture from this period.

The Louis XIII Style
1589-1661

THE REIGN OF LOUIS XIII extended from 1610 to 1649, but the style associated with his name flourished much longer, from the death of Henri III in 1589 to the beginning of Louis XIV's personal reign in 1661. This was a restless period, full of color and rich in contradictions: even as Richelieu sought to construct a strong state, the nobility tried to destroy it.

This was the period of the musketeers and Descartes's *Discourse on Method,* of El Cid and Galileo. Prodigious intellectual activity coexisted with an unquenchable thirst for life.

France was gradually becoming the greatest nation in Europe, but she did not yet set the continent's tone. Quite the contrary, for she was subject to various influences — Spanish, Italian, Flemish — in the guise of fashions that waxed and waned. But after the ravages of the wars of religion and the climate of insecurity that prevailed in France in the second half of the sixteenth century, the French longed for comfort and stability. They built much: in Paris, the Place des Vosges (originally the Place Royale) dates from this period, as do many townhouses in the Marais and on the Isle Saint-Louis; in the provinces, countless Louis XIII châteaux, made of pink brick and featuring high windows, replaced older structures.

In the matter of interiors, rooms — hitherto large and generic — became more numerous, and their distribution changed: *chambres* (bedrooms), *antichambres* (salons), *garde-robes* (dressing rooms), and *cabinets* (studies) proliferated, becoming increasingly refined and use-specific. In response to these changes, there was an increased demand for furniture, tapestry, and *tissus d'ameublement* (matched textile ensembles used for curtains and upholstery), fanned by a growing taste for sumptuousness and excess. Rare was the palace or *appartement* (residential suite) decorated in accordance with a considered scheme: furniture, cosmopolitan in style, was anything but stylistically coherent. Gradually, however, a number of characteristic features began to assert themselves. Greater attention began to be paid to techniques of furniture production as well as to form and comfort. Increasingly, invention and creative imagination were prized in both overall design and ornament, which became less polyglot in the sixteenth century.

Slowly, despite much groping and incoherence, a national style emerged, one that, by increments, rejected foreign influence and cultivated consistency. From the effervescence of this extended and confused period, something new was taking shape. All the constituent parts were in place; with the arrival of a worthy conductor, their profound and inimitable harmony would be revealed.

Turned wood

Toupie *(top), a motif often used on table stretchers*

Spiral leg

Baluster leg

Leg en chapelet ("*rosary" leg; in English: knob leg*)

Moldings

Tas de sable

Pointe de gâteau

Diamond point panel

Cornice and socle

The furniture

Geometric in appearance and austere in conception, Louis XIII furniture features veneer, turned wood, and moldings. There is a tendency toward the architectural, its forms being restrained and often massive.

Materials and techniques. The characteristic period woods are oak, walnut, ebony, pearwood, and pine.

Veneers. Ebony *(ébène)* — or stained pearwood, in the case of nonluxury furniture — was initially the veneer of choice, but it was soon joined by ivory, marble, colored stone, and various metals.

Turning was used widely: throughout chairs, on table stretchers, chests, and cabinets, on the colonnettes of armoires.

The legs of chairs and tables were turned from pieces of wood that were rectangular in section; portions adjacent to stretchers and aprons were often left unturned, the corners of the resulting block-like shapes often being rounded.

As it was much easier to execute spirals turning from left to right, this is the most common type; symmetrical spirals are found only in pieces of very high quality.

Moldings were used prominently: to frame a piece's various subdivisions (doors, panels, drawers); to articulate prominent cornices and plinths; and to create geometric patterns within fielded panels.

Ornament. The period favored thick, heavy, massive motifs lacking the delicacy and fantasy of Renaissance ornament.

The drapery swag

They form festoons held by ribbons; the central motif can represent a woman's head, fruit, or foliage.

The cartouche

Frequently used, this motif can be oriented horizontally or vertically. Its central field is convex and framed by sinuous moldings.

Fronds

Typically, two crossed palm fronds or crossed fronds of laurel and palm tied with a ribbon

Chimeras

Female torsos terminating in rinceaux

Acanthus leaves

Usually in the form of rinceaux

Ball and claw

Putti

Other decorative motifs

Other decorative motifs were also used in this period: interlace surrounding rosettes; scallop shells; gadrooning; cornucopias, or horns of plenty; bulging vases; eagles with spread wings; ovals; feathers; lion and ram heads. Sculptors of wood and stone executed their work with meticulous care but managed to avoid affectation, favoring amplitude and generalized forms.

Bed

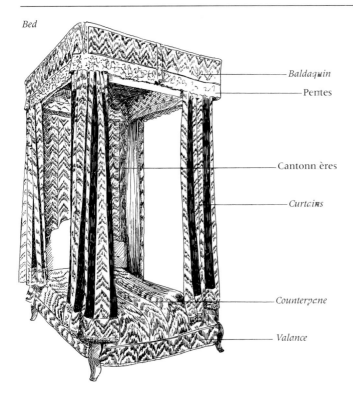

— Baldaquin
— Pentes
— Cantonnères
— Curtains
— Counterpane
— Valance

A certain limpness sometimes prevailed, but as the reign of Louis XIV approached, ornament acquired a nobler character.

Beds

Beds, cubic in outline, were very large. Amply draped, they were more the province of the upholsterer than of the furniture-maker.

• There were no box springs; a wooden frame supporting a platform of planks took its place. This frame was hidden by valances or skirts.

• The mattress, filled with straw, was covered by a bedspread known as a *courtepointe* (counterpane).

• To hide the plain bedposts, they were obscured, inside and out, by drapes: curtains and *cantonnières*.

• The whole culminated in a fabric baldaquin (tester) duplicating the dimensions of the bed proper. It featured valances known as *pentes*.

Tables

Leg stretchers were usually shaped like an H, the crosspiece being decorated in the center with an upright vase, apple, or *toupie* (top-shaped ornament). X-shaped stretchers appeared toward the end of the period, but they remained quite rare.

Draw-top tables have thick, undecorated tabletops covering two supplementary surfaces that can be pulled out to enlarge the total table surface.

Square or rectangular tables, relatively small, were the most common type. Their tops are smooth, but their edges usually feature quarter-round moldings (carderons) or are decorated with demi-

A contemporary witness

The engravings of Abraham Bosse are a precious source of information about daily life in Louis XIII's day, for they depict typical period interiors and costumes.

Painters

The most important French painters active under Louis XIII: Nicolas Poussin, Louis Le Nain, Georges de La Tour, Claude Gellée, known as Claude Lorrain, Philippe de Champagne, Simon Vouet.

Menuisiers

The gallery of the Louvre (below the Grande Galerie) and the Gobelins manufactory housed the workshops of furniture craftsmen. Although we know their names (Laurent Stabre and Jean Macé, menuisiers en ébène; Pierre Boulle, turner and menuisier), we cannot identify their personal styles; their methods were collaborative, and furniture stamps were not yet in use.

Knowing is not knowing by heart; it is retaining what one has entrusted to memory for safekeeping. —MONTAIGNE

Square table

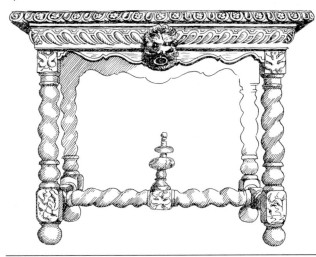

Drop-leaf table

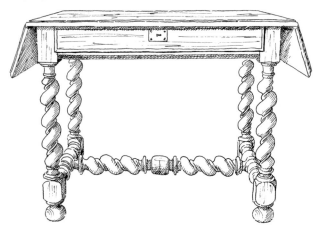

rosettes. Drawer panels might be decorated with relief lozenges or triangles. The legs, often quite thin, are turned.

Drop-leaf tables, charming in this period, were small, rectangular, and equipped with two hinged leaves. The four legs as well as the stretchers were turned.

Note: Trestle tables made of coarse wood were very common at the beginning of the century.

Desks

Cabinets à écrire (writing desks) are tables with drawers and an upright unit resting on the top known as a *cabinet,* itself featuring many small drawers. Rare, these pieces usually have ebony inlay.

Tables bureaux (desk tables) are oblong rectangular tables with two drawer units flanking a void accommodating the user's legs. This is an early version of the Mazarin desk, which evolved into the *bureau ministre* (minister's desk).

Note: Bureau, the French word for "desk," derives from *bure,* a type of woolen cloth sometimes used to cover primitive desks.

Armoires

Armoires (tall cupboards or wardrobes) replaced the all-purpose chests prevalent in the High Middle Ages and the Renaissance. They are decorated with moldings and, occasionally, with sculpture. Their corners are bare, unless:
• they are hollowed to accommodate disengaged serpentine columns that are fixed at the top and the bottom;
• they are pilasters.

Armoire with double doors

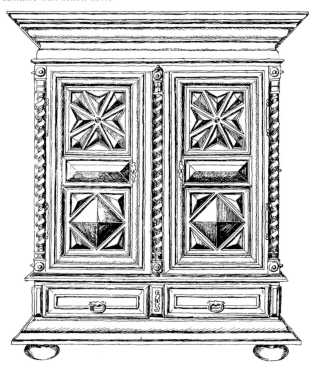

Armoires from this period generally have projecting cornices with thick moldings or even broken pediments (few survive). This projection is repeated in the socle, which is supported by four feet, either bun or ball-and-claw (often the rear feet are not turned).

Armoires carrées (square cupboards) have four hinged doors *(guichets)* with small flat panels.

Armoires droites (upright cupboards) have only one hinged door, tall and narrow, below which is a drawer.

Armoires à deux portes (cupboards with two doors): the two doors are sometimes side-by-side flanking a fixed central post, sometimes one above the other with a false central post.

Armoires à deux corps et à deux portes (two-piece cupboards with two doors), also known as *buffets:* here the upper piece can be narrower than the lower one, or the two pieces can be the same width, in which case there is usually a drawer between them.

Seating

Under Louis XIII, seats proper were just short of seventeen inches above the floor, having been lowered by about two inches from the previous norm. This new, lower height long remained standard.

Chairs were stuffed with horsehair and covered with various materials: tapestry, velvet, damask, satin, Naples or Tours brocade, gilded or goffered leather, tanned hide, or fabric embroidered with *point de Hongrie* (a kind of lace).

This material was held in place by studs, sometimes in daisy configurations and sometimes spaced along braid. Fringe hung from the seat rails and from the bottom rail of the back.

The gallery of the Louvre

To foster the development of national industry, and to assure its independence by reducing the need for expensive imports, Henri IV authorized foreign workers to settle in Paris, in rooms below the Grand Galerie of the Louvre. Among them were goldsmiths, clock-makers, stone engravers, furniture-makers, tapestry-weavers, and carpet-makers, all of whom could work for the court and for private patrons outside of the strict guild system, from whose cumbersome regulations they were declared free. These craftsmen, who enjoyed many privileges, trained apprentices who eventually established workshops of their own, becoming the most accomplished craftsmen of the age of Louis XIV.

Fauteuil à haut dossier
(high-back armchair)

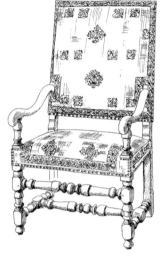

Chaire à bras
("pulpit" armchair)

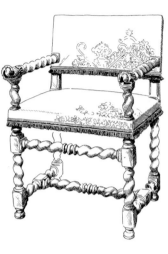

Tabouret (stool)

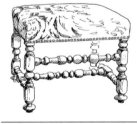

Detail of an arm

Louis XIII or Louis XIV?

*Contrary to widespread belief, mutton-bone legs (pieds à os de mouton)
were not introduced until the Louis XIV period. So say de Felice and
Janneau, renowned specialists in furniture history.*

Cane chairs

Cane-bottomed chairs, of Dutch origin, were rare in this period. They combined turned and carved members. Their front rail was often richly worked.

The legs, which were turned (see page 17), had feet of various kinds, most often bun or block forms.

Fauteuil à haut dossier (armchair with high back) was not yet widely used. These chairs had classic legs, rectangular backs with no visible wood, and wooden arms.

Note: Beginning in the 1630s, chair arms sometimes curve downward and have crosier terminals, but mutton-bone legs *(pieds à os de mouton)* were not used before the age of Louis XIV (see below left).

Chaire à bras ("pulpit" armchair) was higher than it was wide. The turned arms terminate in a simple button or the head of a woman, bull, or lion and rest on turned supports.

Chaire basse (low "pulpit" chair), also known as *chaise à vertugadin* (after an archaic name for hip pads), and *caquetoires* (from *caqueter,* to chatter; see page 14), are *chaires à bras* without arms.

Chaise à haut dossier (high-back chair) resembles the high-back chair *(fauteuil à haut dossier)* but lacks arms.

Escabelles are tabourets (stools) with turned wooden legs and wooden seats; sometimes they have carved friezes.

Bassets are high *escabelles* used both for seating and as portable tables.

Tabourets (stools), also known as *placets,* were made in various heights (between eight and twenty inches) and were covered with needlework tapestry.

Lits de repos (daybeds), rather rare, were introduced around 1625–30. Beds in name only, they were used as chairs. They have one or two raised sides or arms and rest on six or eight turned legs linked by stretchers that are also turned.

Silver

Caster

*Plate à la Mazarine,
resembling a cardinal's hat*

Pitcher

Egg cup

Cup

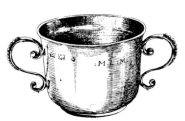

Porringer

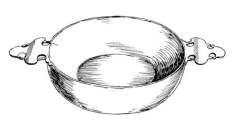

Glassware

*Very little glassware
from this period survives.*

• *Ordinary glassware imitated
the forms of metalwork vessels,
and each drinker had his own
glass.*

• *"Venetian" glassware, much
more original, was made by
Italians active in France. Some
of these glasses were quite elab-
orate, featuring flowers,
serpents, dolphins, etc*

Serpent glass

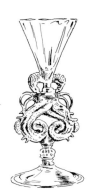

Dolphin glass

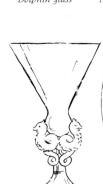

Ceramics

Nevers pottery plate

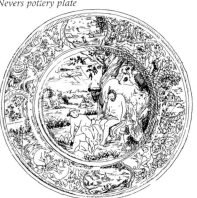

The Louis XIV Style
1661-1700

 FROM 1661 UNTIL THE END of the century, Louis XIV, absolute monarch and superhuman personification of the state, imposed his style on all of the artistic productions of his reign, just as he imposed his policies on his ministers and ambassadors.

The style soon spread throughout Europe, with French influence everywhere replacing that of Italy and Spain — except for painting, which boasted great Flemish masters such as Van der Meulen and Vermeer, the entirety of Western artistic production in the century's second half was marked by the French aesthetic. But it was an extremely formalist one; indifferent to reality, its priority was to embellish nature, not to understand it: the great scientists of the period were not French but English, like Newton, or German, like Leibniz.

Louis XIV was served, with a zeal doubtless fostered by his munificence, by countless artists recruited and recompensed with great care and generosity. The artistic policy of the state was overseen by the painter Charles Le Brun, who, entrusted with the decoration of Versailles, for more than a quarter century coordinated the activities of goldsmiths, furniture-makers, *ébénistes* (specialists in luxury case furniture), upholsterers, engravers, sculptors, ornamentists, and even gardeners.

Le Brun imposed on all of them a homogenous style infused with Latin culture and Roman grandeur, yet utterly removed both from the Italianism of the previous reign and from the fantasy of the Renaissance decorative vocabulary: a style characterized by balance, symmetry, formal amplitude, and a deep distrust of disorder and natural caprice.

This style, of course, was not fully formed in the first years of Louis XIV's reign. For a time, reminiscences of the preceding period were legion; furniture in particular remained quite close to Louis XIII, with carved ornament remaining ponderous. But little by little, the grand lines of the style gained in confidence and precision. They reached maturity in the 1670s, a decade that coincided in more than one respect with the apogee of the reign.

Then, shortly before the end of the century, there was a manifest decline. The king, whose resources were now much reduced, gave fewer lavish entertainments and began to prefer the more intimate atmosphere of Marly and Trianon. Madame de Maintenon's "bourgeois" taste asserted itself. The wars seemed endless, and many craftsmen were pressed into military service.

Soon the style escaped royal control, becoming associated with Paris instead of Versailles. Now used in less grandiose residences, decoration became lighter, freer, more elegant. Elements of the Régence style were already present.

The furniture

Materials became more various, techniques more fluent, and curves more prominent; the massive austerity of Louis XIII gave way to the Louis XIV style. Drawing inspiration for ornamental motifs from mythology, flora, fauna, architecture, and war, the period's *ébénistes,* or makers of luxury case furniture, were indeed servants of the Sun King, who saw himself as a brilliant, indeed universal personage. In the history of furniture, the Louis XIV style was an important development, closing the age of multiple-use pieces and ushering in a new era of individualized, use-specific furniture. Generic chests continued to be made only in the provinces, and the last *cabinets* were executed by Louis XIV's cabinetmaker André-Charles Boulle (1642–1732).

Materials and techniques. Large solid-wood pieces were made of chestnut, walnut, or oak. They were sometimes left natural, sometimes painted bright colors such as red or green, even gilded or coated in silver. The carcases of case furniture decorated with veneer or marquetry plaques were often made of more than one kind of wood: oak for the main case, poplar or pine for secondary elements.

Marquetry, of which Boulle was a supreme master, changed considerably under Louis XIV. It made use of various materials.
- Wood marquetry incorporated many woods of various and contrasting colors: the yellow of almond wood and boxwood, the pure white of holly wood, the red of pearwood, the pinkish gray of wood from Sainte-Lucie, the array of browns shading into black of walnut.
- Boulle marquetry was composed of various mineral and animal materials: on the one hand, brass, pewter, and silver; on the other hand, horn, tortoiseshell, mother-of-pearl, and ivory.

This last technique resulted in the simultaneous production of two slightly different ornamental compositions of extreme refinement:
- Boulle marquetry *en première partie,* in which the background is tortoiseshell and the decorative inlay is brass;
- Boulle marquetry *en contrepartie,* in which the background is brass and the decorative inlay is tortoiseshell.

In both cases, pewter was often used as well as brass.

Note: These marquetry panels were often used on two different pieces with identical carcases, or on two symmetrical parts of a single piece (for example, the two doors of an armoire).

Lacquer. French craftsmen of the period often incorporated panels of oriental lacquer into their pieces. But the rarity and intractability of these imported panels prompted attempts to produce to-order imitations. The result was varnish "in the Chinese manner" *(vernis "façon Chine"),* successfully exploited in the eighteenth century by the Martin brothers, with whom it was most closely associated.

Bronze was often used ornamentally as well as to reinforce a piece's structure. Chased and otherwise finely worked, notably by Cucci, it was also used to make doorknobs, lock plates, hinges, handles, etc.

Molding formats

Arched with shaped indents

Arched with four right angles

Notched corner (échancrée)

Decorative motifs

Sun

Mask

Cloven-hoof foot

Acanthus leaf

Square baluster leg

Console leg

Garland of fruit

Inlay design

Two inter-twined Ls (cipher of Louis XIV, XV, and XVI)

End of a campane (decorative runner) adorned with fleurs-de-lys, the Bourbon emblem

Woodwork motif

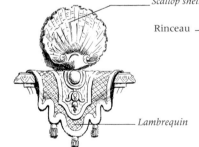

Scallop shells

Lambrequin

Rinceau

Woodwork motif

Decorative motifs

Interlace

Diaper ground with dots

Diaper ground with florets

Ornament

Louis XIV ornament is characterized by rigor and symmetry, resulting in compositions imbued with balance and majesty. Symmetrical elements flank vertical or horizontal axes. Designs of comparable symmetry would recur only under the Empire.

• Straight lines are softened by garland motifs and by modillions, dentils, and fluting, but there are fewer columns and pediments.

• Curved lines are unassertive and relatively short.

• Right angles remain but are less prominent, sometimes being softened by bronze mounts.

• Fielded panels no longer feature projecting motifs.

Moldings are thick. They gradually became thinner and suppler, but they remain responsive to a need for symmetry and framing apparent in the general lines of furniture design.

In Louis XIII furniture, fielded panels have indents and relief ornament (for example, diamond points), but such treatments disappeared under Louis XIV.

Fielded panels are now usually:
• notched in all four corners;
• notched only in the two upper corners;
• arched but with four right-angle corners;
• arched with shaped indents;
• medallions.

Decorative motifs. These are common in both carved wood and bronze. Ample of form and vigorously modeled, they can be ponderous but are nonetheless sumptuous and considerably augment the grandeur of the Louis XIV style

Motifs of human origin. Masks are human faces agreeable to the eye; they are sometimes surrounded by radiating solar rays, in which cases they are called "suns" *(soleils).*

Mascarons represent grotesque faces emerging from vegetation. Masks and mascarons are sometimes surrounded by palmettes disposed in an aureole configuration, in which cases they are known as "peacock tails" *(queues de paon).*

Motifs of animal origin. Scallop shells, sometimes shown from the back and sometimes from the front, are frequent. Often, *rinceaux* scroll symmetrically to either side of them. Also common: lion heads, lion claws, ram heads, dolphins, gryphons, hooved feet, etc.

Motifs of vegetal origin. Most common: oak, laurel, olive, the schematic lily (fleur-de-lys, emblem of the house of Bourbon), garlands of fruit and flowers known as festoons. Acanthus and water leaves (see page 40) are manipulated in various ways: placed side by side in moldings, scrolled into *rinceaux,* disposed as rosettes, etc.

Martial attributes: axes, shields, helmets, arrows, etc.

Motifs borrowed from architecture: balusters, both round and rectangular in section; consoles; modillions; dentils; triglyphs.

Motifs borrowed from tapestry design: campanes (runner ends) and lambrequins, usually decorated with tassels and often featuring scalloped edges. Also: drapery, knots, ribbons.

Patterned grounds: rectangular or diaper (lozenge) lattice patterns decorated with dots or florets; plaiting.

Lit à quenouilles
(distaff bed), detail

Console de milieu
(freestanding console table)

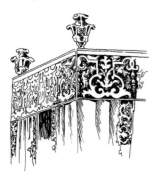

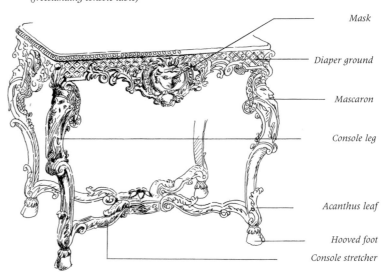

Mask

Diaper ground

Mascaron

Console leg

Acanthus leaf

Hooved foot

Console stretcher

Gaine *leg with square section* *Torchère* *Console*

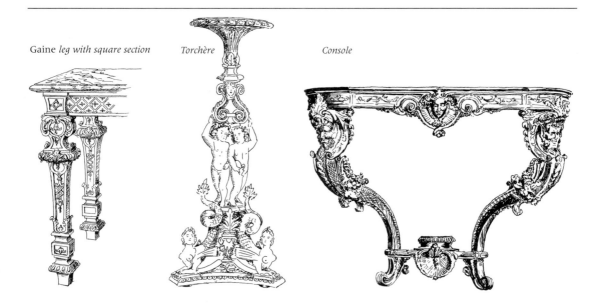

Beds

Few beds from the period survive. As under Louis XIII, they were preeminently the province of upholsterers, for their wooden frames were rarely carved. The ensemble consisting of curtains, bed proper, and baldaquin was known as an *emmeublement*.

Lits à quenouilles (distaff beds) had four bedposts supporting an elaborate crown.

Lits d'ange (angel beds) lacked bedposts, and their *ciels* (canopies) were shorter than the bed below; their curtains were drawn back with the aid of *noeuds galants* (galant knots).

Note: Lits à la duchesse (duchess beds) also lack bedposts.

Tables

Freestanding console tables. These were a particular success of the Louis XIV style. Richly ornamented, they are majestic. Contemporaries dubbed them *consoles du milieu* because their legs resemble architectural consoles or brackets.

Their *tops* — which can be square, rectangular, or, rarely, round — are made of marble, porphyry, or alabaster; of colored-stone marquetry set into black marble; of wood, pewter, copper, and tortoiseshell marquetry.

Their *legs* are always sumptuously carved and decorated.

The stretchers linking their feet consist of consoles or other sinuous motifs decorated at their point of conjunction with a large decorative motif.

The shape of their legs evolved over the course of the reign:

• At the beginning, they were *en gaine* or baluster or, more often, of the console type.

• At the end of the reign, curves became more pronounced and often terminated in cloven feet.

• The friezes are always beautifully carved and sometimes feature openwork elements. There is a mask or mascaron in their center, and they often have lattice-patterned grounds (lozenges or squares).

Less elaborate tables were also made of natural wood (sometimes painted), but throughout the century, even ordinary tables seem to have been given turned legs. There were no dining tables such as we know today; simple trestle tables served this purpose.

Gaming tables were triangular, square, or pentagonal according to the game for which they were intended.

Torchères and gueridons were used to support torches and candelabra. Generally made of carved and gilded wood, they rose from tripod consoles through high *en gaine* shafts to round tops.

Wall consoles

Known as *consoles d'applique* because they were designed to be set against a wall, they are always sumptuously decorated.

Their legs are sometimes straight and sometimes curved inward. At the end of the reign, the rear legs disappeared.

Their tops and friezes are treated much like the analogous elements of other tables.

Writing tables and desks

Writing tables *(tables à écrire)* were introduced under Louis XIV, but there were many varieties.

Tables en écritoire are small, covered in velvet or morocco, and equipped with a drawer for writing implements.

The world is a sphere whose center is everywhere and whose circumference is nowhere. —Pascal

Boulle armoire

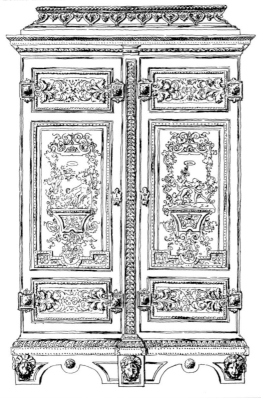

Boulle

Relatives of André-Charles Boulle (1642–1732) had lived in the gallery of the Louvre for two generations before him. After arriving from Switzerland under Henri IV, they were declared free of all guild obligations and worked directly for the king. Although furniture-maker in ordinary to the king, Boulle was not subject to Le Brun's authority. He managed to surround himself with gifted collaborators such as Berain and Caffieri.

Ornamentists and artists

Under Le Brun's direction, the ornamentists Jean and Antoine Lepautre, Jean, Daniel, and Pierre Marot, and Jean and Claude Berain engraved compositions intended to serve as guides to the artists who used them, notably the bronze-caster Keller; Loir, Merlin, and Ballin, who chased precious metals; Caffieri and Girardon, who carved wood; Coysevox and Tuby, who carved stone and marble.

Bureaux plat (flat-top writing tables) are rectangular tables whose tops, covered in leather, have rounded copper edging.

Their aprons, decorated with marquetry, have double or single drawers, those in the center being slightly higher to create a kneehole. They have cabriole legs with cloven feet but lack stretchers. Their drawers and legs are decorated with bronze mounts. At one end of the top there is usually an independent unit known as a *serre-papiers*, equipped with drawers and shelves for papers.

The eight-legged **bureau Mazarin** is the most characteristic desk type of this period. It has two sets of drawers, each supported by four legs — straight, baluster, or console — reinforced by stretchers. A center drawer is higher to create a kneehole. Usually decorated with marquetry made of precious woods or tortoiseshell and copper, this type was also produced in unadorned wood.

Armoires and buffets

Armoires. They remain stiff and majestic. Vertical supports and projecting horizontal cornices remain, but the moldings are now more elaborate.

Their rectangular doors are subdivided into flat panels of various shapes. Sometimes their feet are simple extensions of the vertical supports, but they can also have bun, ball-and-claw, or thick volute feet.

Toward the end of the reign, corners became less prominent as interior lines began to curve, but without any loss of strength.

Boulle armoires, rare and sumptuous, have rather stiff silhouettes. They are decorated with marquetry panels of copper and tortoiseshell, and their cornices, hinges, and bases have superb bronze mounts.

Bas d'armoire *(low armoire)*

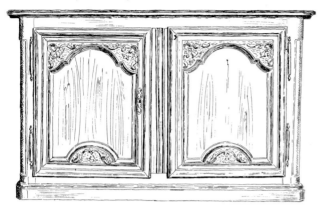

Classic commode

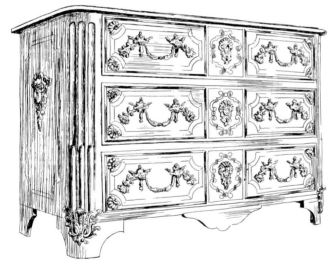

The *fauteuil*

The French word fauteuil (armchair) became current only around 1663, when it replaced the term chaire à bras. According to historians, fauteuil was initially used to designate armchairs with low backs, chaire à bras those with high backs. The current French use of fauteuil to designate Louis XIII chairs is in fact anachronistic.

The bas d'armoire or demi-buffet (low armoire) is a new furniture type with two or three doors, and sometimes featuring drawers just below its marble or wooden top.

The buffets à deux corps (two-part armoires) consists of an armoire placed on top of a *demi-buffet*, with the armoire being slightly smaller than the lower piece.

Commodes

Chests of drawers, introduced toward the end of the century, replaced the cabinet much as the armoire had displaced the more generic chest.

Their panels are made of thick wood, Chinese lacquer panels, veneer, or marquetry. Superb bronze mounts decorate their keyholes and feet, serving as well as handles and corner ornaments.

The **classic commode** has a flat front, flat ends, and a marble top. The front is sometimes bowed *(galbé)*. There are three or four drawers between the corner supports; the corners are rounded or chamfered.

Boulle commodes, with vertical supports and flat ends, have four drawers. Their tortoiseshell and copper marquetry is complemented by bronze fittings in the guise of masks, mascarons, handles, key plates, and corner ornaments. The austerity of their silhouettes is softened by the sumptuousness of their decoration.

Seating

A rigid hierarchy of seating prevailed at court. The use of armchairs, a signal privilege, was reserved for particularly honored guests, and only members of the titled nobility could sit on cushions (known as *carreaux*).

Louis XIV *fauteuils* (armchairs) are solemn and majestic, sometimes of natural wood and sometimes gilded. They are covered with delicate and precious materials: gold or silver brocade, velvet, damask, *point de Hongrie* (a kind of needlepoint), or white *satin de Chine*. These textiles are secured by small studs hidden by silk or linen braid and by fringes, themselves secured by larger studs.

Their *backs* are straight and higher than they are wide (broader backs now disappeared). *Manchettes,* or upholstered arm pads, were still rare. The arms rest on straight, baluster, or console supports aligned with the legs. Toward the end of the reign, arm supports began to be set back, making it easy to distinguish between Louis XIV and Régence armchairs.

Legs, oriented frontally, are sometimes of the baluster or *gaine* type, more often *en console.* Feet are ball-and-claw, bun, rectangular, or, in the case of volute and console legs, small cubes that lift them off the floor.

Stretchers, always large, could be:
• in an H configuration as under Louis XIII, a type still prevalent at the beginning of the Louis XIV period. They could also be turned, volute-shaped, or mutton-bone *(os de mouton).*
• in an X configuration, a type introduced somewhat later. Stretchers of this type consisted of four volutes joining at the center to form a large motif. As the reign advanced, they became thinner and their moldings less prominent.

Note: There are also simpler Louis XIV *fauteuils* made of wood that is rounded but uncarved and without moldings. Their arms terminate in large rounded forms known as *becs de corbin,* or billheads. These examples, quite sturdy and produced in large numbers, are often sold today as Louis XIII.

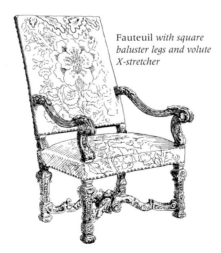

Fauteuil *with square baluster legs and volute X-stretcher*

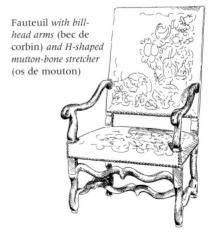

Fauteuil *with billhead arms* (bec de corbin) *and H-shaped mutton-bone stretcher* (os de mouton)

Confessional fauteuils are ancestors of the *bergère* (see page 54). Intended for use by priests listening to confessions, they originally featured *oreilles* ("ears" or wings) equipped with blinds and a thick seat cushion. Subsequently, the blinds in the wings were removed.

The **lit de repos** (daybed) was introduced under Louis XIV; long and narrow, it has eight baluster, console, or pilaster legs joined by stretchers; its back, placed at one end, is low and, like its rails and feet, decorated with carved motifs.

The **canapé** (settee), derived from the *lit de repos*, is three times larger than the *fauteuil*. Its legs (six or eight) resemble those of chairs of the same period, and its seat cushions were sometimes loose.

Caquetoires, also known as *chaires bas* (low chairs), with their low turned feet and high backs, were still current.

Louis XIV **banquettes**, also known as *formes*, are benches with four or six baluster legs and upholstered seats.

Chaises en paille (straw-bottomed chairs), also known as *capucines*, painted black, green, or red *façon Chine* (in the Chinese fashion), were quite common.

Chaises à dos (chairs with backs) from the period resemble contemporary *fauteuils* but have no arms.

Louis XIV **placets** are square or rectangular tabourets (stools) with four straight, gilded legs — baluster, console, or pilaster — reinforced by H- or X-stretchers.

Ployants are simply folding stools made of sumptuous materials and covered in expensive fabric. Their X-shaped carved legs (console or baluster) are sometimes gilded. A few were even made of solid silver.

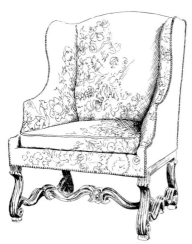

Confessional armchair with volute H-stretcher

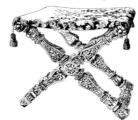

Folding stool (ployant) with square baluster legs

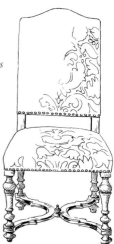

Chair (chaise à dos) with X-stretcher and round baluster legs

Silver

Plate with segmental rim (à pans coupés)

Porringer

Applique (wall light)

Plate with gadrooning

Ewer

Rafraichissoir *(wine cooler)*

Salière (salt)

Ceramics

Rouen pottery plate

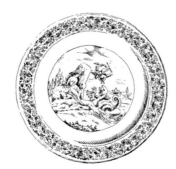

Moustiers pottery plate

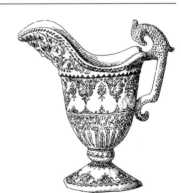

Rouen pottery pitcher

Louis XIV carpet, detail

Pediment mirror

Clock à la religieuse

Candlestick à la
financière

Candlestick

Caster

Candelabrum with
girandoles

Barometer

L'Embrasse
(tieback)

The Régence Style

1700-1730

 THE REGENCY OF Philippe d'Orléans lasted a mere eight years (1715–23), but its characteristic spirit prevailed in French culture for much longer. It emerged early in the century and continued to thrive into the reign of Louis XV, until about 1730.

Régence is best understood not as a style but as a state of mind. The last years — solemn and lugubrious — of the "great king," who by then had renounced lavish entertainments but continued to enforce strict rules of etiquette, were marked by a reactive turn toward intimacy, comfort, distraction, and pleasure, which the nobility now sought not at court but in Paris. The monolithic uniformity that had long characterized French style and artistic production gradually crumbled. Glory and majesty gave way to grace. The nobility sought escape from the stiff ceremonial of Versailles in the salons of witty, libertine princes and great ladies as seductive as they were refined. Protocol was replaced by decorous sociability and elegance.

The term *régence* remains synonymous in French culture with intellectual vivacity, lightness of spirit, and delicacy of expression. This was the era of Watteau and the *Pilgrimage to Cythera*, of Fontanelle's philosophical dialogues set in parks, of such plays by Marivaux as *La Double Inconstance* (reciprocal infidelity) and *Le Jeu de l'amour et du hasard* (the game of love and chance).

Slowly, without revolution and virtually without upheaval, interior decoration also changed.

The artists and craftsmen specializing in such work, now employed only rarely by the monarch and his court, were sustained by commissions from private clients who sought escape from the suffocating constraints of the preceding period. The result was the diversity, sometimes marked by fantasy, that gives the Régence style its novel character. Furniture became less bulky in the interest of comfort and intimacy. Large rooms and ceremonial bedchambers disappeared, giving way to small salons, boudoirs, studies, and music rooms. As a consequence, pieces of furniture became smaller, easier to move, and more numerous. Their lines grew more fluent and curvaceous. Ornament became more fantastic, but not to excess. Veneer and bronze fittings became almost ubiquitous.

Noble without stiffness, rich without ostentation, pure without austerity, refined without preciosity, the Régence style is a poised blend of charm and elegance. Less imposing than that of Louis XIV, less exuberant than that of Louis XV, it is a reflection of the same golden age of the old regime that invented the cult of *douceur de vivre*, or the sweet life.

ABROAD
England: end of Queen Anne period
Italy: end of Baroque period
Spain:
Philip V style (imitation Boulle)

The furniture

Between 1700 and 1730, furniture shapes evolved in ways more subtle than revolutionary, resulting in greater comfort and forms more elegant and agreeable to the eye.

Régence is a transitional style; thus it is not surprising to find conservative and novel elements cheek by jowl in the same piece. Quite often, the addition of bronze fittings sufficed to transform a Louis XIV format into a Régence piece. The originality of Régence bronze fittings resides in the way they manage to be both functional and decorative.

Materials and techniques. Oak was used for the finest pieces, pine and poplar for more ordinary ones. Most seating was made of beech, walnut, fruitwoods, or limewood. Ebony was used less frequently.

Natural woods decorated with refined ornament became fashionable again, but gilded wood remained in vogue for console tables, ceremonial chairs, and frames.

Case furniture made of solid wood, much admired early in the seventeenth century, returned to favor.

Wood veneer entered widespread use. The most prized veneers during the Régence period were rosewood *(palisandre)* and, especially, kingwood *(bois de violette)*, with its curving grain.

Marquetry of colored woods was set into ebony grounds, often in geometric patterns. The brass, ebony, and tortoiseshell marquetry associated with Boulle's name was now appreciated only by a small clientele, but it retained this limited popularity throughout the eighteenth century.

Bronze fittings. Either gilded using the mercury method (in which case it is sometimes called ormolu) or varnished a gold color, bronze was prominently used for fittings: as worked moldings around desk- and tabletops; as drawer reinforcements and handles; as protective *sabots*, or shoes; and as console *espagnolettes* to protect projecting corners.

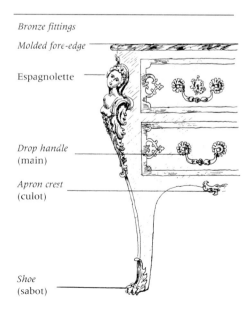

Bronze fittings

Molded fore-edge

Espagnolette

Drop handle (main)

Apron crest (culot)

Shoe (sabot)

Ornament

In the Régence style, the spirit of ornament changes; everything conspires to soften the rigidity associated with the Sun King.

In the Louis XV style, ornament would become so supple as to be virtually uninterrupted, effectively indistinguishable from its supporting armature; in the Régence style, it is calmer and more stylized, remaining subsidiary to the forms that it accentuates.

Asymmetry appears in decorative details, but overall compositions remain quite symmetrical.

Profiles. Curved and undulating profiles, tentatively introduced under Louis XIV, become the norm, but a few surfaces remain flat. Right angles do not disappear but are often softened by decorative motifs.

Moldings, thinner and less assertive than under Louis XIV, are in low relief. Indents and bronze fittings mask corners, adorned with motifs that sometimes extend into adjacent panels. Furniture of solid wood is decorated with delicate ornament on panels fielded by moldings. These panels are of various shapes, notably:

•*cintré,* or with an arched upper border, sometimes consisting of two C-scrolls flanking a palmette or scallop shell;

•*en chapeau,* or with an upper border consisting of an arch flanked by shaped indents (see opposite);

•with an "asymmetrical" upper border, in which case they are always one of a symmetrical pair (double doors, wall paneling).

Decorative motifs. The following motifs were widely used in both carved and bronze-mount form.

Patterned grounds. Rectangular and lozenge patterns decorated with dots and florets remain common; the lines are sometimes wavy, making for a suppler, less rigid design.

Motifs of human origin: masks and mascarons (see page 27) still appear, but they are being replaced by the smiling heads of fauns and women; the lion's head, prevalent in the Louis XIV style, gradually disappears.

Ébéniste Charles Cressent initiated the practice of placing *espagnolettes,* or female busts emerging from foliate consoles, on projecting "shoulders" and "knees" at the corners of flat-top desks, chests of drawers, and console tables. By extension, the same term is used to designate analogous corner motifs featuring the heads of fauns and serene old men.

Motifs of animal origin:

•Scallop shells *(coquilles)* are among the most characteristic motifs of the Régence style. They lose their rigidity in these years, becoming more natural, more attenuated, and even pierced, sometimes rising from two acanthus *rinceaux,* but they are never twisted and tormented as they would be under Louis XV.

They appear as the central motifs of consoles, tables, chairs, and armoires, and sometimes as corner motifs.

• The bat's wing (not to be confused with the scallop shell), a curious motif that came into its own only late in the Régence period. Less common than the scallop shell, it was used in analogous ways.

• Animals appear more frequently toward the end of the Régence period. In both carved wood and bronze, monkeys, dolphins, dragons, birds, and chimeras figure on folding screens, consoles, tables, firedogs, wall lights, clocks, etc.

Motifs of vegetal origin:

• Palmettes, which consist of five radiating leaves joined at the base, lose the stylized character they had under Louis XIV. Incorporated into pediments, leg knees, and corners, they enter widespread use, both carved in wood and

Moldings

Panel en chapeau

Cintré *panel (arched)*

— *Palmette*

— *C-scroll*

Asymmetrical panel

Decorative motifs

Grotesque panel by Berain

Female mask

— *Palmette*

— *Peacock's tail*

— *Acanthus leaf*
— *Scallop shell*

Monkey
(singe)

Openwork scallop shell

Sunflower motif

Bat's wing

Gadrooned leaf

Decorative motifs

Palmette

Acanthus with beading

Water leaves (feuilles d'eau)

Table

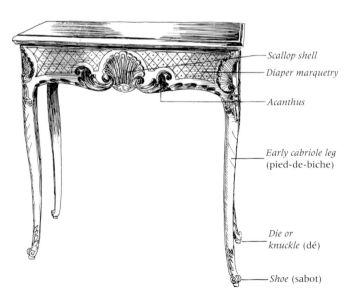

— *Scallop shell*

— *Diaper marquetry*

— *Acanthus*

— *Early cabriole leg* (pied-de-biche)

— *Die or knuckle* (dé)

— *Shoe* (sabot)

cast in bronze.

• Acanthus grows longer and suppler but does not become twisted and jagged. It is used on furniture legs, chair rails, and chair crestings. In conjunction with other motifs, notably scallop shells, mascarons, and palmettes, it is worked in everywhere.

• Water leaves *(feuilles d'eau)* (see opposite) of the most delicate variety, convolvulus, and palm fronds, not to mention gadrooned leaves, especially characteristic of the period, were widely used.

• Toward the end of the Régence period, "sunflowers" with four or five large petals began to appear on the seat rails and table friezes.

Motifs of exotic origin: pagodas, peacock feathers, parasols, humpback bridges, misshapen rocks, and exotic flowers were all put to judicious use.

Note: Martial and heroic motifs were replaced by others evoking the pastoral world, gardening, hunting, fishing, music, and, above all, the game of love (bows, arrows, quivers).

Beds

Like Louis XIII and Louis XIV beds (see pages 19 and 29), Régence beds were largely the province of upholsterers. Such pieces are now extremely rare: Louis XV beds, less cumbersome and, above all, more gracious, with their elaborately carved headboards, soon monopolized all attention.

Lits à la duchesse (duchess beds) and *lits d'ange* (angel beds) retained their appeal. Head- and footboards of exposed wood began to appear, sometimes of like size, sometimes lower at the foot of the bed. These usually had complex profiles and were decorated.

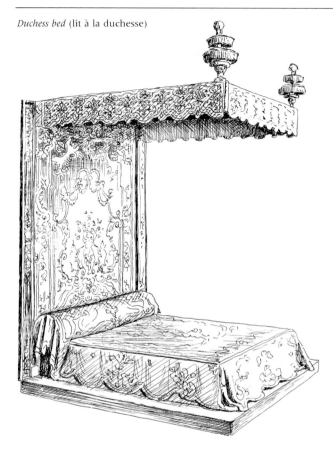

Duchess bed (lit à la duchesse)

Lits à quenouilles ("distaff beds") were disappearing but were still used by the royal family.

Tables

Tables lost their massive quality, becoming small and readily transportable.

The *tops* of salon tables were made of beautiful yellow *brèche d'Alep* and Autun marble, but simpler tables were given wooden tops.

Their *friezes,* with serpentine lower edges, are decorated with ornamental motifs.

Their *frames,* made of wood or gilded wood, are transformed; very often, stretchers are absent; baluster, sheath, and spiral legs disappear in favor of proto-cabriole legs *(pieds-de-biche)* and console legs. Increasingly, they are turned out and continuous with the railings or friezes. They terminate in volutes resting on dice or in bronze "shoes" known as *sabots.*

Freestanding tables from this period (quite rare) are small and elegant. Their friezes, with serpentine lower edges, feature a central scallop shell, mask, etc. Their legs, slender and out-turned, have no stretchers.

Larger freestanding tables, of the console type, sometimes have slightly serpentine stretchers with a carved decorative motif in the center. Elegant bronze mounts adorn the knees and feet of the legs; if the table is solid wood, these areas are richly carved. The friezes sometimes have bronze mounts.

Régence **gaming tables** have curved legs and decorated friezes. Square, rectangular, or pentagonal in shape, they are less various than under Louis XIV.

Console table

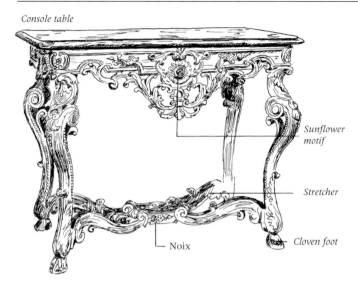

Sunflower motif

Stretcher

Noix

Cloven foot

Flat-top writing table (table bureau)

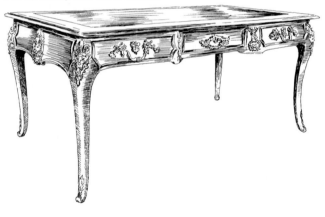

Ornamentists and *ébénistes* (makers of luxury case furniture)

The architect-ornamentists are Gilles-Marie Oppenordt and Robert de Cotte. The period's greatest maker of luxury furniture was Charles Cressent. He abandoned the tortoiseshell, ebony, and brass marquetry associated with his master Boulle and transformed the character of chests of drawers, which acquired a more rounded profile complemented by serpentine lower edges.

Tables de nuit (night tables) were still quite rare, but *tables de toilette* (dressing tables) entered widespread use. These simple tables were originally covered with thin fabric (*toilette,* hence their French name) and lace extending as far as the floor.

Trestle tables were still used for dining.

Consoles

Console tables, which did not change much, retained their decorative character. Their friezes, richly ornamented, sometimes with openwork designs, support beautiful marble tops. Their two or four legs trace attenuated Ss and are elaborately carved, the knees often being decorated with *espagnolettes* or bearded mascarons. Their serpentine stretchers are decorated in the center by a motif known as a *noix.*

Desks

The **table bureau** (flat-top writing table) was the preferred type. Large in size, it has a rectangular top with a molded edge; its frieze contains three drawers, decorated with water leaf or acanthus moldings, with bronze handles and key plates.

Occasionally, these were made with two superimposed drawers on either side and a single recessed drawer in the center.

The curved *pied-de-biche* legs terminate in bronze shoes or acanthus leaves, with bronze ornaments on the hips or knees.

Tables bureaux were usually veneered, but a few surviving examples are made of stained pearwood.

Secretaires à abattant (drop-front secretaries) were in great demand. Always made of solid wood, their panels are flat but decorated with delicate central relief motifs.

Buffet à deux corps
(two-part cupboard)

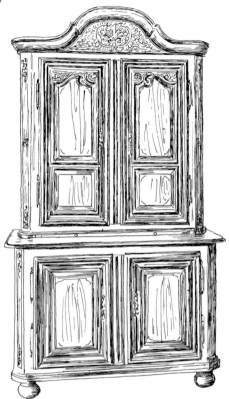

The *buffet-vaisselier* (dresser-cupboard)

Of provincial origin, this popular type was used to display faïence, pewter-ware, and porcelain. It was known as a pallier in Normandy, as a ménager in Champagne. The most beautiful examples are from eastern and southern France. The lower piece, which has double doors with thick moldings, recalls two-piece armoires. The upper piece is surmounted by a pediment (triangular, arched, or en chapeau) decorated with rays and a projecting cornice.

Their lower parts are divided into three segments, the central one being recessed to accommodate the legs. Their supporting structure resembles that of a Mazarin desk, consisting of two groups of four cabriole legs without stretchers, shod in bronze shoes.

Note: Under the Régence, neither the *bonheur-du-jour* nor the rolltop desk existed (see page 62).

Armoires

Régence armoires — high, broad, and always made of solid wood — are quite close to the Louis XIV type but sometimes have bow fronts. Their vertical supports are rounded; when they have pediments (as opposed to culminating in straight cornices), these are of the basket arch or *en chapeau* type. Their aprons, with serpentine lower edges, are sometimes carved with moldings and decorative motifs, and they have short feet.

Their fielded panels, no longer distributed symmetrically above and below a transverse central axis, are often softened at the corners by carved C-scrolls, vegetal pendants, and florets.

Buffets

Buffets à deux corps (two-part cupboards) resemble contemporary armoires, but their lower parts, somewhat wider than their upper ones, usually have plain bases.

Commodes

Commodes à la Régence (two rows of drawers, tall legs) and *commodes en tombeau* (three rows of drawers, short legs) are characteristic productions of the period. Sometimes made of solid wood and sometimes decorated with

43

*Far from being a burden to intelligence, memory nourishes it, sustains it, furnishes it with material. —*GEORGES DUHAMEL

Régence commode, or commode en tombeau

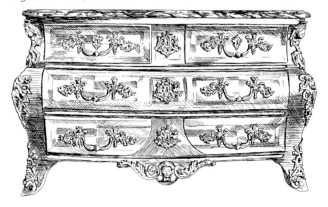

Commode en arbalète *(bowed)*

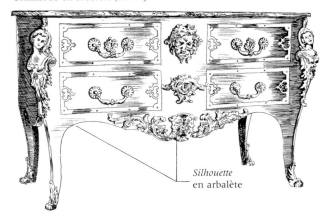

Silhouette en arbalète

Les sièges cannés

Typically, Régence chairs have slender back supports or rails and delicate carved ornament on their arms, back crests, and bases. All chair types from the period were sometimes caned. Many such pieces survive, and their restrained elegance still appeals. In summer they were left as is, which made them very cool. In winter upholstered cushions were tied to their backs and bases with ribbons.

marquetry, they can seem ponderous because of their bulging fronts and ends. They have marble tops; sometimes there are copper grooves between their drawers. Their upper drawers are double, those below broad and single. The corners of their cases are decorated with espagnolettes, masks, or other bronze fittings.

Additional bronze applied ornament — in the form of acanthus, water leaves, and gadrooned leaves — serve as their key plates, shoes, and handles (fixed or drop) and decorate their aprons.

The **commode en arbalète,** a less ponderous type, rapidly became the standard after it was devised by Cressent. With a discreetly bowed front and two rows of drawers, it has rather long proto-cabriole legs *(pieds-de-biche)* and feet shod in acanthus shoes. Its apron has a serpentine or bow profile.

Powerful chased bronze fittings define the drawer edges, serve as key plates, and protect the corners.

Seating

Under the Régence, seating became less cumbersome, easier to move, and more accommodating, despite the retention of rectilinear formats.

Frames. Wooden back frames, always flat *(à la reine),* and seat rails, sometimes straight and sometimes bowed, were left exposed and decorated with delicate carving. At the beginning of the period, the sides of backs remained straight, but later they acquired a slight inward curve. Their tops are curved, their crestings (and sometimes their shoulders) being carved much like the seat rails.

The *legs* of Régence chairs and settees are curved and often out-turned; they

Seating

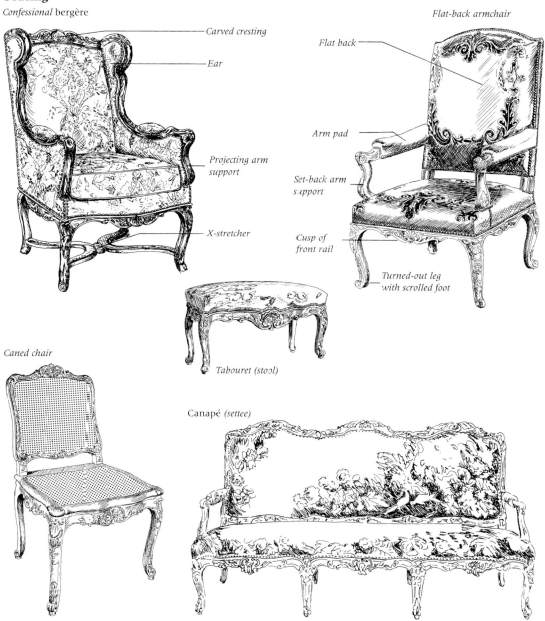

Confessional bergère

— Carved cresting

— Ear

Projecting arm
support

X-stretcher

Caned chair

Tabouret (stool)

Flat-back armchair

Flat back —

Arm pad

Set-back arm
support

Cusp of
front rail

Turned-out leg
with scrolled foot

Canapé (settee)

can be rather short or, alternatively, long and delicate cabriole legs. Their scrolled feet, decorated with acanthus, often rest on dice.

Note: Baluster and pediment legs were no longer used. Stretchers became increasingly rare, but when present they are thin, molded, and in an X configuration.

Upholstery and caning. All upholstered seating was covered with tapestry, leather, or rich fabric. Caned chairs, which were introduced in this period, became quite fashionable.

Note: Only rarely are all of the characteristic features of Régence seating found in a single piece. One often comes across chairs whose backs have no exposed wood but whose seats, legs, set-back arm supports, and carved motifs are typical of the period; conversely, there are examples with no stretchers, with projecting arm supports, etc.

Fauteuils (armchairs). Exposed-wood backs with straight sides are lower, and seats become trapezoidal in shape.

Arm supports are no longer aligned with the legs; they flair outward to accommodate skirts with panniers. They also acquire upholstered arm pads *(embourrures)*. The heavy supports favored under Louis XIV are lightened and decorated with foliate motifs.

Seat rails and back crestings are delicately carved, often with a central motif that accentuates their curved profiles.

The legs, *pieds-de-biche* or cabriole in form and sometimes out-turned, are carved with acanthus at the knees and feet.

Chaises (chairs without arms) adhere to the same pattern as armchairs and are likewise beautifully proportioned.

The **bergère à oreilles** (low armchair with ears or wings) is a lower variant of the Louis XIV *fauteuil en confessional* (see page 33). Its continuous in-filled ears and arms are perpendicular to its back (the gondola back appeared only under Louis XV). Its back cresting, arms, and low seat have refined decorative treatments like those of *fauteuils,* but sometimes the back is fully upholstered with no exposed wood. Thick, loose cushions stuffed with feathers make these chairs extremely comfortable.

Tabourets (stools) were quite popular in the period. Sometimes square and sometimes rectangular, their wooden frames are carved much like those of contemporary armchairs.

Banquettes d'applique (wall benches), a common seating type, were placed along the walls of hallways and large salons. Their rails and legs (four or six) resemble those of contemporary armchairs.

Régence canapés (settees), more numerous now than under Louis XIV, resemble two or three armchairs soldered together. Some examples have stretchers, others do not. This type would develop distinctive features only under Louis XV.

Lits de repos (daybeds) have two "backs" at either end with exposed wood that is richly carved. Their short, turned-out legs are curved and delicately carved.

Chaises longues are armchairs with elongated seats and six curved legs, turned out and carved with acanthus. The bowed rails are adorned with scallop shells. They have single, very long cushions.

Silver

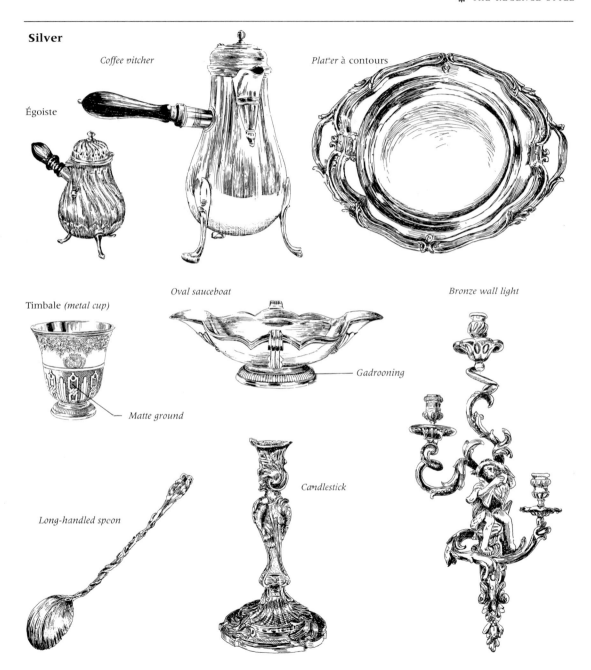

Coffee *vitcher*

*Plat*er à contours

Égoiste

Timbale *(metal cup)*

Oval sauceboat

Bronze wall light

Gadrooning

Matte ground

Long-handled spoon

Candlestick

The Louis XV Style

1730-1760

 ALTHOUGH LOUIS XV'S TITULAR reign (including the regency) extended from 1715 to 1774, the style of the same name began to emerge about 1730 and was transformed into the so-called Louis XVI style beginning about 1760. But these three decades saw the creation and development of a style that is the most brilliant, the most refined, and, arguably, the most charming ever devised.

That is because the reign of Louis XV was the golden age of *favorites*. Madame de Pompadour, Madame du Barry, and a few others were not only delicious royal mistresses; they were also models for countless gracious and intelligent women who subjected the customs, fashions, and decors of the period to their preferences, and sometimes to their caprices.

Everywhere — in Versailles, in Paris, in the provinces — sovereignty passed into the hands of a new personnage whose authority has rarely been challenged since: the mistress of the house. It was for her that Voltaire wrote *Candide* and Diderot *The Indiscreet Jewels*, for her that scholars and thinkers wrote the *Encylopédie*, that generals gave battle, that ministers hatched plots. And it was due to her influence that grand suites of chilly ceremonial rooms in palaces were replaced by smaller ones that were comfortable, well heated, and intimate to the point of coziness.

The rooms in these new residences were smaller and more numerous than had previously been the norm, and more use-specific. They generally boasted several kinds of salon (*salon de compagnie, petit salon, salon de musique*) as well as a boudoir, a library, a *cabinet à écrire*, or study, and soon, around 1740, a dining room.

Above the main floor, each bedroom had its own *garde-robe*, or dressing room, and boudoir, or intimate reception room.

All of these rooms were furnished with unfailing attentiveness to elegance, refinement, comfort, and well-being. On the walls, marble gave way to high paneling that was carved, painted, varnished. On the floor, wood marquetry replaced stone paving, now deemed too cold. Mantelpieces became lower. Knickknacks, lighting fixtures, objets d'art, and exotic curiosities were chosen with an eye to overall effect. Even painters adapted their subjects and formats to this aesthetic of intimacy.

Such was the craze for this delicate style that, for the first time, there emerged a furniture industry worthy of the name. Famous *ébénistes*, or specialists in luxury case furniture, farmed out work to subcontractors, producing series that were sold by special dealers. These *marchands-merciers*, rarely given their due, played an important role; offering advice to clients, serving as middlemen between clients and producers, and coordinating the work done by members of the various craft guilds, they effectively gave the style its unity.

Everything conspired to create an atmosphere of exceptional elegance and refined comfort. One senses this same atmosphere in the literature of the period, imbued in equal parts with irony, libertinage, and civility. Circumstances fostered an inimitable tone that was long regarded, in Europe, as the model for cultivated sociability.

ABROAD
England:
Palladian and
Chippendale styles
Italy:
the rococo
Spain:
Carlos IV style
(rococo and
antique revival)

The furniture

Louis XV is undoubtedly the greatest of all periods for French furniture. The materials are immensely varied and the workmanship exceptional. Forms proliferated, adapting to all manner of demand: furniture became practical and readily transportable without losing any of its elegance.

Materials and techniques. Most solid-wood furniture was made of oak or walnut, but there are also examples made of cherry, ash, plum, chestnut, and olive.

Beech, lindenwood, and walnut were used only in chairs and other seating.

The carcases of elaborate pieces were usually made of oak, but there are also examples made of pine and poplar.

• Painted wood was often used as it fostered harmony between furniture and paneling; the moldings and sculpture of both could be painted the same contrasting color.

• Gilded wood was now used less than previously, being reserved for *trumeau* mirrors, console tables, and the occasional elaborate seating piece.

Marquetry. Many woods were used for marquetry. The availability of no less than a hundred different species, including mahogany, made it possible to execute colorful compositions: baskets and vases overflowing with flowers, smaller bouquets of flowers and greenery scattered here and there, geometric patterns, etc.

Note: Boulle marquetry was now used only for chests, long-case clocks, and table clocks.

Lacquer. Lacquer panels imported from the East were difficult to incorporate into curved surfaces, so French craftsmen began to produce imitations. The most successful technique was devised by the four Martin brothers, who produced gold compositions against black grounds as well as light-ground lacquers (deep blue, emerald green, yellow) decorated with fruit, rustic scenes, and chinoiseries.

But these lacquers proved unstable; only a few examples of lacquer furniture from this period have come down to us.

Bronze fittings. Used on luxury furniture both as ornament and for protection, these cast pieces were gilded using the mercury method (ormolu) or, more often, coated with gold varnish. By and large, Louis XV fittings are less refined than those on Régence furniture.

Beautiful *marble* was used to add color highlights to both furniture and interior decors. Thick overhanging tops honored the complex outlines of the pieces beneath them; generally, their molded fore-edges were a quarter-round surmounted by a cavetto.

Porcelain seduced through its novelty and freshness. Small pieces of furniture featured delicate rectangular or medallion plaques set into mahogany panels. Occasionally, larger compositions served as the tops of gueridons (small round tables with tripod supports).

The curved line is the preeminent line of life.
—MICHELET

Techniques

Marquetry

Marquetry

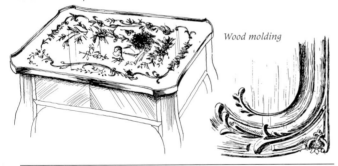

Marble top with molded fore-edge

Porcelain tabletop

Wood molding

Martin varnish

Many types of furniture (chests of drawers, dressing tables, corner cupboards, small tables, writing tables) were coated with Martin varnish, which was quite popular. Such pieces were often conceived as matching ensembles. Bombé ("blown-out") surfaces became fashionable; delicate bronze fittings were applied to corners (which they served to protect) and used as handles and key plates.

Rocaille and rococo

The style known in French as the rocaille, *a late variant of the Baroque that flourished in the Louis XV period, spread rapidly throughout Europe. Its success encouraged designers to take it to outrageous extremes. The result was the rococo, a bastardized version of the* rocaille *that, in France, almost always remained balanced, measured, and elegant.*

Ornament

Louis XV ornament is distinguished by a fantastic movement and throbbing life that make it the antithesis of the stiffness prevalent under Louis XIV. Characterized by curved lines, exotic themes, and forms suggestive of rocks and shells, it delights in asymmetry.

Lines. Curved lines, which are all-pervasive, soften forms and motifs. But the resulting sinuosity does not preclude stability and formal resolution: C-scrolls and S-curves stand nervously erect or bend graciously.

Straight lines are interrupted by motifs or softened by moldings.

The *rocaille.* The ornamentists Oppendordt and Meissonnier were the first to draw inspiration from nature. Their example was soon followed by *ébénistes,* sculptors, painters, goldsmiths, etc.

The term *rocaille* was first used to designate bases made of bronze or faïence and shaped like rocks. Later, it was applied to any tormented design, to such an extent that it became synonymous with an entire way of feeling and seeing: the art of dissimulating order beneath a feigned disorder.

Exoticism was ubiquitous: first imported objects were copied, then graceful French variations were worked on them.

Note: Both the *rocaille* aesthetic and exoticism fostered irregularity, encouraging the use of odd rhythms in all the applied arts; precise mirror symmetry often gave way to the balancing of approximately equal masses.

Decorative motifs were placed on bronze fittings, silver, and carved wood as well

Ornament

Rush stalk

Diaper marquetry with florets

Geometric marquetry

Stylized shell

Winged cartouche

Dolphin

Singerie

Floret on chair cresting

Dervish

Attributes of music

as in marquetry work. Never arrayed in straight rows, they were disseminated wherever the designer wished to attract the viewer's gaze. The themes were inspired by flora and fauna.

• Diaper grounds, with and without florets, are common, as are geometric and imitation wickerwork grounds.

• Cartouches bulge forward, slant, are given *rocaille* frames.

• Scallop shells, still widely used, are now irregular, stretched this way and that: pierced, folded, dentilated.

• Doves and dolphins are the animal motifs of choice.

• Flowers are stylized. Represented as bouquets and garlands, isolated and in bunches of three, they appear everywhere, usually surrounded by delicate greenery. Stemmed florets figure frequently on the tops of chair backs and on seat rails, where they replace the Régence scallop shell.

• Attenuated acanthus is combined with all *rocaille* motifs. Crossed oak, laurel, and palm branches are freely treated. Palm fronds and rush stalks form supple frames totally without stiffness, for delicate twigs interrupt their straight lines.

• Attributes are highly prized: of love, the hunt, fishing, music, and the pas-

toral life. They celebrate the sweetness of existence, of daily life.

• Oriental themes invade decoration: sultans, pashas, dervishes, and elegant monkeys move gracefully through imaginary landscapes.

Frame and solid-wood furniture (menuiserie)

There was a division in the guild of *menuisiers-ébénistes.* In principle, all of its members were permitted to make both solid-wood frame furniture *(menuiserie)* and case furniture incorporating Boulle and wood marquetry. In reality, however, *menuisiers* made only solid-wood frame pieces, while *ébénistes* made luxury case furniture.

It was *menuisiers,* then, who produced beds and seating, not to mention tables, buffets, armoires, and consoles made entirely of walnut or oak. These pieces were delicately carved by the wood sculptors who worked closely with *menuisiers. Ébénistes* devoted themselves exclusively to pieces incorporating Boulle marquetry and wood marquetry.

Beds

Very few Louis XV beds have come down to us; fortunately, they are often represented in contemporary images, thanks to which modern craftsmen have been able to recreate them.

Lits à la française were placed perpendicular to the wall and surmounted by a *ciel,* or canopy.

• Distaff beds (see page 29) are still quite luxurious, but they are now deemed too large and gradually disappear.

• Duchess beds and angel beds are still current.

Menuisiers

Whole dynasties were devoted to this craft, which was transmitted from father to son. Examples include the three Avisses, the three Gourdins, the four Cressons (not to be confused with the ébéniste Cressent), the Tilliards, the Folliots, and the Nadals, who were active throughout the century, not to mention Potain, Boulard, Delanois, Heurtant, and Chevigny; the Séné and Jacob dynasties reached their apogee under Louis XVI. The wood sculptors who collaborated with menuisiers did not sign their refined work. Some of them also produced wall paneling and mirror frames, for example Pineau at the Arsenal and the hôtel de Villars. Many — notably André Verberckt — left carved work of incomparable delicacy and fantasy.

Polish bed (lit à la polonaise)

Plume

Canopy

Curtain

Counterpane

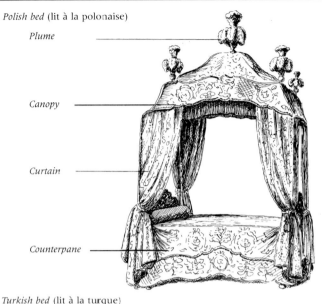

Turkish bed (lit à la turque)

Plume

Curtain

Scrolling
end
board

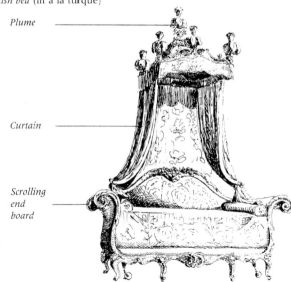

Alcove beds. Called *lits de travers* (transverse beds) because they were placed lengthwise against the wall, they appeared around 1740. Their small size and elegant proportions made them an immediate success. Their head- and footboards (of equal height), front rails, and legs were painted or, occasionally, gilded to match the room's paneling.

Alcove beds were surmounted by a canopy whose form varied according to the bed type.

In French, *ciel* is most often used to designate the canopies over *lits à la française*, and *baldaquin* to designate those over alcove beds.

• *Lits à la polonaise* (Polish beds) have head- and footboards; their four bedposts support an arched iron frame supporting a baldaquin from which hang curtains tied back at the corners. Their dome-like canopies have graceful moldings around their circumference.

• *Lits à la turque* (Turkish beds) have a "back" (set against the wall) as well as head- and footboards. The edges of the latter trace an S-curve and terminate in an overhanging scroll. From the baldaquin, fixed to the wall, hang curtains that are draped over the rear of the boards.

Seating

Armchairs, chairs, settees, and daybeds abounded. Their light and graceful forms by no means preclude comfort; their ornament and moldings are of great delicacy and refinement.

Seats are softer, thanks to the invention of *l'élastique*, or springs.

Made of beech, walnut, or oak, originally these pieces were often painted in several colors. Natural wood was used only for ordinary chairs and caned chairs. The most richly carved pieces

Backs

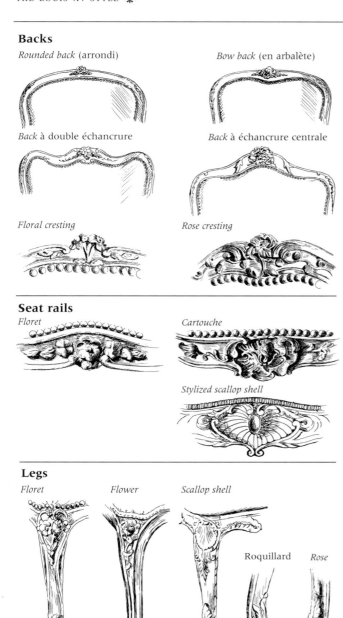

Rounded back (arrondi)

Bow back (en arbalète)

Back à double échancrure

Back à échancrure centrale

Floral cresting

Rose cresting

Seat rails

Floret

Cartouche

Stylized scallop shell

Legs

Floret *Flower* *Scallop shell*

Roquillard *Rose*

were sometimes gilded. Toward the end of the period, pieces painted white or varnished became fashionable.

The carving was sometimes conspicuously sinuous. A chair's quality was recognizable by its supple moldings, by the harmonious curves of its legs, by the subtle relationships between its various parts.

Chair *backs* generally rose only to shoulder height to preclude their disturbing women's coiffures; an exception was made for armchairs in which one could doze off *(bergères, fauteuils de commodité)*. If a chair's back was flat, it was said to be *à la reine;* if slightly coved, it was *en cabriolet.* The sides of all backs from this period curve inward toward the center *(violoné),* if only slightly.

The top rails of chair backs were treated in many different ways (see left).

Chair *legs* with gentle S-curves were decorated with acanthus and terminated in scrolled feet with an acanthus leaf known as *roquillards.* Stretchers effectively disappeared.

Chairs of all types were sometimes caned.

The **cabriolet** armchair was the most common type. Featuring a slightly coved back with in-curving side rails, it was easy to move and ideal for conversation.

The **bergère** armchair, low and deep with in-filled arms, was rendered more comfortable by a thick feather cushion supported by webbing. There were several varieties:

• The *bergère en gondole* has a rather high back with a low arch and very short arms.

• The *bergère en confessional* or *à oreilles* has a high flat back from which ears or wings project at an angle.

Armchairs and chairs

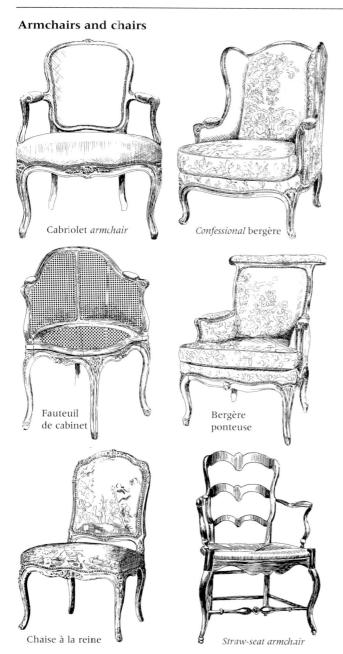

Cabriolet *armchair*

Confessional bergère

Fauteuil
de cabinet

Bergère
ponteuse

Chaise à la reine

Straw-seat armchair

• The *bergère ponteuse* or *voyeuse* has an elbow pad along the top rail of its back on which one could lean to watch a card game.

The *fauteuil de commodité*, low and without exposed wood on the back, has a seat cushion, a bolster-shaped cushion, and in-filled arms, making it especially comfortable — hence its name.

The *marquise* is a very wide *bergère* with a low back capable of accommodating two people. Also called a *demi-canapé*.

The *fauteuil de cabinet* or *de bureau* (study armchair). made entirely of exposed wood, had a low rounded back *(en gondole)* and was often caned or covered with leather. Exceptionally, its four legs are positioned such that one, placed front and center, supports its bowed front rail.

The *fauteuil de paille* (straw-seat armchair), made fashionable by Madame de Pompadour, was widely used. It has four cabriole legs braced by spindle stretchers. Its openwork back has three or four bow-shaped transoms, and its slender, sinuous arms rest on set-back console supports.

Folding **tabourets** with X-supports were now found only in ceremonial rooms. Other stool types were in widespread use, the most popular having four cabriole legs and carved rails.

Armless chairs of the period were treated much like contemporary armchairs.

The **voyelle** has a low back with an elbow pad on top to facilitate the observation of card games.

Banquettes (benches), also called *formes*, were treated much like other seating of the period, having carved rails and cabriole legs.

Settees
Ottomane

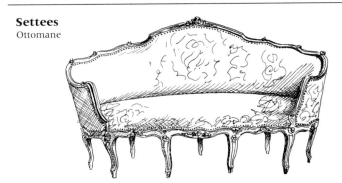

Veilleuse

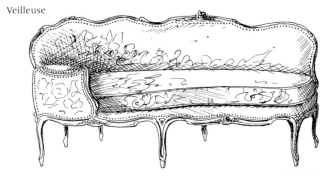

Duchesse brisée sans tabouret

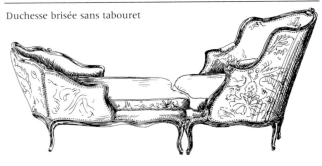

Firescreens and folding screens

• *Firescreens consisted of a molded frame with a carved cresting into which another frame over which fabric had been stretched could be slid. Some were equipped with a pivoting candleholder and a hinged bookstand.*

• *Folding screens, some of which had exposed wood frames and others of which did not, consisted of three or four leaves with curved upper edges. They were usually covered with the same fabric as the rest of the furniture.*

Louis XV settees *(canapés)*, which were quite fashionable in the period, have broad silhouettes analogous to those of contemporary *fauteuils* and *bergères*. Featuring exposed and carved wood frames, they have six or eight cabriole legs and set-back arms, sometimes closed and sometimes open, with elbow pads. They are integrally upholstered, as in *cabriolets*, or covered with soft feather cushions like those found on *bergères*. Distinctive variants were given evocative names: the *sopha* has a very low seat; the *ottomane*, shaped rather like a basket, has a back that curves sinuously forward; the *paphose* ("tipsy") is even more enclosed; *les veilleuses* ("for sittingup"), placed on either side of a fireplace, have inclined backs and are open at one end.

Lits de repos (daybeds) with backrests of equal height at both ends were called *turquoises*, but daybeds with only one back were also made. They were made comfortable by a mattress, cushions, and cylindrical pillows.

The **chaise longue**, halfway between a settee and a daybed, is an elongated, very low *bergère* with feather mattress, cushion, and a bolster.

The similar *duchesse en bateau* is a single piece whose foot resembles a very low *bergère*. The *duchesse brisée*, by contrast, consists of several pieces: a principal *bergère*, a central tabouret, and a low, *bergère*-like foot. Some examples have no tabouret, the foot having been elongated instead.

Chaises d'affaires or *chaises percées* (closestools) were widely used. Their cases, of solid wood with moldings and carved panels, rest on low cabriole legs; their lids and backs of exposed wood are generally caned, but some examples with veneer and delicate marquetry survive.

Chest of drawers
(detail of moldings)

Gadrooned leaf

Armoire

Cornice

Frieze

Hinge

Lock

Apron

Scrolled foot

Die

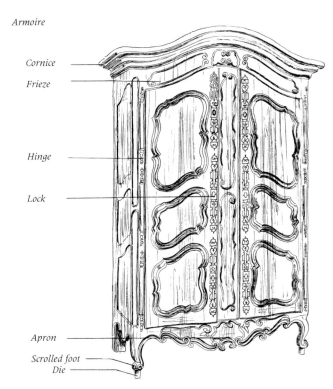

The "flying table" and the "servant table"

Louis XV, whose refined tastes are proverbial, had a "flying table": the floor of his dining room was decorated with a rosette pattern; at a given signal, the floorboards forming the rosette slid back to reveal an opening through which a set table rose from the room below. For each new course, the table descended and then rose again with a new setting. It was also Louis XV who adopted the "servant table," devised to preclude the need for servants during intimate dinners. This was equipped with two shelves, a drawer for eating utensils, and a pewter cooler for beverage bottles.

Tables

Tables made of solid wood have the same volumes and silhouettes as those made by *ébénistes*. The legs terminate in scrolled feet raised on dice, in wooden "shoes," or in small acanthus leaves. The animated friezes, fielded by moldings, have light patterned grounds and delicate carving.

Dining-room tables, round or oval, were always covered with a floor-length tablecloth. The "Louis XV" dining table was a nineteenth-century invention.

Commodes

These, too, had the same volumes and lines as marquetry commodes (see page 63), but they had few or no bronze fittings, the occasional exceptions being key plates and handles. Their tops were made of wood; moldings emphasized the shapes of their drawers and aprons.

Note: Menuisiers also made *coiffeuses* (dressing tables), *chiffonnières* (small tables with drawers), *encoignures* (corner cupboards), flat-top desks, fall-top desks, and night tables of solid wood, all cut to the same patterns as those produced by contemporary *ébénistes.*

Armoires

Armoires, two-part buffets, *bonnetières,* and low armoires as well as *buffets-vaisseliers* (china cupboards) were always made of solid wood and had no decorative bronze fittings. Their sole metal ornaments were *fiches* (elongated hinges) with turned ends and long key plates, elegant of profile and sometimes with openwork.

Louis XV armoires, **bonnetières,** and two-part buffets were all of similar design; they no longer have ball-and-claw feet or projecting cornices, and their bases lack assertive moldings.

Low armoires from the period are between thirty-nine and fifty-one inches high. Often built into the woodwork, they rest on bases with moldings or on short console legs. Directly below their thick marble tops are two drawers. Between their doors, decorated with moldings, is a stationary post known as a *dormante* ("sleeper"). In general disposition, the designs of these pieces resemble those of Louis XV full armoires.

The **buffet-vaisselier** (china cupboard) consists of a low armoire on which rests a set-back unit of three or four shelves. The upper piece has a full back, and the sinuous edge-fronts of its shelves are molded.

The **secrétaire-commode** combines a fall-top desk (see page 62) with a chest of drawers: its lower part, shaped like a bowed chest of drawers, is surmounted by a case with a drop leaf. Occasionally, this piece is itself surmounted by a shallow armoire, in which case it resembles a Dutch *scribane*. Examples of this type sometimes have marquetry decoration.

Luxury case furniture

Ébénistes, who left furniture made of solid wood to the care of *menuisiers* (see page 52), specialized in case furniture with veneer and/or marquetry decoration. French furniture of the Louis XV period owes its renown to their ingenuity and skill; such names as Cressent, Oëben, and Van der Cruse will always be remembered by those with an interest in French style. Both the finesse of their marquetry and the inventiveness of their designs are remarkable.

Ébénistes

There were not enough French ébénistes to satisfy the demand for their work, which is why so many foreign craftsmen settled in France. Guided by ornamentists and clients, they adapted themselves to French taste, making substantial contributions to this brilliant period of furniture production.

• *Under Louis XV, Cressent continued to maintain the high quality that had made his reputation during the Régence. He avoided the excesses of the new style and was regarded as a master (examples in the Louvre).*

• *Oëben, who worked frequently for the marquise de Pompadour, was one of the period's greatest ébénistes. Although he died young, he produced many remarkable pieces, notably the cylinder desk commissioned for Louis XV (at Versailles). Some of them feature secret doors and false backs. His chests of drawers have marquetry panels of exceptional quality, their only bronze fittings being on the corners and feet.*

• *The Migeon family (father, son, and grandson) had a large workshop. Pierre II, the son, is the most*

famous member of the clan. At the creative forefront of his field, he trained many craftsmen. Although he excelled at small pieces, his style is most notable for its restraint (examples in the Louvre and the Musée des Arts Décoratifs).

• *Joubert, Migeon's cousin, was named ébéniste to the king on Oëben's death. Restrained by nature, he sought to temper some of the excesses of his contemporaries. His lozenge marquetry is especially fine.*

• *Roger Van der Cruse worked in Migeon's workshop. He composed very beautiful exotic scenes and made lemonwood with ebony inlay fashionable (examples in the Louvre and the Musée des Arts Décoratifs, and at Versailles).*

• *Bernard Van Riesen Burg, heavily influenced by the craze for chinoiserie, produced lavish pieces notable for their emphatically curvaceous forms and their use of Chinese lacquer (examples in the Musée Camondo and the Musée des Arts Décoratifs).*

• *Joseph Baumbauer was ébéniste to the king. His work infuses the rococo idiom with exceptional energy and solidity (at Versailles).*

Characteristic details of tables

Top

Corner of frieze

Foot

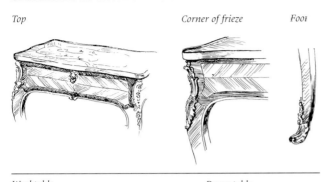

Worktable

Drum table

For each game, its own table

Triangular for parties of three, square for parties of four with a rounded projecting shelf for candlesticks, pentagonal for brelan, *pivoted for* piquet, *with a marquetry checkerboard for* trictrac, *gaming tables either had velvet tops or were covered with a tablecloth.*

Dressing table accessories

Amenities commonly found on dressing tables: two gantières *(oval glove trays); an oval washbasin with water pitcher; two* ferrières *(perfume jars); boxes for face powder, face cream, and* mouches *(beauty spots); a rouge dish; a container for false teeth; a candlestick with a handle; a mirror; a spittoon; a comb.*

Tables

Marquetry and lacquer tables were numerous under Louis XV. Small, gracious, and fragile, these pieces are as practical as they are beautiful.

Thanks to the ingenuity of the period's craftsmen, they are almost infinitely varied in design. Setting aside jewelry tables, gaming tables, dressing tables, etc., we will describe only the most pervasive types, but many of their basic features are found in other marquetry tables as well.

Tops — square, rectangular, oval, or round — always projected beyond the supporting frame; they were often hollowed slightly, or surrounded by a copper or bronze molding.

The *frieze* has curved lower edges and refined marquetry decoration: floral or vegetal *rinceaux;* patterned grounds.

The *legs* are always curved, attenuated, and delicate. They end in chased gilt bronze shoes or in scrolled feet resting on dice. The absence of stretchers accentuates their elegance and lightness.

Louis XV **worktables,** round or rectangular, supported by three or four curved legs, have shelves between their legs edged by high fillets, marble or marquetry tops, and storage compartments or small drawers. Often, a writing slide draws out from below their tops.

• Some have tops that can be removed to expose storage compartments below.

• Others have stationary tops and two or three small drawers, sometimes with built-in storage compartments.

• Occasionally, the shelf between the legs is absent.

*The Louis XV style marked a return to a feeling for
life and humanity.* —MICHELET

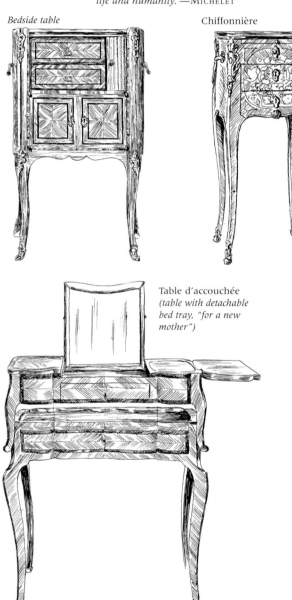

Bedside table

Chiffonnière

Table d'accouchée
*(table with detachable
bed tray, "for a new
mother")*

Tables en haricot or en rognon (bean or kidney tables) have tops of crescent-like shape; primarily decorative, they were used to support a tray, candlestick, or knickknack.

Tables de tambour (drum tables), cylindrical in form, have round marble tops with copper fittings and curved legs; their curved and hinged doors dissimulate three small drawers or a single large storage compartment.

Tables à écrire (writing tables) remained small. Below their removable tops were paper, ink, drying powder, seals, and wax; they had one sliding shelf for writing, covered in velvet or leather, as well as two others on either side.

Tables de chevet (bedside tables) have two bronze handles on the sides to facilitate their transport; adorned with delicate veneer or marquetry, they have shelves concealed by double doors, a compartment closed by a sliding tambour door, two drawers, and a marble top. Three of the sides rise above the top, and the legs — cabriole and rather short — are decorated with bronze fittings, as are their keyholes. Simpler variants consisted of an open, box-like compartment resting on four long cabriole legs. Grip holes made them easy to move.

Chiffonnières (catchalls, not to be confused with chiffoniers; see page 65) are small, readily transportable tables. Their long cabriole legs support a small case equipped with three drawers and a slide-out shelf; two of the drawers open from the front while the third opens from the side. Decorated with marquetry and/or lacquer panels, these tables always have precious bronze mounts.

Tables d'accouchée (tables with detachable bed trays, "for new mothers"), extremely

Coiffeuse
(dressing table)

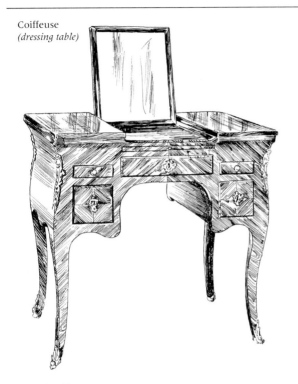

Console table

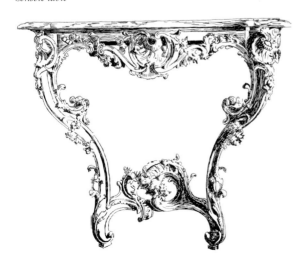

elegant and refined, consist of two independent units: a table proper with a single drawer; and an over-fitting bed-tray unit, sometimes of openwork design and equipped with two pivoting candle stands. The tray unit frequently has mirrors and toiletry jars.

Note: Coiffeuses d'accouchées (dressing tables with detachable bed trays) were also made, but these are quite rare.

Coiffeuses or *poudreuses* (dressing tables), small in size, are precious and elegant pieces. They have many fewer bronze fittings than commodes of the same period.

Note: Occasionally, dressing tables were given butterfly-, crescent-, kidney-, or heart-shaped tops. The latter shape was designed to accommodate the presence of two male companions at either side.

Console tables

Under Louis XIV, pieces of this type were dubbed *tables en console* or *pieds de table en console avec son marbre*. Fixed to the wall, they were not so much pieces of furniture as parts of the woodwork. Made of wood, they were usually gilded, but sometimes they were painted to harmonize with the adjacent paneling, or even in naturalistic colors (pink roses, green leaves, white daisies, etc.).

Richly carved, these pieces are explosions of fantastic, dextrously deployed curves. Their narrow marble tops have extravagantly sinuous and molded fore-edges.

They can have anywhere from one to six or eight legs, depending on the table's length. Over time, the back legs disappeared and the curves of the front legs became increasingly pronounced.

Note: Console tables were never impressed with *estampilles* (see glossary), as they were collaborative efforts of craftsmen of different specialties (*menuisiers*, architects, ornamentists, gilders, etc.).

Desks

Bureaux plats (flat-top writing tables) have rectangular writing surfaces covered in colored morocco secured by delicate studs; their tops are edged in copper or bronze quarter-round moldings. They have three drawers, of which the central one is recessed and the flanking ones flush with the frieze; they are decorated with delicate bronze moldings chased with water leaves. The key plates, handles, corner ornaments linked to the moldings by agrafes, and shoes are of chased and gilt bronze, acanthus usually being the dominant motif.

Note: At one end of the top sat a *bout de bureau* or *gradin de bureau,* a small storage unit for papers and effects consisting of a single drawer and several shelves.

Bureau dos d'âne, *secrétaire à pente, secrétaire à dessus brisé,* and *secrétaire en tombeau* (literally: mule-back desk, sloped secretary, break-top secretary, tomb secretary) are alternative names for desks of the same general type. They are small in size, and all of their sides feature delicate marquetry or lacquer panels.

Rectangular and supported by slender cabriole legs, they have friezes equipped with one to three small drawers. The equivalent of a *serre-papiers* is integrated across the back of the nest, which is hidden from view by a hinged top covered with leather or velvet that, when open, doubles the size of the writing surface. During use, this leaf is reinforced by two vertical wooden slides or folding metal struts.

Bronze fittings adorn their legs and feet and serve as key plates, the latter sometimes located on the drop leaf.

Many variants of this type were produced during the Louis XV period.

The **bonheur du jour**, less common than it would become under Louis XVI, is a table with drawers and cabriole legs and equipped with an upright armoire whose tambour doors slide or retract into the sides. Sometimes these doors are solid and decorated with marquetry.

The **bureau capucin** (capuchin desk), also known as the *bureau à la bourgogne* (Burgundian desk), has a commode-like front. Its top splits lengthwise in two: the front half folds forward to create a writing surface; when the back half is similarly opened, a spring mechanism lifts a hidden *serre-papiers* or a shelf unit from below. On the sides there are secret drawers.

The **bureau à cylindre** (rolltop or cylinder desk), configured much like the *bureau en dos d'âne,* has exposed drawers and a nest with storage compartments across the back, but a simple gesture suffices to make its rolltop — made of tambour or solid wood — descend to hide one's papers and bolt the drawers. This desk type was invented by Jean-François Oëben, *ébéniste* to the king, around 1750. The most spectacular example is now at Versailles, but two others of superb quality are now in Britain (Wallace Collection, London; Waddesdon Manor).

Secrétaire à abattant *(fall-top secretary)*

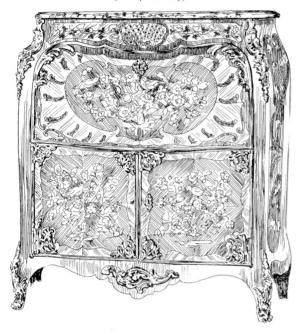

The **secrétaire à abattant** or *secrétaire en armoire,* a type introduced toward the middle of the century, was retained in later periods. Designed for placement against a wall, it is effectively divided into two portions:
- a lower portion, resting on short, bulging legs and equipped with two hinged or sliding doors hiding drawers or compartments: in effect, a safe;
- an upper portion, culminating in a marble top with molded fore-edge, that contains a nest with drawers and compartments hidden by a drop leaf (serving as a desk when open) or by two sliding doors; in the latter instance, a writing slide draws out below the doors. Often, the upper portion is set back and includes an exposed drawer.

Always decorated with refined marquetry, these pieces also have bronze key plates, shoes, and corner fittings.

Commodes and Chiffoniers

Louis XV commodes, elegant and refined, were produced in many forms, all of them beautiful. Three of their characteristics are especially notable: the balance of lines, the quality of materials, and the finesse of decoration.

While the fronts are never flat, their bulges are restrained and harmonize with the curves of the legs; the ends are treated much like the fronts.

The cabriole legs are decorated with chased bronze fittings, but sometimes the back legs are straight; in the finest examples, the bombé bulge is most extreme at the level of the middle drawer.

Most commodes from this period feature marquetry: flowers, birds perched on branches, and trophies are the most common motifs. Examples incorporating lacquer panels are rare.

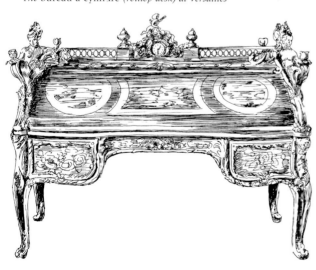

The bureau à cylindre *(rolltop desk) at Versailles*

Commode with long legs

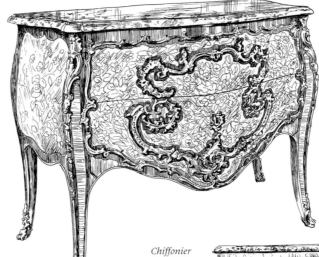

Long-case clock

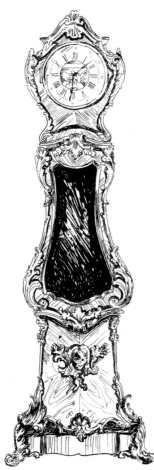

Chiffonier

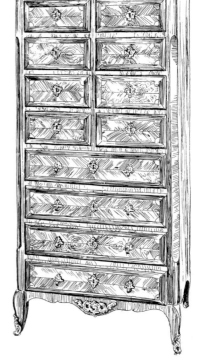

Encoignure
(corner cupboard)

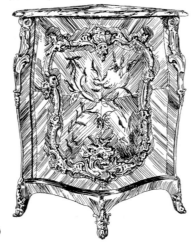

Bronze fittings are crucial to the effect of Louis XV commodes, appearing as corner fixtures, plume motifs, handles, key plates, and shoes; sometimes they appear in the form of chased moldings tracing a cartouche across the front, thereby accentuating the bombé curves. In the finest pieces, the fittings are fully integrated into the form and decorative scheme.

Drawer fronts are often contiguous, without intervening transverse rails, a feature that obscures the underlying structure and heightens the effect of decorative integration. But the basic design was subject to manifold variations.

Louis XV *commodes à la régence* are distinguishable from examples dating from the Régence by their bronze fittings, and sometimes — especially late in the period — by the absence of transverse rails between their drawers.

Commodes with long legs usually have only two drawers, and their slender cabriole legs give them profiles of exceptional elegance.

Commodes de religieuse, narrow and high, have three drawers and short legs.

Commodes en console have bulging silhouettes that narrow toward the bottom. The upper row of drawers is concave, the one in the middle convex, and the one at the bottom tapers inward. The legs are short.

Chiffoniers, higher and narrower than commodes, have many drawers and a marble top. Their elegance has made them much coveted.

Encoignures

These corner cupboards, also called *ancognures* and *coignades*, are treated in much the same way as commodes of the same era. The same word was used to designate built-in corner cupboards, which were rather high and divided into two parts,

their moldings and colors matching the room's decor.

Produced in pairs, incorporating fine marquetry or lacquer panels, and decorated with beautiful bronze fittings, they have one or two curved doors surrounded by framing stationary panels. Their elegance is accentuated by short, bulging legs and aprons of serpentine profile. Their tops, marble with molded fore-edges, echo the shape of the cabinet below. Sometimes there is a mirror between the top and the hinged door.

Originally, they were often surmounted by pyramidal shelf units known as *coins* or *tablettes d'encoignure*, intended for the display of porcelain or other precious objects, but these pieces were so fragile that few survive.

Bookcases

Louis XV bookcases, now rare, were veneered or decorated with marquetry; long and low, they had marble tops and two cabriole legs. Their doors were pierced by openings, elegant of profile, fitted with brass grilles.

Note: Bookcases made of solid wood were often built into the woodwork. Access to their upper shelves was facilitated by small stepladders decorated with sinuous brass fittings.

Long-case clocks

Given their tall and elegant forms, these pieces should be regarded as furniture. Veneered and decorated with marquetry or lacquer panels, sometimes painted with Martin varnish, their corners, legs, and crowns are decorated with beautiful bronze fittings, and their edges are accentuated by bronze or copper fillets. In French, these clocks are known as *horloges de parquet* or *régulateurs*.

Note: There are also examples of solid wood.

Our silverware . . . twisted and twisted again as though we had no further use for the circle and the square,
our ornaments are in the most extreme baroque style. —PRÉSIDENT DE BROSSES

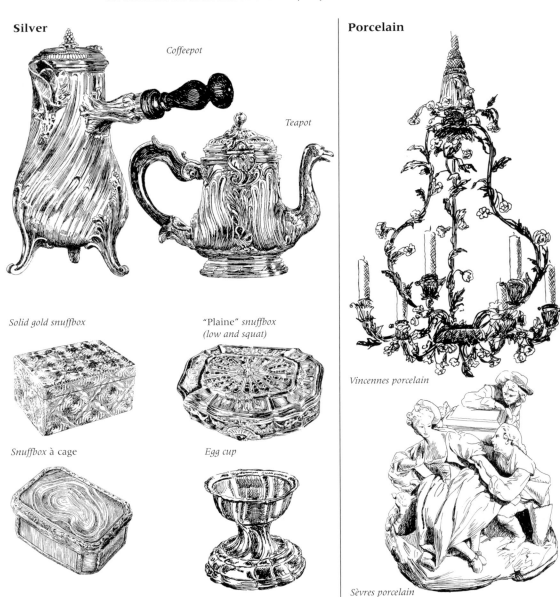

Silver

Coffeepot

Teapot

Solid gold snuffbox

"Plaine" snuffbox
(low and squat)

Snuffbox à cage

Egg cup

Porcelain

Vincennes porcelain

Sèvres porcelain

Faïence

Rouen

Marzeilles

Moustiers

Pont-aux-Choux

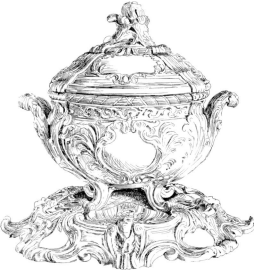

Cartel clock

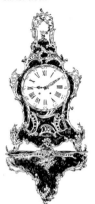

Rocaille *cartel clock*

Barometer

Flowered wall light

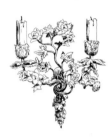

Firedog

Wall light

Flour box

Candlestick

Mantel

The Louis XVI Style
1760-1789

THIS WAS MORE THE STYLE of Jean-Jacques Rousseau than that of Louis XVI, who, courageous but compliant, sensitive but awkward, was by temperament more craftsman than patron. Furthermore, the tendencies associated with the style appeared more than fifteen years before he mounted the throne and began to wane at the first approach of the Revolution that brought him down. Nonetheless, the geniality and simplicity of Louis XVI, the gaiety of Queen Marie-Antoinette are consistent with the decorative arts produced in this period, which, weary of the exotic refinements and disorderly exuberance of the *rocaille,* embraced freshness and ease.

The relentless pursuit of originality had grown tiresome. There was a rekindled interest in the cult of reason, to which the revolutionaries would soon erect altars. After the urbanity — enclosed and snug to a fault — of the long reign of mistresses, there was a longing for fresh air. A vogue developed for the country, both the real country of Rousseau's *La Nouvelle Héloise* and the false country of the Petit Trianon at Versailles. The ceremonial rooms and townhouses of large cities were abandoned in favor of small, rustic retreats. Fussy elegance came to be less favored than spontaneous grace. In provincial salons, where future actors of the Revolution — Mirabeau, Danton, Robespierre — were already holding forth, liberty was already in the air.

The illustrious lineage of this liberty was now often invoked. Hitherto, antiquity had been imagined through the deforming prism of ancient monuments in Rome and Athens, of great literary texts, of imperial statuary. Discovery of the ruins of Pompeii suddenly revealed the particulars of everyday life in the first century A.D., sweeping away these somewhat academic notions. There was a dawning realization that the social world of Plutarch's heroes was neither stable nor grandiose. On the contrary, it had been characterized by a kind of juvenile grace, by a reasoned candor.

True simplicity, however, like true nature, was still remote. Court style — the solemnity, bombast, and pomp endemic to absolute monarchy — was at odds with the growing desire for escape, familiarity, and naïveté. Interior decoration reflected this profound contradiction: increasingly, furniture was shorn of superfluous ornament, rococo redundancies, and baroque excess, but the floral bouquets that replaced them can seem artificial and tacked-on. Similarly, lines became more restrained, but they developed a new heaviness: despite the striving to be more "natural," the resulting pieces can seem affected and stiff.

In all likelihood, it would have been impossible for the ancien régime to attain bourgeois equality and republican fraternity without upheaval; only the violent tempest of revolution could sweep away old habits and entrenched custom.

Everyone must accede to fashion: the mad introduce it, the reasonable accept it. — EIGHTEENTH-CENTURY SONG

The furniture

Marquetry

Indented corner (egg-and-dart) with rosette

Examination of Louis XVI furniture reveals a profound change in decorative vocabulary. Social mores having remained unchanged, furniture types were still numerous and varied, each designed to satisfy a specific need of the refined culture to which they catered. Imitation of the antique was quite free, full of fantasy and influenced by taste. It is this transposition that is responsible for the high reputation of Louis XVI furniture.

Forms became stiffer and ornament changed, but the basic configuration of desks, commodes, and small tables remained much the same. Thus it would be superfluous to describe again the structure of fall-top secretaries, *coiffeuses,* and small tables; we refer the reader to the descriptions of these types in the chapter on the Louis XV style (pages 48–65). We will mention here only those features that were new.

Case furniture for the urban market was decorated in accordance with its intended destination. Pieces commissioned by the court tended to be quite lavish; despite the elegance of their forms and the finesse of their ornament, today they seem a bit overwrought.

Materials and techniques. Oak was used for solid-wood pieces, for the carcases of marquetry pieces, for carved wooden ornament, and for certain chairs.

Walnut, ash, and burled walnut was used for seating and movable pieces.

Mahogany became very fashionable. *Moiré, moucheté* ("plum pudding"), *ronceux*

("figured" with a wavy pattern), or *chenillé* (with shaded pale lines), it was used both as veneer — its beautiful veining and other irregularities being shown to advantage — and in solid-wood pieces.

Ebony, out of favor since the days of Louis XIV, became fashionable once more. The various fruitwoods were still used.

Satinwood in particular should be mentioned; rare under Louis XV, it was often used under Louis XVI.

• Wooden pieces were often painted. Seating and wood paneling were painted light colors, with trim highlighted in gold or another contrasting color.

• Gilded wood was used for ceremonial chairs, console tables, and mirror frames.

Marquetry of colored woods, highly developed under Louis XV, continued to showcase the same materials and techniques, but generally speaking, it took on a darker cast.

Geometric patterns proliferated, but bouquets, historiated landscapes, and rustic scenes were also common. Lozenge and checkerboard patterns, interlace, rosettes, frets, and rectangles with indented corners were placed so as to underscore a piece's structure. When there are central motifs, these are set within rectangles or medallions.

Turned elements again became common, thanks to the new vogue for straight lines.

The legs and vertical supports of chairs and other pieces were turned in various ways, resembling spindles *(en*

fuseau), quivers *(en ccrquois)*, columns *(en colonne)*, and balusters *(en balustre)*.

Lacquer and Martin varnish were used much as in the preceding period.

Porcelain plaques were often set into surface panels. Round, square, oval, or rectangular, Sèvres porcelain plaques — usually decorated with bouquets, garlands, animals, or pastoral scenes against a white ground — were incorporated into plant holders, tabletops, and secretary drop leaves; late in the period, Wedgwood reliefs — featuring white figures against a blue ground — of extreme refinement were sometimes used.

Copper was used in very characteristic ways: in the form of collars circling turned legs; as strips used to accentuate panels, moldings, and fluting; as openwork galleries on desktops and tabletops. Some key plates were also made of copper.

Steel began to be used for decoration, notably as a ground setting off openwork bronze and copper fittings. Sometimes, steel plaques were set into friezes, and occasionally the tripod feet of gueridons were made entirely of steel.

Wrought-iron supports were used for furniture inspired by artifacts made of this material excavated at Pompeii and Herculaneum.

Bronze fittings were applied to almost all Louis XVI furniture, but in terms of both craftsmanship and function they differed from those produced under Louis XV. Of jewel-like delicacy, they were more ornamental than protective.

Fittings from this period are so small and finely detailed that they resemble goldsmith work. Arranged symmetrically as frieze panels, corner ornaments,

shoes, handles, and key plates, their forms derive from

• Antiquity: dentils, gadrooning, interlace, egg-and-dart, *rais-de-coeur*, frets, imbricated disks, laurel and oak *rinceaux*, beading;

• Upholstery: simulated drapery, festoons, tassels, cords, fringes, and knotted ribbons;

• Nature: flowers, fruit, and animals, all rendered naturalistically, but such that their meticulous details do not preclude elegance of expression.

Pierre Gouthière, the most skilled bronze-worker of the period, perfected the technique of matte gilding, which makes bronze resemble gold.

The *marble* of preference was white, gray, or sometimes red with veining. Always handcrafted, it was used for the tops of chiffoniers, commodes, some desks, and tables of every variety.

Ornament

Lines. The return to antiquity is synonymous above all with a return to the straight line: strict verticals and horizontals were the order of the day. Serpentine lines were no longer tolerated, save for the occasional half circle or oval.

Interior decor also honored this taste for rigor, with the result that flat surfaces and right angles returned to fashion.

Ornament was used to mediate this severity, but it never interfered with basic lines and always was disposed symmetrically around a central axis. Even so, *ébénistes* often canted foreangles to avoid excessive rigidity.

Moldings, thinner more elegant, and less emphatic than hitherto, were inspired

Pierced galleries

Drop handles

Classic

Wreath

Drapery

Key plates

Ornament
Knotted ribbon

by antique models; thanks to the careful balancing of solids and voids and to the judicious use of framing elements, harmony prevails on all surfaces.

Wall panels tend to be square, rectangular, or arched, and accompanied by rosettes and acanthus.

Vegetal interlace and *rinceaux* are sometimes arrayed vertically, winding supply around central rods or branches.

In paneling, the corners sometimes have rectangular or rounded indents adorned with small rosettes. Central motifs, quite characteristic of Louis XV designs, still appear, but less systematically. Characteristic decorative elements, generally situated toward the top and bottom, are floral sprays hanging from knotted ribbons, or vases and urns containing flowers and greenery. Furniture panels were conceived along similar lines.

Decorative motifs of Louis XVI style were inspired by antiquity, the Louis XIV style, and nature.

Ornament

Rais-de-coeur

Laurel

Egg-and-dart

Beading

Fretting

Characteristic elements of the style: imbricated disks, guilloche, double bow-knots, smoking braziers, finely striated bronze plaques on join cubes, linear repetitions of small motifs (rosettes, beads, oves), and, finally, trophy or floral medallions hanging from a knotted ribbon.

Classical motifs. These figure, variously treated, in almost all styles. They are: egg-and-dart, *rais-de-coeur,* water leaves, acanthus, gadrooning, interlace, fretting, *rinceaux,* laurel and oak torus moldings, fascia moldings (sometimes called *croisillons Louis XVI*), cornucopias.

Architectural motifs. These were used both as supports and as decorative elements. They are: fluting, cabled fluting (known as *asperges* or *chandelles* when the cables terminate in leaf bud motifs), pilasters (fluted and unfluted), fluted balusters (twisted and straight), columns (engaged and unengaged, sometimes replaced by caryatids), volute consoles, triglyphs with guttae (in relief and trompe-l'oeil).

Objects unearthed at ancient sites: vases, urns with squared handles, tripods, braziers and perfume burners, dentils, paterae (antique rosettes), eagles, dolphins, ram and lion heads, chimeras, sirens, gryphons.

Human faces. These often figure in *rinceaux* and decorative reliefs. In Louis XVI work, female masks often have a knotted ribbon in their disheveled hair. Figures of children are also frequently used.

Elements of natural derivation: delicate scrolling *rinceaux,* intertwined strings of olive and oak leaves, short garlands of flowers and foliage with pendant ends between them, wreaths of laurel, ivy, and flowers, pinecones, pomegranates, thyrsis.

Note: Rustic and martial attributes are frequent, as are those evoking the hunt, fishing, music, religion, science, and the game of love.

Ornament

Striated bronze plaque

Female head

Brazier

Volute console with triglyph

Fascia molding

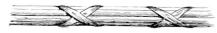

Interlace with rosettes

Pinecone

Rosette patera

Garland

Rinceau

Trophy

Urn

Frame and solid-wood furniture

As under Louis XV, accredited *menuisiers* produced beds, seats, and screens of exceptional quality. Virtuoso specialists in such pieces, they were adept at giving them beautiful shapes and exquisite ornament.

Neither the court nor Parisian high society ever used cupboards, buffets, and tables made of solid wood; most such pieces were made by provincial craftsmen.

Beds

A number of different bed types were current in the Louis XVI period. Aside from those previously described, we might mention beds *à la romaine, à la chinoise, à la militaire, en tombeau, en chaire à prêcher.* They were differentiated from one another primarily by their textile accoutrements.

The only distaff beds to be found under Louis XVI were in the royal palaces.

Angel beds, without posters and placed perpendicular to the wall (see pages 29 and 52), are surmounted by a shallow canopy whose long drapes are tied over the back. Their two end boards resemble the backs of contemporary armchairs, having upper rails that are sometimes straight, some-

times arched *en chapeau.* The side rails of the boards, which resemble pilasters or columns (sometimes fluted, sometimes not), are surmounted by pinecones, pomegranates, small feather *panaches,* or acanthus motifs. They have tapered, baluster, or *carquois* (quiver) feet (see next page). The rails, end boards, and feet are linked by cubic joins that are often decorated with rosettes.

Polish beds *(lits à la polonaise)* (see page 53) remain essentially unchanged, but their ornament reflects shifts in taste. Their backs now have straight rails.

The long backs of **Turkish beds** *(lits à la turque)* (see page 53), parallel to the wall, were now decorated with a carved motif. Their two end boards and feet were treated like those of contemporary angel beds. Pieces of this type were now also known as English beds *(lits à l'anglaise).*

Seating

Louis XVI armchairs, chairs, and settees are not as comfortable as their Louis XV analogues. Made of beech, ash, or walnut, they were often waxed or painted to match the woodwork; soon after the style's birth, mahogany began to be used. Gilded seats were reserved for ceremonial furniture.

The frames of Louis XVI chairs and settees — fabricated by a *maître menuisier* (guild-certified furniture-maker) and carved by a *maître sculpteur ornemaniste* (certified ornamental sculptor) — have none of the continuous, sinuous curves characteristic of the preceding period; their constituent parts are visually discrete from one another and the nature of their frame construction instantly legible. Their legs are straight, their backs rigid, their arms severe: the types introduced under Louis XV were transformed in ways consistent

Ornamentists

Ornamentists produced many prints that convey precious information.
- *Delafosse made extensive use of garlands and heavy volutes. His style is a bit ponderous.*
- *J.-F. Boucher, son of the painter, was a committed "modernist": his antiquity was the* rocaille.
- *Lalonde, designer for the "garde-meuble royal," favored fascia and helmets.*
- *Dugourd initiated a vogue for the "Etruscan" style, herald of the Empire style.*

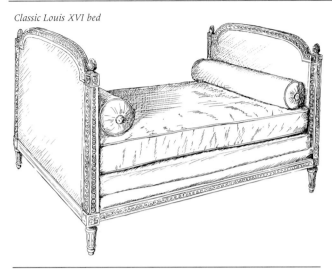

Classic Louis XVI bed

Louis XVI chair backs

Various flat backs (à la reine):

Rectangular

En chapeau

Oval with knot at apex

Coved backs (en cabriolet):

En chapeau

Medallion

with the new taste for things *à la grecque.*

The charm of these pieces derives from their elegant silhouettes and the discreet but varied ornament on their backs, seat rails, and arms. Chair backs — sometimes flat *(à la reine)* and sometimes slightly coved *(en cabriolet)* — often have knotted-ribbon motifs at their apex, and their side rails tend to be simple. If the latter are straight, they frequently resemble colonettes and have pinecone or pomegranate finials.

Flat backs (à la reine) can be square, rectangular, *en chapeau* (arched with the arch-springs indented, an especially characteristic Louis XVI treatment), or with all four corners indented.

Coved backs (en cabriolet) can be square, rectangular, round, or oval. When essentially rectangular but tapering inward toward the bottom, they are said to be *en hotte,* after the name of a basket of analogous shape carried on the back.

The *seats* of Louis XVI chairs can have various forms: round; square; horseshoe shaped; trapezium shaped; straight at the back with slightly bowed sides and front. Chair rail decorations, like those of the back rails, are consistent with the classicizing vocabulary of the period.

The *legs* are always straight. Occasionally tapered, they are most often *en carquois* ("quiver legs": conical with straight or twisted fluting). When the fluting has inset rods to a certain height, it is "cabled." The legs end in dice, and their junction with the seat rail — preceded by a narrowing or a collar — is articulated by a cubic block, or joining die, decorated with an acanthus rosette, a disk, or a daisy.

In late Louis XVI pieces, the back legs are sometimes square and slightly splayed but

Louis XVI chair legs

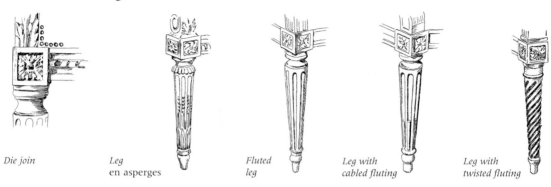

Die join

*Leg
en asperges*

*Fluted
leg*

*Leg with
cabled fluting*

*Leg with
twisted fluting*

Louis XVI armchairs

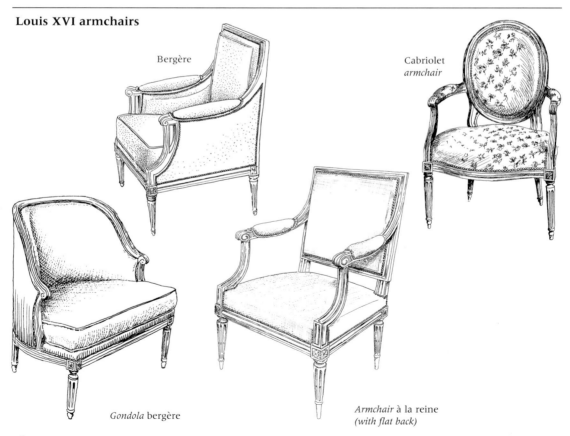

Bergère

Cabriolet
armchair

Gondola bergère

Armchair à la reine
(with flat back)

continuous with back supports, in which case they are *en sabre* (saber legs).

Coverings. Chairs destined for ceremonial rooms were covered in Beauvais tapestry, Aubusson tapestry, or Lyon silk; otherwise, the materials most frequently used were ribbed velvet and *toile de Jouy*. Chairs of most types were also caned on occasion, or outfitted with loose cushions.

Armchairs have set-back arms, always with arm pads, that curve down from the sides of the back and terminate in the front with simple volutes. The arm supports rise from podia aligned with the legs and usually curve backward; their moldings and decoration match those of the seat rail. When the arm supports are vertical, they take the form of a smooth, fluted, or twist-fluted baluster.

Armchairs "*à la reine*" and "*en cabriolet*" from the period are perfectly proportioned and exceptionally elegant.

Bergères with feather cushions, still quite fashionable, were made in gondola, confessional, and *marquise* models.

Office armchairs (fauteuils de cabinet) and *hairdressing armchairs (fauteuils à coiffer)* are more rigid than under Louis XV but still often caned.

The *menuisiers*

• *Georges Jacob's invention and originality make him the most brilliant of eighteenth-century menuisiers. The slender, wiry moldings and elegant forms of his chairs make them exceptional. He invented the lyre, sheaf, and Etruscan chair types.*
• *Jean-Baptiste Boulard is an inspired craftsman of the early, transitional phase of the style. His carving is particularly refined.*
• *Jean-Baptiste-Claude Sené, menuisier to the court, produced work of great variety. His pieces often resemble those of Jacob.*
• *Tilliard produced chairs notable for their classical elegance.*
• *Dupain, Gourdin, and Lelarge were also fine craftsmen, as were Delanois, Demay, and Pluvinet.*
• *Mention should also be made of Nadal and Michard, whose names are stamped on pieces of great beauty.*

Transitional furniture

Stylistically transitional pieces are especially prized because of the skill with which craftsmen managed to combine Louis XV and Louis XVI elements. The new tendency was apparent in bronze fittings and other decoration before it affected overall shapes, which were slower to change.
• *Rectangular chests of drawers with geometrically placed bronzes, interlace bands, and Greek keys were sometimes given Louis XV curved legs, tables with rais-de-coeur moldings and fluted legs were sometimes given Louis XV pied-de-biche legs.*
• *In armchairs, sinuous Louis XV backs, arms, and seats were sometimes decorated with imbricated disks and beading and accompanied by turned legs decorated with acanthus leaves.*
• *Conversely, the back, arms, and seat might be rectilinear but the legs curved — and linked to the frame with a die join! Examples of such stylistic inconsistency could be multiplied ad infinitum.*

One sees nothing without taking the time to look.
— J.-J. ROUSSEAU

Seating

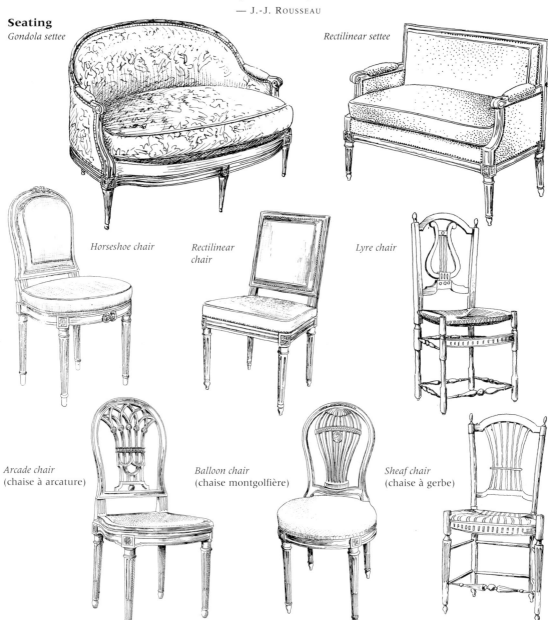

Gondola settee

Rectilinear settee

Horseshoe chair

Rectilinear chair

Lyre chair

Arcade chair
(chaise à arcature)

Balloon chair
(chaise montgolfière)

Sheaf chair
(chaise à gerbe)

Louis XVI settees are treated much like chairs from the period, with rectangular, *en chapeau,* or medallion backrests and arms whose supports rise from podia flush with the front rail before curving back. Their backs are sometimes *en corbeille.*

As in the Louis XV period, they are known as *ottomanes* when their encompassing, in-filled arms curve almost into the plane of the front rail, and as *confidantes* when, quite long, they have seats appended beyond the arms at either end.

Note: The *canapé d'alcôve* (alcove settee), introduced in this period, resembles a Turkish bed, but its back and arms are flat and somewhat lower.

Rectangular banquettes and stools of all formats — square, oval, rectangular — were treated much like other contemporary seating. In the 1770s, the folding stool made a comeback; Marie-Antoinette ordered forty for the château at Compiègne.

Chaises longues, also called *duchesses,* were still sometimes made in one piece and sometimes *brisées,* or broken into three pieces: a *bergère,* a stool, and a footrest.

In every respect, Louis XV **chairs** resembled contemporary armchairs. Under Louis XVI, however, *menuisiers* gave freer rein to their invention; legs and seats were comparable, but backs were treated with much greater variety. Many are just like those of armchairs (rectangular, medallion, *en chapeau, en hotte;* in-filled arms), but other examples are of openwork wood construction and decorated with novel motifs: lyres, sheafs, baskets, and, more rarely, hot-air balloons. In some cases, fluted moldings trace arched patterns.

These wooden backs could be painted, waxed, or gilded.

Note: The frames of rush-seat chairs *(à la capucine),* which acquired a new elegance in this period, were made of walnut, oak, or, often, fruitwood. Simply turned or sparingly decorated with carved ornament, their arched or pedimented backs set them apart from Louis XV examples: thin pieces of wood curve outward to trace sheaf patterns, delineate lyres, or outline compound arch patterns. Their edges are sometimes beaded, and the front of the rush seat is dissimulated by a narrow "apron" that is sometimes grooved, sometimes carved.

Other solid-wood furniture

Solid-wood case furniture adhered to the same basic formats as were used by *ébénistes* for luxury class furniture (see pages 80–89). In some instances, classicizing motifs were added to pieces that retained Louis XV bowed and bombé forms, but with the passage of time case shapes became more austere and their ornament more sparing, consisting in large part of moldings. Flowers, foliage, *rinceaux,* egg-and-dart moldings, fluting, and beading became increasingly pervasive.

• Armoires retained their basic Louis XV format but acquired thin molded cornices, some of them straight. Their aprons are almost always serpentine, molded, or carved, and they have console or scrolled feet. Usually, bands of Greek fretting and other classical motifs, flowers, *rinceaux,* and acanthus are combined with beading and fluting.

More rarely, moldings are prominent, in which case only the presence of canted angles with fluting, rectangles of striated wood meant to evoke copper plaques, and antique vases make it possible to identify them as Louis XVI.

Bureau plat *(flat-top writing table)*

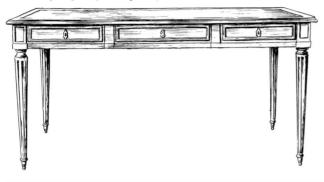

Tapered leg
(en gaine)

Toupie
foot

Corner cupboard

Fluted
toupie foot

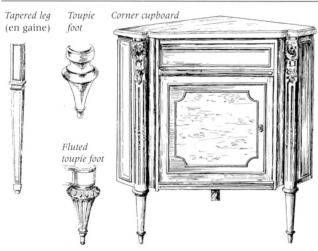

Tapered legs *(pieds en gaine)*

Gaines ("terms" or "herms" in English) are pillar-like supports for sculpture, usually made of marble or stone, that taper toward the bottom and have projecting socle bases. Richly decorated, Louis XVI gaine legs are often deeply fluted.

Fire screens

These pieces assumed various forms according to the ensembles of which they were a part. Usually rectangular in format, their side rails sometimes resemble pilasters, detached columns, or thin balusters. Their feet, usually biped, are decorated with acanthus leaves; their tops and fabric were coordinated with those of the nearby chairs and/or bed.

Note: Such mixtures are found in low armoires, two-part buffets, and dressers.

• Most tables (small as well as large), bookcases, and vitrines (glazed display cupboards) were made of solid wood; their decoration is simple and their profiles elegant.

• Corner cupboards, commodes with two or three rows of drawers, consoles, chiffoniers, and desks were made of walnut or fruitwood. Their treatments evolved in tandem with changing fashions in architecture and decoration.

Their lock plates and handles, drop or fixed, are made of bronze or copper. Support posts resemble pilasters; feet are tapered, *carquois*, or toupie, with or without fluting. Crisp moldings, beading, and narrow grooves carved into the wood articulate the various parts. The tops of commodes, chiffoniers, and slope-top desks are usually made of wood, occasionally of marble, and lack copper galleries.

Luxury case furniture

Case furniture with veneer and marquetry panels was produced in large numbers. These pieces are decorated with classicizing motifs (see page 72), which craftsmen of the period used with great freedom, revealing themselves to be just as inventive as their predecessors.

Commodes and chiffoniers

Under Louis XVI, the commode was indispensible, figuring in almost every room. It is worthwhile becoming sufficiently familiar with the distinguishing qualities of these pieces to be able to spot the better ones, for they can still be found at auction and in dealers' shops.

Harmony of proportion is crucial. The volume

of the case should be consistent with the volume of the legs: a quality Louis XVI commode will not seem ponderous.

The front, always rectangular, sometimes projects slightly in the center, especially in later pieces from the period. These breakfronts are decorated with bronze fittings or marquetry panels.

The ends are always flat and the feet always straight.

Louis XVI marquetry, of exceptional craftsmanship, usually takes the form of fret or lozenge patterns, floral bouquets, or landscapes — pastoral or antique — contained within medallions or rectangular fields with indented corners.

Mahogany *veneer* — especially *moucheté* ("plum pudding") and *ronceux* figured) — became widespread toward the end of the period. Thin moldings chased with ornamental motifs frame the drawer fronts. The front corners are sometimes canted, in which case they are often decorated with floral pendants or scrolled consoles terminating in foliage.

The *ébénistes*

We can only mention the most important Louis XVI ébénistes.
- *Jean-François Oëben, the greatest innovator of the transitional style.*
- *Jean-Henri Riesener (trained by Oëben) is considered the greatest ébéniste of the period. Informed by a remarkable sense of proportion, his designs are carefully structured without being massive, elegant and refined without being fussy (examples at the Louvre; château de Fontainebleau; Metropolitan Museum, New York).*
- *Leleu, also trained by Oëben, was the first to line fluting channels with copper and to place copper strips or collars at the top of pilasters and toupie feet. His work is massive and a bit dry (examples at the Louvre; Petit Trianon, Versailles).*
- *Carlin produced very attractive Louis XVI furniture whose lacquer plaques, mahogany, and ebony are brightened by delicately worked bronze fittings (examples at the Louvre).*
- *The stamps of Topino, Bury, Denizot, and Gibert, like those of Guignard, Levasseur, Avril, and Ohneberg, are found on some very beautiful pieces.*
- *A remarkable group of German craftsmen, notably Weisweiler, Benneman, and Schwerberger, later joined by Roentgen, were accomplished specialists in trompe-l'oeil marquetry.*

Note: Few surviving Louis XVI commodes feature painted compositions or Martin varnish, but many make use of lacquer panels: Chinese, Japanese, or indigenous imitations. Porcelain plaques were also occasionally set into such pieces.

Marble tops were the norm, usually white or gray and projecting slightly beyond the rectangular case below, whose canted or rounded corners they honor.

Bronze and copper fittings, placed symmetrically, are used more sparingly than under Louis XV. In the form of escutcheons, medallions, or horizontal ovals, they serve as lock plates.

Handles are either of the drop type, usually rings or half-rings attached to plates, or fixed, in which case they are frequently garlands attached to medallions.

Bronze moldings, fretwork frieze panels, garlands, and lion heads are also common.

The feet are generally shod in gilded bronze feet.

There are two basic types of Louis XVI commodes, both subject to countless variations:
- Initially, two-drawer commodes were given long, slightly curved legs, but straight legs soon replaced them. They can be tapered or square; occasionally fluted, they are more often decorated with "false" fluting.
- Three-drawer commodes have thin upper rows, sometimes subdivided into three drawers. Support posts often resemble pilasters or columns (sometimes fluted), depending on whether the corners are canted or given rounded projections. The feet are toupie (sometimes fluted) or, toward the end of the period, tapered.

These two basic types were given many different forms.

Chest of drawers (commode)

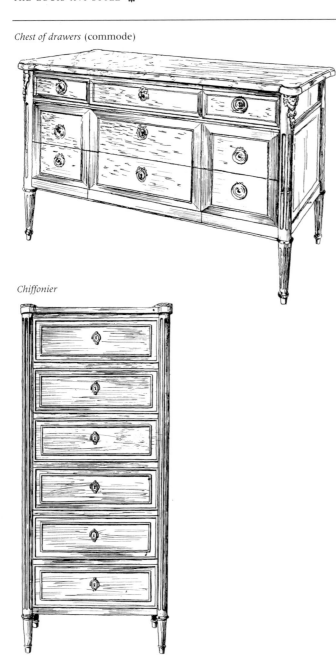

Chiffonier

Commodes à portes have two hinged doors behind which are three rows of drawers, but they retain the shape of the classic three-drawer type. These pieces are rare.

Semicircular *or* **demi-lune commodes** have two or three rows of front drawers and a curved hinged door at each end. In finer examples, the proportions of the legs harmonize with the volume of the case.

Commodes à coins arrondis (chests of drawers with rounded corners) have flat or slightly bowed fronts with two rows of drawers, and the front corners have semicircular forward projections.

Commodes en console are semicircular with three drawers, the topmost of which is thinner than the others and resembles a frieze.

Chiffoniers are narrow and have six to eight superimposed drawers; if equipped with seven drawers (one for each day of the week), they are known as *semainiers*. Their marble tops sometimes have bronze galleries on three sides, and their legs are short.

Note: These pieces were also made in wider formats, in which case they have thinner drawers.

Corner cupboards

Encoignures changed in much the same way as commodes, which they were originally meant to accompany.

Bombé fronts disappear, but sometimes slight breakfront projections animate their flat fronts. Slender panels perpendicular to the wall give them what are in effect canted corners, often decorated with marquetry fluting or bronze fittings.

The marble tops conform to the shape of the case below. Usually, there is a single hinged door surmounted by a single drawer.

Tables

Louis XVI tables are as various as those produced under Louis XV. Made of mahogany, decorated with marquetry and lacquer panels, they can be round, oval, square, rectangular, or kidney shaped.

Their *tops*, made of wood or marble, echo the shape of the cases below, which are unremittingly vertical. Their friezes are decorated with rosettes, interlace plaques, fluting, and field moldings of marquetry or copper. Often, their vertical surfaces are animated by rounded or rectilinear projections continuous with the capitals of the legs (round or square).

In early pieces from the period, the legs were slightly curved, but straight legs soon prevailed:

• If square in section, they taper toward the bottom and rest on dice.

• If round or conical, they can be fluted vertically, with or without cabling (*carquois* legs), or have twisted fluting. These are the most characteristic types.

• Late in the period, if round and unfluted, they end in toupie feet and copper feet, and their capitals are decorated with small striated copper plaques. They are often on rollers. Lyre- and X-stretchers are sometimes found on small tables, which are often oval.

Gaming tables and *chiffonnières* were likewise given treatments consistent with prevailing taste; drum tables, round under Louis XV (see pages 59 and 60), now became oval or square.

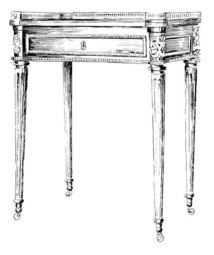

Side table

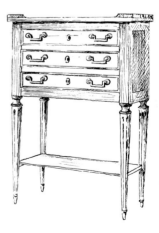

Chiffonnière

*In a hundred years the world will still exist in its entirety: the same theater
and the same decors, but with different actors.* —LA BRUYÈRE

Bouillote *table*

Trictrac table

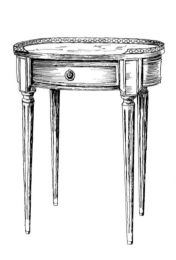

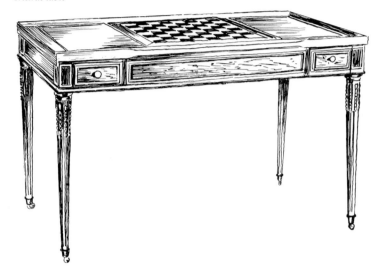

Round projecting corner

Demi-lune table

Drum table

Canted angle

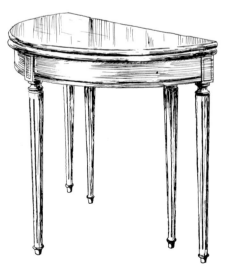

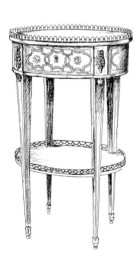

The legs and support posts of bedside tables grew stiffer, but sometimes they were still made with kidney-shaped lower shelves. Elegant trictrac and *brelan* tables (sometimes with fold-out tops), coffee tables, and tea tables with marble or porcelain tops were also produced.

Louis XVI dressing tables are distinguishable from those of the previous period (see page 61) primarily by their straight legs and flat sides and their tops, which are often subdivided into rectangles.

Dining-room tables entered widespread use: traditional trestle tables were replaced by extendable tables — leaves could usually be added in the middle — and drop-leaf tables. Made of mahogany and fruitwoods, they were most often round or oval. They have friezes and four, six, or eight legs, tapered, *en carquois,* or round.

Demi-lune tables are semicircular and thus fit nicely against a wall, but they have a fold-over leaf, supported by pivoting legs, that opens to double their surface and accommodate six diners.

Rafraichissoirs (wine coolers), square or rectangular, are equipped with two small wine tubs and a lower shelf.

Bouillote tables were quite popular, as they remain to this day. Their marble tops are partially circled by a copper gallery, and their friezes have two small drawers and two shelf slides. Their straight legs are generally round or *en carquois.*

Worktables, rectangular in shape, have several shelves and spindle legs.

The **tricoteuse** is a type of *chiffonnière* whose top is enclosed by a gilt brass gallery sufficiently high to prevent balls of yarn from rolling off. Sometimes a wooden rim is substituted for the gallery.

Jardinières, as their name suggests, are flower stands, making them characteristic productions of this nature-smitten moment. Fresh flowers replaced the porcelain ones that had been prized under Louis XV.

Tronchin tables can be used for either reading or writing, and in either a standing or sitting position. Ratchets hidden in the legs make it possible to raise or lower the top, which is equipped with an adjustable reading stand. This type is reminiscent of the *table d'accouchée* developed under Louis XV (see page 60).

Tables à ouvrage-liseuse have two round shelves surrounded by galleries and are supported by a tripod stand. Their top shelves are equipped with two hinged candlesticks.

Athéniennes, which resemble gueridons and were quite fashionable toward the end of the period, have a marble or porphyry top and a tripod base that is sometimes made of gilt or gold-patinated bronze, sometimes of gilt wrought iron. The feet are hoofed.

They are decorated with the heads of sphinxes, swans, or rams, depending on which Pompeian prototype served as the designer's model.

The *salon de musique*

Salons de musique, *or music rooms, were refined environments, with hinged candlestands, elegantly decorated drum tables, and delicately carved harps. Their harpsichords were luxury objects boasting painted and varnished cases and gilded feet carved with fashionable motifs. Pianofortes, newly introduced, had cases with mahogany veneer, with or without copper fillets, and fluted legs.*

Desks

Cylinder desk

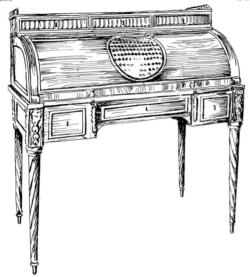

Bonheur-du-jour

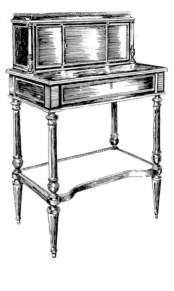

Lady's writing table

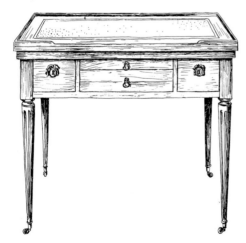

Fall-top secretary
(secrétaire à abattant)

Desks

Bureaux plats (flat-top writing tables), with their rectangular tops and frieze drawers, were still current. They have tapering or *carcuois* legs terminating in copper or bronze feet. Occasionally, copper fillets field the writing surface and reinforce the drawer and end moldings, but sometimes their only decorative fittings are interlace or imbricated disks on the frieze.

The **bureau ministre** (minister's desk) is an eight-legged *bureau plat* with racks of drawers flanking the kneehole.

The **cylinder desk,** introduced under Louis XV (see page 62), became widespread. Rather large, these pieces are usually veneered in mahogany. Nonetheless, exceptional examples survive with rich marquetry decoration.

Their tops, made of marble, have copper galleries. As under Louis XV, the cylinder tops, made of tambour or solid wood, slide upward to reveal a nest of drawers and compartments. Below the writing surface — in some cases a slide-out shelf — are two racks of drawers flanking the kneehole that act as visual counterweights to the mass of the cylinder frame. In the most elegant examples, the frieze is straight and has three drawers. The legs are usually either *carquois* or tapered.

In some instances, the drawer racks descend clear to the floor, a format especially favored by the *ébéniste* Teuné.

Decoration consists primarily of field moldings of copper or bronze on the panels and drawers (often chased with beading or other motifs) and grooves or fluting on the legs and posts.

The **bonheur-du-jour** was introduced under Louis XVI. Charming small desks for women, they often have mahogany veneer and marquetry or lacquer decoration, and

there are also examples with Sèvres plaques. Although produced in many variants, the basic type remained unchanged: a table, with or without shelf stretcher, surmounted by a small set-back armoire. The latter, containing drawers and compartments, is closed by two hinged doors — solid, glazed, or mirrored — or by sliding tambour doors. The top of the armoire stage is marble with a copper gallery.

Some examples have cylinders or sloped fall-tops.

Bureaux en dos d'âne (mule-back or slope-top desks), with their writing table, drawers, and fall-tops, remained largely unchanged, save that straight lines now replace all curves and bulges. Their tops are always made of wood.

Secrétaires à abattant (fall-top secretaries), already fashionable under Louis XV, became still more widespread. Their rectilinear lines made them ideal supports for the classicizing ornament of the period. Interlace and rosette friezes often adorn the top drawer, which is surmounted by a marble top. The canted corners are decorated with triglyphs, which are sculpted in bronze or rendered in trompe-l'oeil marquetry.

The fall-leaf is often decorated by an oval marquetry composition or by a rectangular frame with indented corners, executed in marquetry or in moldings of bronze or copper.

The lower doors are treated in a similar spirit, with great attention to balance and symmetry. Behind them is a nest of drawers or storage compartments. Sometimes the lower doors are replaced by exposed drawers.

These secretaries usually have tapered or toupie feet.

Covered in mahogany veneer and decorated with strict moldings (sometimes accentuated by copper fillets), these are elegant pieces.

Vitrine

Console table

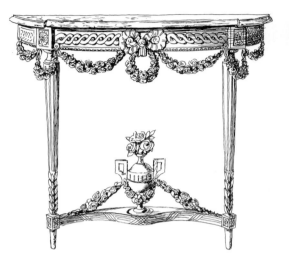

Commode servante
(serving table with drawers)

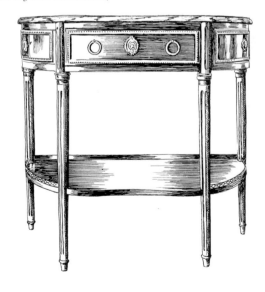

Bookcases

Increasingly, bookcases were not now part of the woodwork, but decorators still made sure they harmonized with the surrounding decor. The most widespread types had two parts:
• an upper part, surmounted by a thin cornice, with two hinged doors, which are either glazed or fitted with brass grilles;
• a lower part with two wooden doors decorated with field moldings, sometimes of copper or bronze and chased with beading.

They have short toupie, turned, or *carquois* feet.

Vitrines

Introduced under Louis XVI, these small, simple armoires with glazed doors were intended for the display of prized knickknacks.

Their decoration was kept simple so as not to compete with the objects within; some examples have a drawer below their marble top, which has a copper gallery on three sides. Their short legs, which end in *sabots,* are toupie or fluted. The treatment of their forecorners, often canted and/or made to resemble fluted pilasters, was consistent with contemporary fashion.

Metamorphic furniture

Considerable ingenuity was lavished on interior mechanisms: thanks to tracks and hidden springs, certain elements could be made to move laterally or vertically (shelves, drawers, writing surfaces), facilitating the use of a single piece for more than one purpose. Examples: the table à la Tronchin, *the* coiffeuse d'accouchée *(dressing table with detachable bed tray) and the* bureau capucin.

Oëben, Weisweiler, and Roentgen made a specialty of such metamorphic mechanisms.

Such was the success of this type that *ébénistes* began to produce smaller models for placement on top of commodes.

The secrétaire à archives

The proportions of this type, another invention of the Louis XVI period, resemble those of contemporary chiffoniers (see page 82); within, they contain morocco-lined nests for the storage of documents.

Console tables

Louis XVI consoles are very different from those of the preceding period. They have straight and fluted legs, sometimes cabled, and curved stretchers supporting an antique urn or vase with squared handles.

They have rectangular or semicircular marble tops and friezes decorated with rosette interlace or vertical grooves. Often, the frieze projects slightly above the legs and is complemented by pendant garlands, knotted ribbons, and roses.

The most beautiful Louis XVI consoles are decorated with marquetry, but there are also fine examples made of painted or gilded walnut.

The **commode servante** is a kind of semicircular, rectangular, or trapezium-shaped console supported by four straight legs. The top, usually marble, rests on a rather thin frieze with drawers. It has one or two stretcher shelves and a back panel.

Examples can be found with only one stretcher shelf and no back panel. The shelves and marble top sometimes have openwork galleries, and the frieze is sometimes decorated with bronze or copper fittings.

Self-esteem is the great motivator of proud souls.
— J.-J. ROUSSEAU

Silver

Ceramics

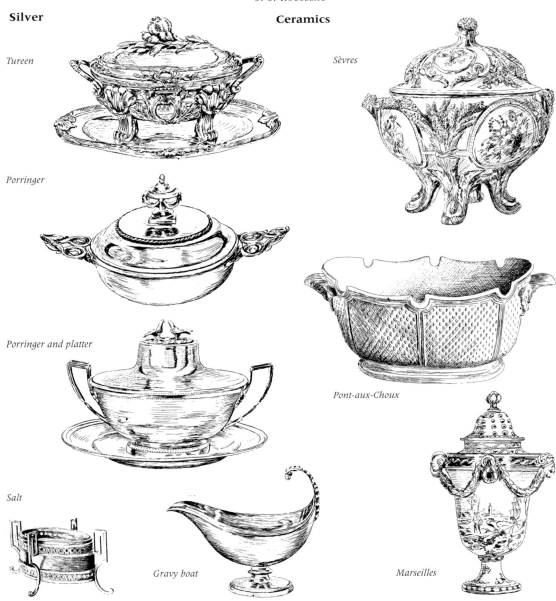

Tureen

Sèvres

Porringer

Porringer and platter

Pont-aux-Choux

Salt

Gravy boat

Marseilles

Accessories

Carved pediment

Braiding

Wall light

Lock plates

Candlestick

Drapery tie with tassels

Clock

Candlestick

Baluster

Candelabrum

Mantel

Firedog

Mirror tablet with garlands and brazier

The Directoire Style

1789-1804

THIS FIFTEEN-YEAR PERIOD was the most troubled in French history. Its passage from absolute monarchy to empire was by way of three successive intermediate regimes: the first Republic, the Directoire, and the Consulate. The great revolutionary tempest devastated the old realm of the Bourbons and disrupted society from top to bottom: its customs, its taste, its decors. Everything associated with the old regime — royal luxury, aristocratic power and privilege — was condemned.

Equality, simplicity, and civic virtue became the new ideals, advocated with a zeal bordering on frenzy and frequently insincere: affectations of simplicity sometimes existed side by side with conspicuous luxury.

If Robespierre, Saint-Just, and Marat tried to cultivate the authenticity and austerity of Roman republican heros, Barras, Tallien, and Josephine de Beauharnais regarded these models merely as a pretext for often ostentatious fashion. This was the age of the Incroyables and the Merveilleuses, of extravagant public festivals and astonishing collective debauchery.

Parvenus, speculators, and arms traffickers spent exorbitant sums on receptions where women were as scantily clad as antique statues, and at which guests, reclining on divans, drank Samos wine from Greek cups filled by servants dressed as ancient slaves.

The furniture from this period has — in its forms as well as its ornament — the same ambiguous simplicity, and the result was a certain impoverishment.

The revolutionaries suppressed the guilds, which could no longer guarantee the level of craftsmanship. On the other hand, the growing number of personal fortunes led to an increase in demand. However, the limited sophistication of the new clients made them less than exacting: they were often satisfied with surface glitter and placed a high priority on rapid execution. The Directoire government sought to address the situation by organizing the first public exhibition of French artistic productions and awarding prizes to work of high quality, but in this domain as in others, it lacked the requisite resolve and authority; only after Bonaparte's seizure of power would France again cultivate a grand style.

The furniture

The troubled economic situation had a direct impact on contemporary furniture production. The process of simplification begun under Louis XVI in response to the growing taste for classical forms was accelerated. The disappearance of *ébénistes* obliged furniture-makers in the faubourg Saint-Antoine to simplify their forms and materials: the basic Louis XVI types were retained, but little invention was lavished on them.

Elegant and gracious, imbued with antique references, Directoire furniture heralds the Empire style but is less ponderous and sumptuous.

Materials and techniques. Most furniture from the period is solid wood: elm, walnut, fruitwood, or beech. Only luxury work is made of solid and carved mahogany or has mahogany veneer.

Painted pieces, usually made of beech, were common (gray, white, sea green, lime green); their carved ornament was painted a contrasting color or different shades of the same color, an evocation of Pompeian decoration.

There was a revival of inlay decoration of the kind prized in the seventeenth century (ebony and citronnier, sometimes even copper and brass); on painted pieces, simple colored fillets imitated such work.

Marquetry was almost totally absent due to economic constraints and a lack of craftsmen with the requisite skill.

Bronze fittings became rare, appearing only on the finest pieces, but the great bronze caster and chaser Gouthière produced beautiful work of classical inspiration.

Ornament

Spare and light, inspired by Greek and Pompeian models, Directoire ornament never obscures a piece's basic structure.

Lines. The style favors crisp geometric forms, straight lines, simple curves, flat surfaces, and clean corners.

Ornament. The Directoire ornamental repertory is small, due in part to an absence of ornamentists.

Characteristic motifs:
• Squares and rectangles, often striated horizontally, are pervasive.
• Palmettes, already frequent under Louis XVI, are common, often arrayed in vertical or horizontal bands.
• Single lozenges are used in isolation; delineated by ivory or painted fillets, they contain a motif, often a Greek tureen or a medallion; they also figure on the cubic joins of chairs, where they contain a medallion. Sometimes single hexagons. octagons, or slender spindles are used instead.

Revolutionary and symbolic motifs. For several years. pieces that are essentially Louis XVI were decorated with phrygian bonnets, fascia, pikes, oak branches (emblems of civic virtue), triangles containing an eye

Ornament

Isolated lozenge

Palmette

Winged sphinx

Facing gryphons

Revolutionary trophy

Die joins . . .

with square inset

with lozenge inset

Striations

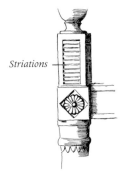

Tureen

Bed

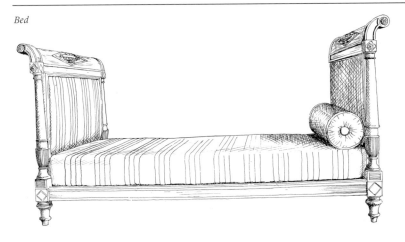

Gueridon

(reason), clasped hands (fraternity), poplars (trees of liberty), tablets of the law, cockades, Gallic cockerels, evocations of the fall of the Bastille, etc. But these motifs soon disappeared.

Antique motifs. Tureens, urns, disengaged columns, arrows, dragons, winged lions, sirens, swans, gryphons, winged geniuses, and figures of fame and fortune were used repeatedly.

After the Egyptian expedition, craftsmen began to use sphinxes, lotus flowers, scarabs, pyramids, and caryatids.

Beds

Beds were made of painted beech, their carved decoration and slender moldings being picked out in a darker shade of the same color.

Beds of the revolutionary period are Louis XVI beds decorated with patriotic motifs: their support posts are fascia surmounted by a phrygian bonnet.

Directoire beds, which survive in larger numbers, have head- and footboards of equal height whose end supports resemble disengaged columns or balusters. Their tops curl outwards and are decorated with oblong lozenges enclosing an antique tureen; these motifs are sometimes carved and sometimes painted a contrasting color.

The short turned legs are of the *carquois* type; the join dies are decorated with lozenges containing rosettes or striated plaques, motifs that sometimes recur at the tops of the end supports.

Note: Sometimes the boards are surmounted by pediments decorated with an antique vase, in which case the end posts are likely to have pinecone or urn finials.

Tables

Generally, Directoire tables resemble Louis XVI tables in their basic structure (see pages 83–85). Both their materials and their ornament, carved or picked out in a darker shade, are very simple, but their friezes are sometimes decorated with the chimeras, swans, gryphons, and sphinxes that would become ubiquitous under the Empire.

Small tables (sewing tables, plant stands, tidies) conform to this pattern; the presence of inlaid or painted lozenges makes it easy to date them.

Gueridons are generally made of mahogany and have round marble or wood tops; they are supported either by three legs or by a tripod stand.

Desks and secretaries

The last **slope-top desks** date from the revolutionary decade; rectilinear in design, they are simply decorated with revolutionary emblems. This desk type was abandoned under the Empire.

Fall-front secretaries and cylinder desks were no longer decorated with marquetry: made of solid wood, they were decorated with flat pilasters, term figures, or columns.

Galuchat

A humble craftsman named Galuchat discovered a way of treating shark-skin so that it could be used to sheathe coffers, and the material has borne his name ever since. Quite fashionable from about 1750, it was also used on jewel caskets and sewing boxes. A charming shade of green, galuchat is still prized by many collectors.

Armoire

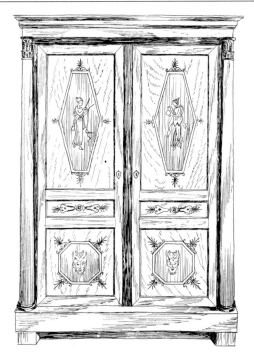

Armoires

This was the last great moment for the provincial production of armoires. Such pieces retained their Louis XVI formats but received new ornamental motifs: full or truncated lozenges, tureens, civic emblems, geometric decors.

Commodes

Variations on this basic type proliferated under Louis XVI, but under the Directoire little imagination was lavished on them. All examples dating from this brief period are of the same basic format: rectangular with flat ends, they usually have three drawers and a wood or marble top. Their legs are straight or tapered with ball-and-claw, toupie, or *carquois* feet. The forecorners, often treated as columns, term figures, or unfluted columns, can be decorated with palmettes and wreaths.

Bookcases and console tables

These pieces, now made of mahogany or painted wood, are no longer built into the woodwork, and semicircular console tables disappear.

Psyché mirrors

Psyché mirrors were introduced under the Consulate (1799–1804). Made possible by advances in the technology of mirror production, they now became essential fixtures in every home.

They consist of large portrait-format mirrors set into a wooden frame and supported by a stand with two side posts

Commode

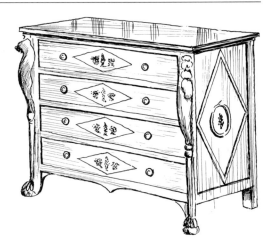

Bookcase

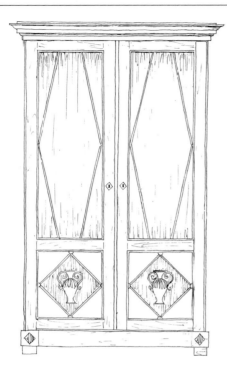

Chair backs

à crosse
(crook back)

à cornes
(horned back)

à bandeau
(band back)

(resembling columns or balusters) and a large base. Decorated with palmettes, swans, and lion paws, they usually pivot along their central horizontal axis and sometimes have candle holders on their side posts (see page 111).

Seating

Seating was the only area of furniture production characterized by invention in this period. Directoire chairs, daybeds, and settees are light, elegant, and slender without being fragile.

Armchairs. Often made of fruitwood, mahogany, or painted beech, they were covered with goffered or embroidered velvet in a solid color, with solid or striped satin, or with damask. An especially fashionable color was gray, typically enlivened with red, green, or yellow antique motifs. Often the braiding has palmette, Greek fret, or rose ornament.

Back treatments vary considerably, but full upholstered backs are much less common than openwork or pierced backs made of solid wood.

• The "horned" back *(à cornes)* is full and coved with side and top rails that curve inward to create "horns" at the corners, which sometimes terminate in scrolls.

• "Crook" backs *(à crosse)* are often pierced; their side bars curve backward and end in small scrolls, while their center panels are carved with a motif in low relief: a tureen within a lozenge; radiating striations within a lozenge; a pair of facing gryphons. Sometimes the top rail is disengaged, making these chairs easy to lift. Charming, light pierced motifs link the center panel to the seat: lozenges or palmettes, less frequently a lyre or triangle.

Legs

Spindle Carquois

Die joint

Arm details

Armchair *Curule chair*

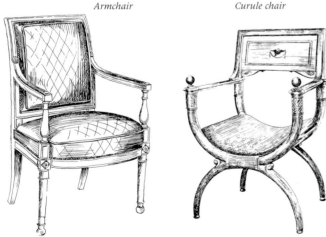

• "Band" backs *(à bandeau)* have a wide upper transom that extends beyond the side rails, which are prolongations of the back legs. They were decorated much like crook backs.

The forelegs, straight, are usually turned and of the *carquois,* baluster, or column type with rings, but occasionally they are square in section. The splayed back legs *(en sabre* or *à l'étrusque)* are always square in section. The join dies linking the legs to the seat are decorated with recessed lozenges containing a rosette or a daisy (the same motifs that were inscribed within squares in Louis XVI join dies).

Note: Roman curule chairs were made during this period, but they are rare. (Adapted from the stools on which Roman senators sat, they are usually made with curved X-frame legs.)

The arms are square in section and terminate in small scrolls or spheres, or are carved with daisies in relief. There is a palmette or a shell of characteristic form where they connect with the back. Their supports are balusters or colonettes decorated with collars or relief zigzags.

Note: On exceptional pieces, the arms have lion- or eagle-head terminals and the side rails of the back terminate in female busts, winged geniuses, or sphinxes that repeat on the leg capitals. After the Egyptian campaign, the forelegs and arm supports become continuous, with no interruption at seat level.

The **bergère,** a survival of the Louis XVI period, remained as comfortable as ever, with upholstered arms and back and loose feather cushion.

Daybed

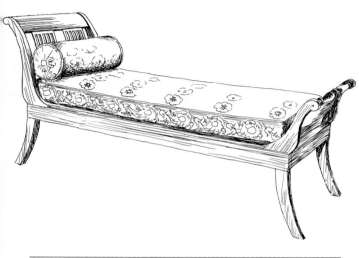

Directoire **settees,** rather stiff, are treated much like contemporary armchairs. Their designs are less various than under Louis XVI.

Daybeds, long and narrow, now begin to replace chaises longues. Inspired by antique models, with saber legs and out-curving head- and footboards of unequal height, they were made famous by Madame Récamier.

The **méridienne** is a daybed with a back whose sinuous curve links the head- and footboards.

Note: Some *méridiennes* have only a headboard and a back.

Chairs. Made of fruitwood, mahogany, or painted wood, Directoire chairs are treated much like contemporary armchairs save for their absence of arms. They are light, charming, and decorative.

The *gondola chair* is one of very few new furniture types introduced under the Directoire. Rather low, it has a rounded and enveloping back that slopes forward before it meets the seat. Its legs and seat rail are treated much like those of other chairs from the period.

Gondola chair *Chair with flat back*

True collectors enjoy knickknacks not only with their eyes but with their fingers. To touch a marble, a bookbinding, a delicate piece of glassware is to enjoy it all the more. —P. REBOUX

Silverware

Teapot

Coffeepot

Pediment mirror

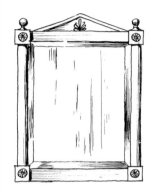

Candlestick

"Closed umbrella" candlestick

Detail of silver foot with paw and winged chimera

Mantel plaque

Ceramics

Wall light

Firedog

Sèvres plate

Sèvres vase à l'antique

The Empire Style
1804-1815

 THE EMPIRE STYLE was deliberately propagandistic. An unambiguous expression of imperial majesty, it provided an apt frame for the Napoleonic adventure, which, according to the general himself, could be compared only with the conquests of Alexander the Great and the brilliant military career of Caesar. This explains its striking difference from the styles that immediately preceded it: intentionally rejecting the grace and elegance typical of French furniture since the Régence, it embraced what was most monumental in ancient art: only the Rome of Augustus, the Greece of the oracles, Pharaonic Egypt, and the Macedonia of Alexander the Great were thought to offer suitable analogies to the new French Empire.

To secure settings worthy of his genius, Napoleon proceeded much as he had with regard to government administration and the Civil Code, imposing a tyrannical centralization on artistic production, decreeing that henceforth it would be subject to control from Paris and overseen by the architects Percier and Fontaine and the painter Jacques-Louis David. The old academies and traditional guilds were abolished and replaced by exhibitions at which government officials distributed prizes and medals to works consistent with Napoleon's policies. The potential clientele of the *ébénistes* was also under his thumb. The former nobility was now impoverished or in exile. The new elite owed the whole of its fortune and glory to a master whose predilections it imitated shamelessly — followed in this, of course, by the commercial and financial parvenus enriched by the Empire's permanent wars. The result was a style whose spectacular success and uniformity was unprecedented in France.

However, this success would not have been as great, despite imperial tyranny, if it had not also been profoundly consistent with the spirit of the era, which had been seduced by martial grandeur. Simultaneously simple and majestic, sturdy and theatrical, it seemed altogether new and consistent with the great revolutionary principles of 1789. It abjured everything tainted by the frivolous grace of the old regime, everything that might evoke the decadent heritage of the Bourbon line. The issue of the unbridled will of a single man who succeeded in subjecting all Europe to French dominion, the style's dry, ample lines, ornamental vocabulary inspired by great vanished civilizations, and exceptional craftsmanship make it an appropriate expression of a great historical moment: a fifteen-year span during which, to the strains of Beethoven's *Eroica* symphony and the drums of Austerlitz and Jena, the marshals and old guard of the Grande Armée strove to equal and even surpass the exploits of legendary heroes.

ABROAD
England:
the Regency style
Italy:
the neoclassical style
Spain:
the Joseph
Bonaparte style

The furniture

Dominated by Greco-Roman models, the Empire style — spare, noble, massive — has a studied dignity consistent with Napoleonic majesty.

The characteristic Empire furniture types are a bit stiff but imposing; their flat surfaces and sharp corners, together with their lack of moldings, produce an effect of grandeur that is not without beauty. They are the principal elements of solemn designs conceived to be viewed frontally.

As solemnity prevails over comfort in this aesthetic, the small pieces conceived for precise purposes that had been so dear to the eighteenth century became rarer.

Bronze fittings from the period, always placed with an eye to geometry, are of high quality.

Materials and techniques. Mahogany was the wood of choice, solid mahogany being preferred for fine pieces and veneer for seating and other movables, with blond, dark, moiré, figured, or flame varieties all being used. But beginning in 1810, when mahogany became unavailable because of the continental blockade, furniture-makers were obliged to use walnut, burled elm, beech, ash, yew root, box-wood, olivewood, maple, and, on rare occasions, citronnier.

Complex marquetry designs disappeared, giving way to discreet inlay orna-ment consisting of slender fillets, wreaths, and rosettes:
• fillets of blond wood (citronnier, olive-wood), copper, or steel set into dark wood (mahogany);
• fillets of dark wood (ebony, mahogany, yew) set into blond wood (beech, elm).

Some chairs, settees, and other pieces were gilded or painted white or gray:
• if gilded, their ornament was, too;
• if painted, their ornament could also be painted or gilded.

Bronze fittings — gilded, matte, polished, and very finely chased — are the only ornaments on furniture other than seat-ing. Purely decorative, they are placed symmetrically on flat surfaces, whose dark masses they enliven, drawing atten-tion to a piece's mass as opposed to its profile. Furthermore, the fittings on a sin-gle piece are often quite different in scale.

Usually quite flat, they are delicately yet vigorously chased and their modeling is precise. Each of them is perfectly self-sufficient.

Marble tops have sharp corners and are most often gray or black, but white mar-ble tops were sometimes used.

Percier and Fontaine

When still quite young, the architects and decorators Percier and Fontaine were asked by David to furnish the assembly hall of the Convention, a com-mission that inaugurated their remarkable joint career. Subsequently taken up by Napoleon, they restored Malmaison (acquired by Josephine in 1798), then the château of Saint-Cloud, the Tuileries palace, and the Louvre. Possessed of unerring taste and a sophisticated architectural sense that informs all of their work, they devised an official Empire style that was suit-able for virtually any purpose. Rejecting French eighteenth-century models, they embraced those of antiquity (Roman, Etruscan, Egyptian, and Greek); rejecting grace, delicacy, and intimacy, they cultivated a brand of grandeur and nobility and did not preclude refined details.

Decorative motifs

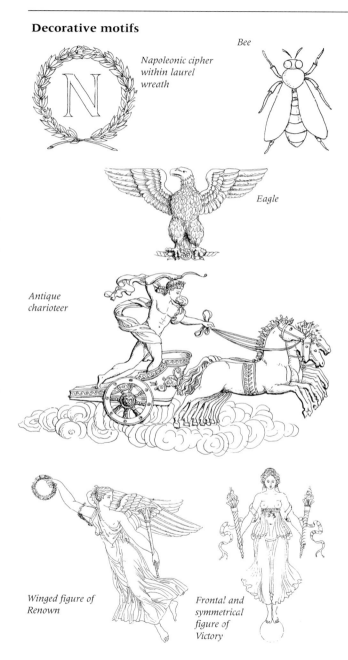

Bee

Napoleonic cipher within laurel wreath

Eagle

Antique charioteer

Winged figure of Renown

Frontal and symmetrical figure of Victory

Ornament

All Empire ornament is governed by a rigorous spirit of symmetry reminiscent of the Louis XIV style. Generally, the motifs on a piece's right and left sides correspond to one another in every detail; when they do not, the individual motifs themselves are entirely symmetrical in composition: antique heads with identical tresses falling onto each shoulder, frontal figures of Victory with symmetrically arrayed tunics, identical rosettes or swans flanking a lock plate, etc.

The rectilinearity of these designs produces a severity alien to eighteenth-century practice:

• Moldings are either completely absent or, if present, are unassertive, never interrupting flat surfaces, which always have right angles.

• Usually, support posts are incorporated and sheathed in the same mahogany veneer that covers the rest of the piece.

• If visible, they are dissimulated by square-section caryatids or detached colonettes that leave the corners of the post visible.

• These cubic forms often rest on full bases (commode, secretary, or bookcase) that intensify the massive effect.

The same characteristic *decorative motifs* appear on bronze fittings, textiles, and applied-arts productions as well as in interior decors, giving the style its unity.

Like Louis XIV, Napoleon had a set of emblems unmistakably associated with his rule, most notably the eagle, the bee, stars, and the intials I (for Imperator) and N (for Napoleon), which were usually inscribed within an imperial laurel crown.

Motifs of human origin: figures of Victory bearing palm branches; Greek dancers; nude and draped women; figures on antique chariots; winged putti; masks of Apollo, Hermes, and the Gorgon.

Decorative motifs

Swan

Bucranium

Helmet

"Klaft" lion head

Palmette

Rosette

Crown of
laurel and oak

Caryatid en gaine

Thyrsus
with grape vine

Cornucopia

Acanthus rinceau

"Egyptian" water leaves

Lyre

Motifs of animal origin: swans; lions; the heads of oxen, horses, and other wild beasts; butterflies; claws; winged chimeras; sphinxes; bucrania; sea horses.

Motifs of vegetal origin: compact rose wreaths; oak wreaths knotted by their trailing ribbons; climbing grape vines: poppy *rinceaux;* quadrilobe rosettes; palm branches; laurel; "Egyptian" water leaves.

Note: Vegetal motifs, less common than under Louis XVI, are treated more schematically, but the refinement of their chasing is still admirable.

Greco-Roman motifs: stiff and flat acanthus leaves; thick scrolling acanthus; cornucopias; *rais-de-coeur;* florets; beading; amphoras; tripods; imbricated disks; craters; caduceuses of Mercury; thyrses of bacchantes; lightning bolts of Jupiter; tridents of Neptune; vases; battleaxes; lances; helmets; torches; winged trumpet players; ancient musical instruments (tubas, sistrums, rattles, lyres).

Note: Despite their antique derivation, the fluting, triglyphs, and interlacing so prevalent under Louis XVI are abandoned.

Egyptian motifs are especially common at the beginning of the period: scarabs, lotus capitals, "klaft" or "pschent" lion heads (in pharaonic headdresses), winged disks, obelisks, pyramids, caryatids *en gaine* supported by bare feet and with women in Egyptian headdresses.

Geometric motifs: circles, squares, lozenges, hexagons, octagons, and ovals are widely used as frames for isolated motifs.

Beds

Whether or not they are situated within an alcove, beds are meant to be seen from one side only; consequently, their frames are decorated on only one side.

Beds with upright headboards resemble those of the Louis XVI period. Their four support posts, treated as columns, pilasters, or caryatids, culminate in cups, spheres, or antique heads.

Note: The posts closest to the wall are sometimes taller than the two posts in front.

Boat beds (lits bateau; sometimes called sleigh beds in English) have two end boards of identical height that scroll outward at the top; the support planks applied to their outer edges, often wide, are decorated with bronze fittings that emphasize the basic structure (see page 106).

Similar beds were made with only one end board.

Tables

The most characteristic Empire tables are round, being massive variants of the gueridon type, but many attractive lighter ones were also produced in various formats.

Those of the **gueridon** type frequently served as dining tables. Their tops, often round, were usually made of wood or marble, more rarely of porphyry, mosaic, or malachite. Their friezes, wide with flat lower edges, are often plain but are sometimes adorned with bronze fittings. Their legs and bases, usually made of gilded wood or bronze, take various forms:

• a thick central column on a flat triangular base with concave sides;

Beds

Bed with straight headboard

Boat bed with scrolling headboard

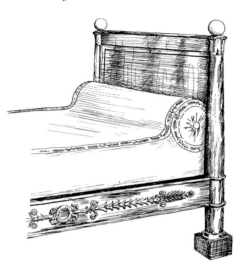

Tables

Gueridon
with monopod sphinx legs and central urn

Gueridon
with volute tripod stand

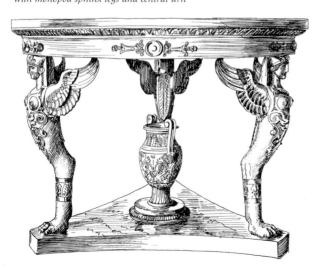

Tables

Athénienne

*Gueridon
with flat tripod stand*

*Night table
(somno)*

Dressing table

• with three or four legs that support the top and rest on a base that is round or triangular with concave sides and decorated in the center with an urn; sometimes the legs take the form of caryatids, sphinxes, monopods, or gryphons, in which case they are made of carved mahogany, gilt wood, or bronze (gilt, patinated, or black);

• with three legs in the form of attenuated and cantilevered volutes, often rising from gryphons and terminating in lion or eagle heads, joined toward the bottom by a ring or a shelf.

Most **small tables** — round, square, hexagonal, or rectangular — are work tables, tea tables, or lunch tables. Notable for their refined silhouettes, they are easily recognizable by their characteristic Empire ornament. Their legs — lyres, Xs, or slender colonettes — are elegant.

Athéniennes have thin tops — round or hexagonal — made of marble or porphyry and are supported by metal tripod bases. Their legs, made of bronze, iron, or steel, rise from paw feet and culminate in sphinxes or lion heads.

Note: These pieces can be used in various ways (plant stands, gueridons, dressing tables, etc.).

Empire dressing tables are quite different from those produced in the eighteenth century. Their rectangular tops, made of white or gray marble, rest on wooden friezes equipped with a drawer and decorated with bronze motifs, as are their X or curule supports. On their tops is a rather large pivoting mirror (round, oval, rectangular, with chamfered corners) supported by posts that resemble torches or quivers and are equipped with lighting fixtures.

Joy is a whole; one must know how to extract it.

— CONFUCIUS

Note: Empire tables, consoles, and even commodes were sometimes transformed into dressing tables by the addition of a portable mirror on a wooden stand equipped with a drawer. In effect, these units are miniature Psyché mirrors.

Empire **lavabos** (wash stands) are *athéniennes* equipped with two small shelves made of marble or wood, one meant to accommodate a basin and the other a pitcher. Two columns shaped like swans' necks rise from their tops to support a round mirror and a hook for washcloths. This type was quite common.

Shaving stands from the period are high and narrow. From their lower parts, equipped with many drawers, rise four columns supporting a frame with a single small drawer and a marble top. Between the back columns there is a sliding mirror that can be raised during use.

Night tables, known as *somnos* during this period, have marble tops that slightly overhang their cylindrical or cubic cases, which have no moldings or other protruding elements. Their spare forms are enlivened only by bronze decorative motifs or lock plates on the drawers and sides.

Rectangular tables from the period are rare but always quite beautiful. Their thick tops and friezes, richly decorated with bronze fittings, rest on four majestic caryatid legs.

Plant stands, which proliferated in the period, have tops made of gilt and chased bronze or of varnished and painted tôle (a kind of sheet metal). These are supported by wooden or metal bases incorporating winged animals or human figures.

Console tables

Empire consoles, rigid and solemn, are usually rectangular but occasionally semicircular. Their marble tops rest on thick friezes decorated with bronze fittings, and their four legs rise from heavy bases, which replace the characteristic stretchers of their antecedents. Their forelegs can take the form of sphinxes *en gaine* or caryatids, but often they are simple columns or posts decorated with bronze fittings. The space between the rear legs is usually occupied by a simple panel, sometimes fitted with a mirror.

Desks

The **flat-top writing table** continued to exist. The ample proportions, ornament, and Greco-Roman supporting elements of Empire examples make them readily distinguishable from their Louis XVI antecedents.

Note: Some examples have a plaque that can be used to cover papers left on top.

Minister's desks were produced in two variants:
- The two ranges of drawers flanking the kneehole descend all the way to the floor, resulting in a design reminiscent of a triumphal arch. The corners are often decorated with caryatids *en gaine*, monopod lions, or sphinxes.
- The two ranges of drawers flanking the kneehole stop short of the floor and are supported by two groups of four legs.

Cylinder desks retain Louis XVI lines, but their ornament becomes heavier. Sometimes the cylinder is surmounted by a bookcase or a range of drawers. Their lower portions are made in accordance with both minister's desk types.

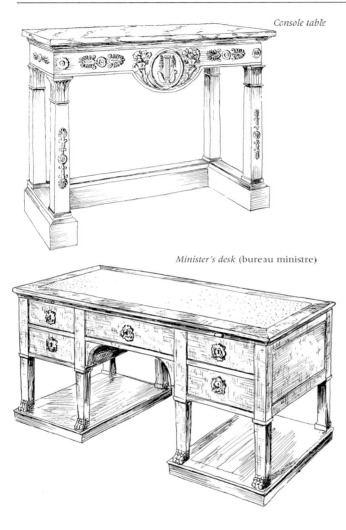

Console table

Minister's desk (bureau ministre)

Rustic furniture

The official Empire style, virtually synonymous with polished mahogany, is rather rich, but cruder variants of it also flourished. These pieces, made of indigenous woods and virtually — sometimes entirely — without bronze fittings, are not unattractive; their forms, while a bit ponderous, are not without charm; their knob handles, in the form of flat cups chased with guilloche "paterae," modestly enliven their fronts. Given an encaustic patina, they are more comforting and less solemn than the more sumptuous Empire pieces.

Fall-top secretaries were very fashionable. Quite elegant, they retained the basic structure of their Louis XVI antecedents (see page 87). Their support posts, which sometimes have female- or sphinx-head capitals, rise from claw feet; often there is a single drawer between the fall-top and the marble top.

Behind the fall-fronts, rectangular and decorated with chased bronze fittings, are drawers and compartments made of a lighter wood. Their lower parts, also decorated with bronze fittings, sometimes have two hinged doors that open to reveal shelves or three superimposed drawers.

Bonheurs-du-jour (usually ladies' writing tables) from the period are rare; while not as graceful as their eighteenth-century antecedents, they are still elegant. Their upper cases, massive and rectangular, have two hinged doors decorated with bronze figures and *en gaine* support posts with female-head capitals. Their lower parts, which resemble console tables, have pier legs with claw feet and massive platform bases, sometimes with a mirror between the two rear legs (see page 110).

Armoires

Sparsely decorated, Empire armoires have wide, flat doors without moldings; their angles are emphasized by colonette support posts with gilt and chased bronze collars circling the bases and capitals. They culminate in triangular pediments or horizontal listel cornices. For the first time, mirrors sometimes appear on the doors.

Low armoires were very fashionable. Rather like commodes with hinged doors but no drawers inside, their doors are decorated with bronze motifs.

Bonheur-du-jour

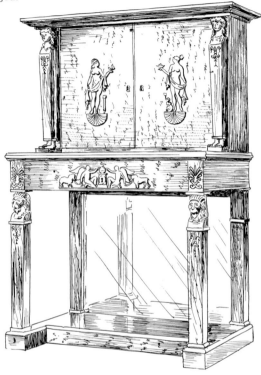

Typical base of pieces with hinged doors

Bookcases

Empire bookcases are quite large. Their upper parts, which constitute two-thirds of their height, have glazed doors; their lower parts, somewhat deeper, have two hinged doors decorated with bronze fittings. Their cornices are straight, and their pilaster support posts have bronze fittings at the top and bottom.

Note: Low bookcases were also made in this period.

Commodes and chiffoniers

The multiplicity of commode types characteristic of the old regime disappeared.

Three-drawer commodes have gray or white marble tops. Their pilaster support posts, sometimes tapered, often rise from claw feet and have human- or sphinx-head capitals of carved wood or bronze.

Delicate bronze fittings surround the keyholes and ornament the pilaster capitals. Knobs, wreaths, or rings suspended from lion heads serve as drawer handles.

Commodes with hinged doors, known as *commodes à l'anglaise,* have three drawers behind hinged doors as well as another drawer, left visible, immediately below the marble top. Their plain, flat surfaces make them admirably well suited to bronze mounts.

Chiffoniers or ***semainiers,*** higher and narrower than commodes, generally have seven drawers. Their tops, support posts, and feet resemble those of contemporary commodes. Sometimes there is a narrow door at the top, in a frieze supported by the posts.

Three-drawer commode

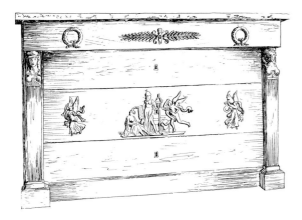

Psyché mirror

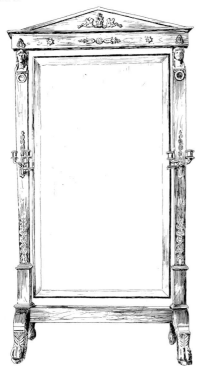

Psyché mirrors

Psyché mirrors became widespread under the Empire.

Their high support posts, round or rectangular in section, have bronze capitals (vases, urns, antique heads); halfway up are sconces of chased bronze. They sometimes have triangular pediments, and their bases, which of necessity must be heavy, are sometimes full socles. Their mirrors, rectangular or oval, are mounted between the posts on pivots and thus can be tilted.

Seating

Under the Empire, seating, usually made of mahogany, became heavier, ampler, less easy to move. The grace characteristic of eighteenth-century chairs and settees gave way to solemnity.

Backs, always upholstered and sometimes pedimented, often curve slightly forward at the sides but can also have straight sides. Chairs with straight backs have bronze mounts on their upper rail and on the front seat rail.
• If flat, backs are square or rectangular.
• If coved, they are of the scooped or gondola type. Gondola backs were especially successful; resembling a half-cylinder and encompassing the shoulders, they flare forward in a continuous downward curve to join the chair rail.

Upholstered *seats* are square or almost rectangular with straight rails.

Forelegs are straight; back legs are square in section and flare outward.

Coverings popular in the period are brocaded and embossed velvet, damask, brocaded silk, satin, leather, or taffeta. Favored textile motifs, usually rendered

Every created form, even if devised by man, is immortal. For form is independent of mat ter: it is not molecules that constitute form.

— CHARLES
BAUDELAIRE

in gold or silver against a red, violet, rose, or green ground, are oak and laurel leaves, rosettes, stars, palmettes, vases and urns, and geometric patterns.

Armchairs were especially various under the Empire, but several characteristic features can nonetheless be singled out.

Arms are straight, with relief palmettes above their joins with the back.

Arm supports, extensions of the forelegs, either:
 • rest on the figures serving as the legs' capitals, without interrupting the chair rail; or
 • culminate in winged lions, chimeras, sphinxes, swans, or eagles whose backspread wings support the arms.

The *forelegs — en gaine,* caryatid, or monopod lion — have paw, plain, or reversed palmette feet. Their capitals can be female busts or Egyptian heads.
 Some forelegs have square sections, or are round with fluting and collars.

The *rear legs* are always square in section with a more or less pronounced saber flare.

Note: The legs and chair rails of gondola armchairs are identical, but their coved backs are continuous with their arm supports.

Bergères have in-filled arms and thick cushions. Their lines and ornament resemble those of other contemporary armchairs.

Chairs have upholstered or pierced backs. The latter can be:
 • with a broad upper plank *(à bandeau),* much like their Directoire antecedents;
 • rectangular but flaring slightly outward toward the top, in which case they are sometimes pierced;
 • straight, upholstered, or pierced, and sometimes pedimented;
 • gondola, upholstered or pierced, and continuous with the arms rising from the forecorners of the seat.
 The back legs always flare outward and the forelegs are always straight (square-section, flared, or turned).

Stools are quite common. Their rectangular seats have X or curule supports, culminating in lion heads that rise above the seat; sometimes these ends are linked at either side to form armrests.

Settees from the period are quite heavy, resembling beds more than chairs. Their backs and arms resemble those of contemporary armchairs. Various support systems are used:
 • six or eight legs resembling those of armchairs;
 • cubic or lion-paw feet;
 • a heavy, solid base resting on the ground.

The *Pommier settee* has a very low back that turns forward ninety degrees at the ends to constitute the arms.

Daybeds increasingly replace chaises longues. Narrow and delicate, they have saber legs and two back supports, of equal or unequal height, that curve outward at the top.

Méridiennes have two back supports at either end of unequal height, connected by another support whose upper head slopes downward from the higher to the lower of the two.

Seating

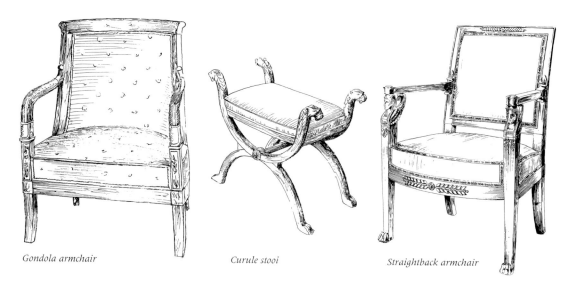

Gondola armchair *Curule stooi* *Straightback armchair*

Gondola chair Méridienne *Straightback chair*

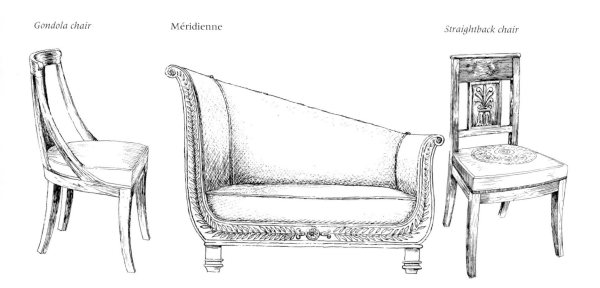

Empire silver plate

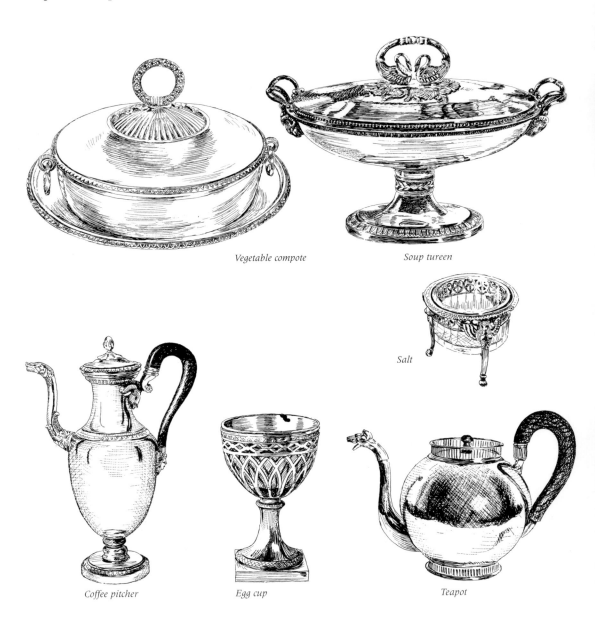

Vegetable compote

Soup tureen

Salt

Coffee pitcher

Egg cup

Teapot

The Restoration Style
1815-1830

AFTER FIFTEEN YEARS OF RINGING fan-fares from one end of Europe to the other, the Napoleonic adventure ended in the summer of 1815 on the plain of Waterloo. France, bled dry, ruined, drunk on a great dream that had no future, entered a period of recovery overseen by the two brothers of Louis XVI: the comte de Provence, who reigned as Louis XVIII (1815–23), succeeded by the comte d'Artois, Charles X, who, overthrown by the 1830 revolution, was the last of the Bourbon kings. These survivors of the old regime sought to revive, in addition to the politics and privileges of the former monarchy, its manners, its state of mind, and its material culture, a project that was only partly implemented.

To be sure, the Restoration was first of all a reaction against the gaudy spectacle and monumental pomp of the Empire. It fostered an elegance, refinement, and subtlety that had been obscured by Napoleonic grandeur. Mahogany, deemed too heavy, was replaced by blond woods; bulky pieces with brass fittings gave way to smaller ones with delicate profiles and inlay decoration. As under the Régence a century earlier, and for much the same reasons, contemporaries turned their backs on vast ceremonial chambers, preferring the charm and intimacy of small reception rooms and boudoirs.

But this stylistic shift did not affect certain essential elements of the formal vocabulary, which survived from the preceding period. The Empire had not had sufficient time to achieve all its goals; in addition to completing monuments that had been begun under Napoleon, notably the Arc de Triomphe and the church of the Madeleine, the Restoration continued the neoclassical tradition, which it developed to an unprecedented degree of refinement. Some specialists hold that French *ébénistes* produced their finest work during this brief period.

If the attempt of the last Bourbons to turn back the clock thirty or forty years ultimately failed, this was due only in part to the determined persistence of the Empire style, for France, like the rest of Europe, was being flooded with a constant stream of new ideas. Romanticism, which manifested itself in Lamartine's *Harmonies poétiques* and in Victor Hugo's lyrical *Ruy Blas*, in the oratorios of Berlioz and in Delacroix's *Pesthouse of Jaffa*, was as far removed from the grace of the preceding century as it was from the ruthless ambition of the defeated emperor. The long-haired young men dressed in flamboyant brocades who made Romanticism fashionable drew their inspiration from farther afield: from a half-imaginary idea of the Middle Ages in which, curiously, classical ornament coexisted with the lancet arches, pinnacles, and rose windows of Gothic cathedrals.

Consequently, this period, while still subject to the rules of Greek and Roman art, evoked simultaneously, sometimes with happy results, the austere beauty of the Acropolis and that, more tormented and sinuous, of Notre-Dame de Paris.

The furniture

Elegant yet unpretentious harmony characterizes Restoration furniture, which is comfortable, gracious, and portable. While the basic shapes of Empire pieces survive, they now grow softer and more supple, acquiring a new grace. Dimensions become smaller in response to more restrained interiors. Blond woods, gently rounded forms, and discreet, refined ornament all help to give this style its distinctive character.

Materials and techniques. The craftsmen of the period were quite skillful, being equally adept at the use of veneer, solid-wood construction, and inlay work, all of which they employed in accordance with the desired effect. The use of light wood inlay against dark wood grounds is typical of Restoration furniture, but on occasion — especially during the reign of

Charles X — inlays of dark wood were set into blond grounds.

The *blond woods* used included varnished ash, elm, figured plane tree, mottled beech, bird's eye maple, burr thuya, sycamore, boxwood root, orange wood, citronnier, olive wood, and acacia. The availability of so many woods gave *ébénistes* a wide range of choices, making it possible for them to multiply their decorative effects.

The *dark woods* used were mahogany, palisander, and purple wood.

The *inlay work* of this period is of exceptional quality and finesse: fillets, rosettes, palmettes, and *rinceaux* are as delicate as goldsmith work. They function much like the bronze fittings in Empire furniture, which they sometimes recall.

Bronze fittings are used much more sparingly than under the Empire, and the preferred motifs are much more attractive; lyres, swans, putti, palmettes, and rosettes figure discreetly on the fronts of some pieces.

The *marble* of furniture tops can be pale gray with subtle veining, white, or, less often, black. The corners of the tops are rounded and their fore-edges have cyma profiles.

Note: Occasionally, painted panels or Sèvres porcelain plaques decorated with flowers were set into case furniture.

The Cathedral style

The vogue for things medieval spurred craftsmen to adopt Gothic decorative motifs, a Romantic revival tendency that flourished under the Restoration.

In terms of shape, furniture made of dark woods resembled furniture made of blond wood. If made of mahogany or palisander, commodes, secretaries, tables, gueridons, buffets, plant stands, and bookcases had ornament of blond wood, in the guise of blind, rose, lancet, or trefoil windows and delicate lancet arcades.

Chauffeuses and prayer stools were made with pierced designs describing bell turrets, lancet arches, trefoils, and rose windows.

Decorative motifs

Tulip molding

Swan

Cornucopia

Palmette

Gothic rosette

Lyre

Floral wreath

Ornament

Restoration ornament is light and refined, emphasizing structural forms without ever betraying them. Moldings, abandoned under the Empire, reappear, but they are now thin and delicate. Sometimes they are introduced on smooth surfaces or serve to soften corners.

On occasion, strong variants of cyma reversa moldings known as tulip moldings are introduced at the tops of secretaries and commodes.

Some Empire motifs survive, but in simplified form: palmettes (rounder, smaller, sometimes quite stylized), cornucopias (of moderate size), stars, swans, lyres, and dolphins; more rarely, chimeras, gryphons, and sea horses.

They are easy to distinguish from their Empire antecedents, for they are much less solemn, having a new lightness and amiability.

Geometric motifs: squares, lozenges, rectangles, octagons, and ellipses are used, but less frequently than in Empire furniture. Circles are replaced by tight floral rosettes.

Classical motifs: oves, beading, *rinceaux*, gadrooning, floral garlands and bouquets, ribbons (especially common).

Allegorical and antique motifs become rarer; only Cupid, Psyche, Adonis, and sentimental subjects survive. Columns and pilasters, pediments, and straight cornices adorn large pieces such as bookcases.

Gothic motifs: decorative rose windows, Gothic tracery, and bell turrets, carved in wood and heightened by inset fillets and rosettes, evoke the work of Gothic stone sculptors.

Living art does not reproduce the past: it continues it.
— AUGUSTE RODIN

Boat bed

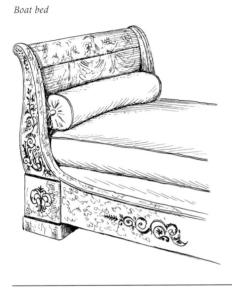

"English" table

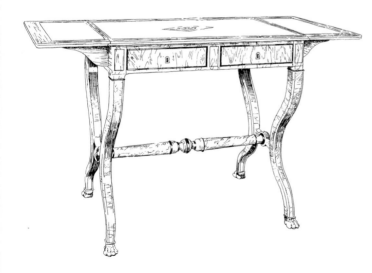

Beds

As under the Empire, all beds were designed for placement lengthwise against the wall.

Boat beds (or *lits bateaux*) have two end boards, usually of equal height. The curved end posts, which are wider at the bottom, curve slightly outward at the top and terminate in scrolls. They have short feet; inlay motifs decorate the board posts and front rails.

Lits nacelles (skiff beds) have silhouettes like those of *lits bateaux,* but the outward curve of their end boards is more extreme. These beds were generally placed on a small dais and given luxurious appointments.

Beds with straight end boards have pilaster or column end posts; inlaid fillets and motifs decorate their various parts.

Tables

Tables proliferated. Although they resemble Empire tables in general outline (see page 105), they are lighter and more various.

Tripod, column, console, and lyre support systems are still used, but some tables now have in-curving, square-section legs with paw feet. Turned legs, which would become quite fashionable again under Louis-Philippe, begin to reappear.

"English" tables have rectangular tops and drop leaves at both ends. They are supported by consoles, S-legs, or lyres linked by a stretcher.

Worktable

Plant stand

Note: Dining tables sometimes adhere to the "English" model, i.e., with drop leaves at both ends.

Rectangular tables have inlay decoration on their friezes. They are supported by a pair of lyres linked by a turned stretcher, by four turned legs, or by four console legs. They vary greatly in size, sometimes being as long as flat-top writing tables.

Gaming tables have rectangular or round tops with drop leaves; often decorated with the thin torus moldings that became pervasive under Louis-Philippe, they were covered with green tablecloths.

These tables are light and, when closed, quite compact. They were given a wide range of support systems.

Night tables (known in French as *somnos*) retain their Empire forms (see pages 107 and 108) but are made of blond wood and are decorated with inlay in dark wood.

Worktables have lids whose interior surfaces are fitted with a mirror framed by fillets; these lift to reveal storage compartments. In some instances, there is an additional shelf or compartment below.

Whether round, oval, or rectangular, they are always elegant. Their legs can be volutes with paw feet, consoles, or lyres.

Plant stands, cylindrical, oval, or with segmental rims, are rather high. They rest on three or four slender legs with volute or lion-claw feet and are decorated with fashionable motifs.

Dressing tables have rectangular marble tops and oval mirrors that pivot on two long swan-neck supports.

Psyché mirror

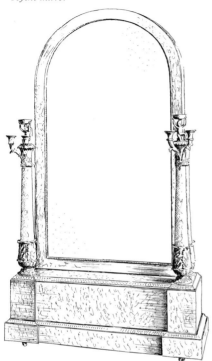

Bookcase

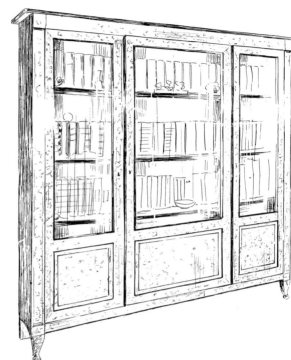

Console

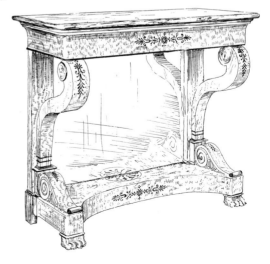

Gueridons, often used as side tables in dining rooms, were produced in large numbers and in all sizes. Their tops, round or with segmental perimeters, made of marble or wood, rest on friezes decorated with inlaid motifs that recur on the top if these are made of wood. They are supported by tripods or by single columns rising from a tripod base. In large examples, the feet sometimes rest on a large socle base.

Note: Made of blond wood and decorated with fillets and motifs inlaid in dark wood, small Restoration tables — round, square, rectangular, or oval — reveal the talent and invention of the period's craftsmen. They were usually produced to serve a specific purpose: catchall, jewel chest, tea or luncheon table, table with secret compartments, etc.

Consoles

Console tables, narrow and rectangular with rounded corners, are suppler variants of their Empire antecedents.

Their marble tops rest on wide friezes decorated with inlaid ornament and supported by two curved console legs that sometimes flare outward from straight rear legs. They have solid socle bases raised on short feet; sometimes there is a mirror between the rear legs.

Psyché mirrors

Psyché mirrors are now round or oval, pivoting on colonette supports that culminate in swan necks. Their thick bases, mounted on rollers, are decorated with lion claws or winged chimeras. They are decorated with delicate gilded bronze fittings or inlays.

Bookcases and storage pieces

Restoration **bookcases** are tall and spare. Their pilaster support posts are surmounted by thin, straight, slightly projecting cornices. The upper two-thirds of their two or three doors are glazed, the lower thirds being decorated with dark inlaid motifs or fillets that define the panels. These pieces either rest on full bases or have very short legs.

Note: Cartonniers (filing cabinets) and other pieces for the storage of papers and documents are quite simple; made of blond wood, their decoration is limited to dark inlaid fillets.

Desks

Minister's desks are large; their tops, which project slightly, rest on friezes with two or three drawers. They have turned legs.

Fall-front secretaries usually have marble tops with rounded corners; often, immediately below the top there is a high drawer concealed in a tulip cornice. In the nest behind the fall front, the small drawers and compartments are underscored by inlaid fillets and other ornament. The lower part often has two hinged doors. The lower transom, which is also decorated, either rests on short feet or sits directly on the floor. The keyhole is usually surrounded by inlay decoration.

Cylinder desks, rare in this period, retain their traditional form (see pages 87 and 108). The cylinder top is usually solid wood and, like the drawers, is decorated with a large inlay motif. The whole is supported by straight spindle legs.

Bonheurs-du-jour become lighter but retain the basic structure of their Empire antecedents.

Low armoires and corner cupboards

The doors of low armoires and corner cupboards (which can have curved or flat fronts) are decorated with light fillets or other inlay motifs. Their tops, which project slightly, are marble. Their bases, which also project slightly, usually sit directly on the floor.

Commodes and chiffoniers

Commodes, rectangular and massive, retain the lines of their Empire antecedents (see page 110) but lack bronze fittings and only rarely have column or pilaster corner treatments. The many drawers are inlaid with *rinceaux* and — around the keyholes — rosettes. The gilt bronze rosette or wreath knobs are small. The upper drawer, less high than the other drawers and sometimes slightly flared in a tulip profile, resembles a frieze or cornice. The simplest examples are decorated with dark inlaid fillets.

These commodes rest on full socle bases or on short, thick feet. Their tops are of gray, white, or black marble.

The drawers of **commodes à l'anglaise** are hidden by two decorated hinged doors. The structure of these pieces resembles that of the classic commode.

Chiffoniers or **semainiers** resemble their Empire antecedents (see page 110), from which they are distinguishable only by their materials (blond wood with dark wood inlay).

Seating

Restoration chairs are graceful, charming, and easy to move but sturdy. The backs of chairs and settees are arched, adding a new softness to lines inherited from the Empire and the Directoire.

In early chairs from the period, *backs* are flat, but they soon become coved. Gondola backs were still favored; their upper rails are continuously curved or gently arched, incorporating facing volutes.

The forms of *seats* proper match those of the backs; they can be square, rectangular, or slightly rounded.

The *legs* have various forms that figure in seating of all types. They are:
- straight or slightly out-turned forelegs, the back legs being given a pronounced outward flare;
- spindle or baluster forelegs with back legs that are square in section and usually straight;
- flared console forelegs with *cuisses de grenouille* — "frog thighs," backward scrolls with pendant tongue fronts — at the top (see opposite).

Inlaid *ornament*, sometimes framed by fillets, was placed at the top of the back and on the front rail of the seat. A wide variety of motifs were used.

Springs were incorporated into the upholstery of many pieces. Fashionable *coverings* were horsehair fabric, satin, smooth or embossed velvet, tapestry with large floral sprays, and raw silk or other dark materials decorated with brightly colored foliage.

Base of cabinet with hinged doors

Gondola back with arched top rail

Frieze drawer with tulip profile

Gondola back

Spindle legs

Frog-thigh legs

Saber legs

Seating

Sofa

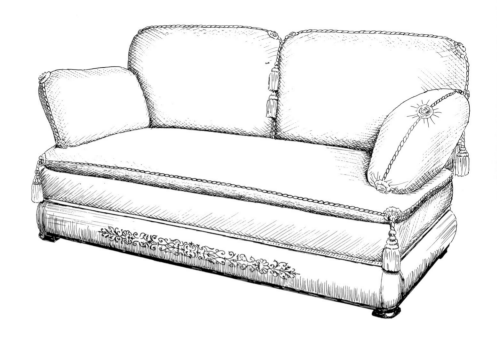

Settee with chapeau de gendarme *back*

Méridiennes and **settees** were produced in a wide variety of formats.

Restoration *méridiennes* are distinguishable from their Empire antecedents (see page 113) only by their blond wood, their lower seats, and, above all, their ornament.

The small Restoration settees known as *causeuses* (from *causer*, "to chat") and *dormeuses* (from *dormir*, "to sleep") derivatives of the *méridienne*, likewise have sides and backs of unequal height. but these are coved.

Baigneuses (from *baigner*, "to bathe") have continuously curving backs and sides, one of which dips so low that its upper rail merges with the side rail.

The most characteristic Restoration *settees* have straight backs and gently flared arms that culminate in volutes or dolphins. They have four or six legs of the console or baluster type.

The *sofa* is a plushly upholstered banquette with back and side cushions but without exposed upper frame and resting on a sturdy wooden base.

Canapés en chapeau de gendarme (gendarme-cap settees) have gently scrolling arms of equal height and a gently arched back that gives the design its name. These pieces are rather rare.

Canapés en haricot (kidney-bean settees) have arched and curving forms consistent with their name. Large and thickly upholstered, they are extremely rare.

Restoration **armchairs** are varied in design but always harmoniously proportioned. The Voltaire armchair was introduced during this period, but it entered widespread use only under Louis-Philippe.

Straightback armchairs have backs quite close to those of their late Empire antecedents. Their arms, which sometimes have pads, flare outward and terminate in scrolls, swan necks, or dolphins.

Gondola armchairs were quite fashionable. Their coved backs, low and arched, curve gently forward; their arms, continuous with the back, have front posts (not really supports) that curve downward to join the seat rail, sometimes terminating in volutes. Occasionally the arms are open, but they never interrupt the continuous line of the back.

Voltaire armchairs have high upholstered backs with a forward bulge just below shoulder level that makes them extremely comfortable. The arms, which have large pads, have swan or volute supports.

Restoration *bergères*, which have a thick separate seat cushion, are rather heavy. In both their form and their inlaid ornament, they resemble larger versions of Restoration gondola armchairs.

Blond wood and its *ébénistes*

Archival records indicate that it was the dealer Weber, simultaneously a decorator, a draper, and an ébéniste, who initiated the fashion for blond woods, not the duchesse de Berry, as has often been claimed. In 1824, the duchesse indeed used blond furniture in the remodeling of her apartments in the Pavillon de Marsan of the Louvre, but the vogue for such pieces dates from as early as 1819.

Some great ébénistes worked in this period, developing their artistic skill to its apogee; the precision and care of their work could not be bettered: cases, facings, and interiors are all marvelously executed.

Greatly influenced by English furniture, which strove above all for comfort, craftsmen produced much metamorphic furniture adaptable to various uses.

Jacob-Desmalter was an exceptional craftsman. The Bellangé clan possessed infallible taste, as did Jeanselme, Bigot, Benard, Le Sage, Lemarchand, and Durand.

Seating

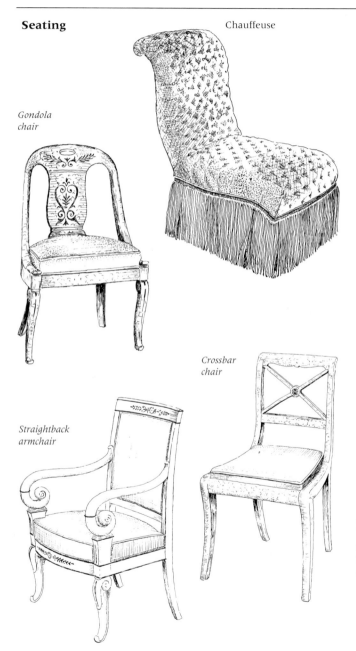

Chauffeuse

Gondola
chair

Crossbar
chair

Straightback
armchair

Armchairs with pierced-splat backs from this period are somewhat rare, but those that survive are quite charming, featuring hearts, lyres, vases, or open fans.

Restoration **chairs** evolved in much the same way as contemporary armchairs.

Chairs with backs that are straight or slightly curved proliferated in the early Restoration period. Light and elegant, they still exert considerable appeal.

Gondola chairs were quite common. Their arched backs, pierced by two large openings, curve gracefully downward to merge with the side rails of the seat.

Chairs with pierced backs retain the gondola silhouette but feature pierced lyres, fans, shells, vases, half-circles, or crossbars. The top rail of the back is sometimes shaped or turned so as to make it easier to grip.

The *chauffeuse* (from *chauffer*, "to warm") has a low seat and a high, upholstered, and scrolling back whose profile resembles that of the Voltaire armchair.

Restoration *desk chairs* have round seats that pivot on a tripod base. Their backs have arched upper rails or transoms supported either by a pierced motif or by two posts.

Stools, still quite popular, become lighter. They have rectangular seats, curule supports, and, quite often, lion-paw feet or ball feet made of dark wood.

Note: Some Restoration stools have scrolling arms that make them resemble curule chairs. These pieces are quite elegant.

Restoration Silverplate

Sugar bowl

Platter and warmer

Coffee pitcher

Large cup

*Wine cooler in the form of
the Medici vase*

Teapot

Salt cellar

The Louis-Philippe Style
1830-1848

THIS STYLE, devised for a busy but coddled bourgeoisie, sought both to satisfy their desire for comfort and to give them a sense of social legitimacy. Interior decors began to manifest a trait that would prove long-lived, a systematic avoidance of anything that seemed modern. New furniture was disguised in strange ornament inspired successively by the Gothic period, Islam, and China, just as Romantic poets dressed up their heroes and heroines in oriental veils and medieval armor, or certain of Balzac's characters appropriated venerable names and titles.

This attitude was to sterilize creativity in furniture production for more than half a century. The Louis-Philippe style, then, was less preoccupied with originality than it was with comfort and new techniques of production. Above all, it sought to reconcile large-scale production, in some respects already machine-assisted, even quasi-industrial, with the qualities associated with the great French craft traditions. This is why Louis-Philippe furniture was less expensive than, yet made with just as much care as, furniture from preceding periods. And, despite their neo-Gothic and "Chinese" excesses, these pieces make comfort a priority, for newly rich bankers and industrialists wanted to make things easy for themselves and

had a practical bent. The less wealthy members of this new social class lived in small apartments built in a modern spirit of real estate speculation. Such dwellings needed furniture designed for their small rooms; many of the resulting pieces are well suited to today's apartments.

Finally, although Louis-Philippe furniture often represents only a bastardization of past styles based, in some instances, on dubious archival sources and adapted to the exigencies of machine-assisted production, the knickknacks, decorative objects, and other accessories from the period tend to be quite rich and inventive.

The Romantic era, at its height in the 1830s, was marked by a thousand and one evocative and touching details: fans recalling the night of a ball, dried flowers associated with the first stirrings of love, handkerchiefs bearing the traces of passionate tears. It is as though a certain intensity of affective life, often bordering on the maudlin, were mutely contending, in the dark townhouse of Père Grandet and in the apartment of César Birotteau, with the passionate materialism of parvenus feverishly implementing the banker Lafitte's order to "get rich."

The furniture

The Louis-Philippe style is not original but, rather, an extension of the Restoration style, whose basic structures it retains while dispensing with their elegance and refinement. Forms grow heavy, ornament becomes formulaic, and inspiration, disordered, draws its themes first from the Middle Ages, then, toward the end of the period, from the Renaissance. The tendency toward pastiche heralds the Second Empire style that would follow.

However, some pieces with fashionable forms have more refined ornament:
• pieces with light wood inlay decoration set into dark wood;
• dark pieces decorated with naturalistic flowers and heightened with discreet mother-of-pearl inlays;
• pieces in a medievalizing style more extreme and elaborate than that of the preceding period.

Materials and techniques. Dark woods replaced the blond ones favored in Restoration furniture.

Producers strove for a rapid pace of execution facilitated by machine tools, which were then entering widespread use (between 1830 and 1870, more technical advances were introduced than in the preceding four hundred years of artisan production). Bronze fittings and marquetry work, which considerably increased production expenses, were eliminated. However, despite the paucity of formal invention, craftsmen still took pride in quality workmanship, selecting woods with great care as well as assembling and finishing their pieces by hand.

Dark and warm *woods* are fashionable: mahogany, palisander, and ebony as well as yew, walnut, and beech.
Blond woods such as sycamore, burled elm, citronnier, and maple are favored for the interior veneers of certain pieces.

Brass fittings are rare, but keyholes are sometimes surrounded by copper inlay ornament.

Marble tops are gray, black, or white and have subtly molded cyma fore-edges.

Advances in *turning and shaping* technology make it possible to produce spherical, cylindrical, and shaped elements with relative ease.

Inlay work is rather rare, but floral bouquets painted on dark wood sometimes have mother-of-pearl accents, and light-wood fillets occasionally decorate mahogany pieces.

The Wasp

Claude-Aimé Chenavard (1798–1838), nicknamed "the Wasp" by Balzac because of the way he "sucked up" treasures from the print room of the Bibliothèque Nationale, was the great ornamentist of the period. Director of the Sèvres porcelain manufactory, he influenced artistic production of all kinds. Collecting ornamental motifs from every period and style, he assembled them into overloaded compositions heedless of their original context and scale. His Recueil d'ornements *(album of ornament) was widely disseminated, providing inspiration to craftsmen of all kinds.*

Note: Sèvres plaques, copper and pewter inlay in the Boulle manner (see page 25), and bronze fittings analogous to eighteenth-century examples are sometimes used, but only on luxury pieces destined for a wealthy clientele; these latter were executed by the great *ébénistes* of the period, who looked to analogous work from earlier periods for inspiration.

Ornament

Machine-assisted production methods entailed an impoverishment of the decorative vocabulary, and they also led to a pervasive dryness and impersonality.

Moldings virtually disappear; panels become flat and lack moldings; support posts, straight and smooth, are bare of ornament and their corners are rounded.

Machines can now carve notches, wide and deep cyma moldings, double and triple torus moldings, spiral legs, knob legs, and large gadroons.

Decorative motifs are few. Fillets in low relief underscore volutes.

Large-leaf foliage and palmettes are carved on chair arms and table legs.

The "frog's leg" motif is characteristic, often figuring on the legs of Louis-Philippe chairs, settees, and case furniture.

Beds

Louis-Philippe beds, accorded considerable prominence in decorative schemes of the period, resemble Restoration beds but are heavier and more massive. Some have canopies, others do not.

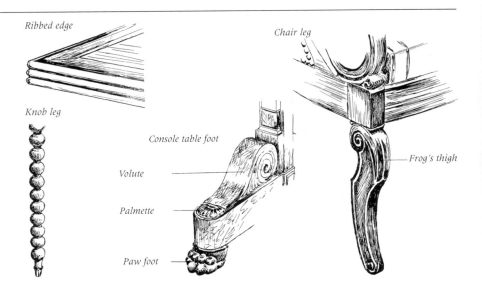

Ribbed edge

Knob leg

Chair leg

Console table foot

Volute

Palmette

Paw foot

Frog's thigh

Boat bed

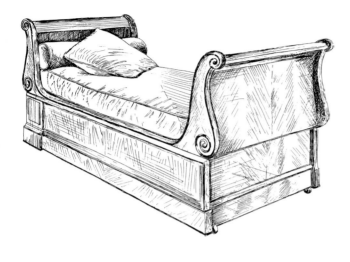

Gueridon

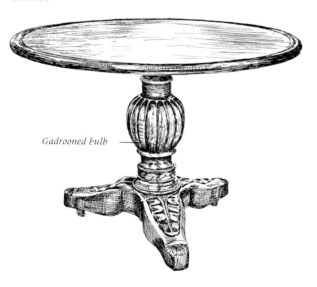

Gadrooned bulb

Boat beds *(lits bateaux)*, still in favor, retain the structure of their Restoration antecedents (see page 118). The end boards still scroll outward but are a bit stiffer and more clearly differentiated from the base, which is higher than in Restoration examples. Sometimes these beds rest directly on the floor, but they can also be raised on short, heavy feet.

Beds with straight end boards have pilaster or column end posts surmounted by a sphere. The bases, rather high, are linked to the posts of the end boards by volute panels that soften the lines.

Tables

Louis-Philippe tables are many and various; they retain the basic structure of their Empire and Restoration antecedents, from which they can be distinguished only by their materials, their turned and shaped elements, and the ornament.

Gueridons proliferate in the period, when they were produced in all sizes. The tops, round or oval and sometimes festooned with a groove, are made of wood or marble.

The central supports of turned wood can be of the baluster type or feature a swollen bulb in the middle, sometimes smooth and sometimes gadrooned. The tri- or quadripod stands terminate in lion paws or volute consoles decorated with broad acanthus leaves.

Note: Regardless of their shape, most small gueridons have tilt tops.

Dining-room tables are rectangular or round and almost always have end leaves. They are supported by four or six turned legs mounted on rollers.

Gaming tables proliferated. Their wooden rectangular tops, which often open into square ones, have ribbed edges and green velvet insets. Their four turned legs, usually on rollers, are baluster or knobbed and sometimes fluted.

Note: A few demi-lune gaming tables survive from this period.

Small salon tables, rectangular or square, have ribbed edges and drop leaves. They have console, baluster, or knobbed legs.

Worktables and sewing tables have hinged double tops that open to reveal a storage compartment below. Their four legs, mounted on rollers, are usually knobbed.

Dumbwaiters, known as *tables servantes* in French but modeled after the English type, have two shelves of different sizes supported by a central baluster support rising from a tripod base with volute or lion-paw feet.

Night tables are cylindrical cases with marble tops and a hinged door. Their plinth bases rest directly on the floor.

Dressing tables, mounted with oval mirrors in mahogany frames, have white marble tops. In general form, they resemble console tables with straight, console, or curule legs.

Louis-Philippe *shaving stands* differ markedly from their Empire antecedents. A high shaft, columnar or baluster in form, rises from a tripod base on rollers to support a small round top surmounted by a pivoting mirror just below face level.

Note: Tidies, plant stands, small reading tables, and whatnots (étagères) were produced in the same materials and styles.

Night table

Consoles

Console tables become simpler, consisting of a rectangular marble top supported by two wide volute legs resting on a thick socle. Typically, the frieze contains a drawer.

Desks

Flat-top writing tables (bureaux plats), rectangular in form, have a set-back row of small drawers on the top. The friezes also have drawers, and the straight legs are baluster or knob.

Minister's desks have two banks of drawers flanking the kneehole, and the rectangular tops can be enlarged, thanks to two slides. They have straight turned legs.

Cylinder desks were still made, but they are cumbersome. The stacked drawers flanking the kneehole either extend to the floor or are supported by two groups of four legs. Some Louis-Philippe cylinder desks are surmounted by a bookcase.

Slope-top desks, out of favor since the Empire, now reappear. They are often surmounted by a small cupboard, and the legs can be either straight or curved.

Drop-front secretaries (secrétaire à abattant) are quite popular. The gray or black marble tops have cyma edges and rounded corners. The upper drawer is slightly convex; the support posts are straight and plain, and the corners are rounded.

The interior nests of small drawers and compartments are often made of blond wood.

The lower parts have three drawers

Gaming table

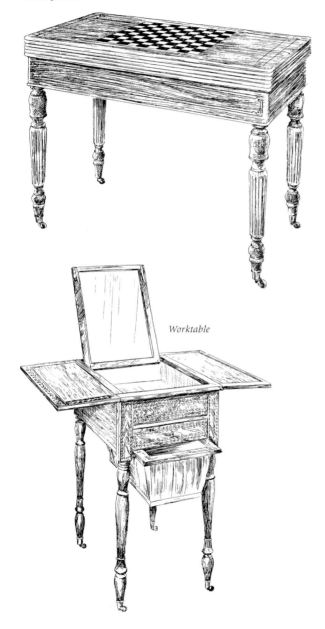

Censole table

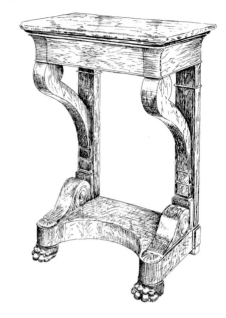

Worktable

Small salon table

resting on ball or paw feet.

In some instances, the drawer above the fall-front is flat rather than convex.

Louis-Philippe **bonheurs-du-jour** have two parts. The upper one is set back slightly by comparison with the lower one, which has either three drawers or two hinged doors.

Writing stands, light and portable, are a period innovation. Small slope-top desks, they have sliding panels that can protect the user from the heat of a fireplace — or from prying looks.

Armoires

These wardrobes were quite fashionable under Louis-Philippe, becoming essential furnishings in every bedroom. They are tall and wide and rest on ball feet; the hinged doors are fitted with mirrors. Quite often, a drawer is disguised by a molding on the base that echoes the molding of the cornice.

Bookcases

These pieces are treated much like contemporary armoires, but the upper two-thirds of the hinged doors are glazed.

Commodes and chiffoniers

Furniture-makers of the period were quite imaginative when it came to commodes. While retaining the structure of the classic commode, they sometimes added a dressing table or drop-front desk unit to the top.

The **classic Louis-Philippe commode** is massive, an impression reinforced by its

Toilette-commode

Desk-commode

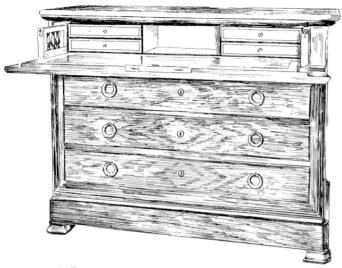

Dessert buffet

total lack of bronze fittings (present under the Empire) and inlay decoration (present under the Restoration). Its fronts and sides are flat; its low feet take the form of buns, paws, or thick volutes.

Usually, these pieces have three or four drawers; sometimes the top drawer has a cyma profile.

In Louis-Philippe **English commodes** (*commodes à l'anglaise* or *à vantaux*), the drawers are hidden behind two undecorated hinged doors.

The **commode-toilette** resembles the typical commode of the period, but its top lifts to reveal a mirror, a basin, a water pitcher, and toiletry vials.

The **desk-commode** has a high upper drawer whose fall-front opens to become a writing surface covered in leather or fabric; there is also a nest of small drawers and storage compartments at the rear of the drawer.

Chiffoniers or **semainiers**, high and narrow, have seven or eight superimposed drawers. Assertively vertical, their corners are rounded and they rest on bun or paw feet.

Buffets

These pieces resemble commodes with hinged doors but have no drawers.

Dessert buffets, which can be broad or narrow, are surmounted by shelf units with volute or pierced supports.

Psyché mirrors

Adhering to the same formula current under the Restoration (see page 121), they remain fashionable despite the proliferation of mirrored wardrobes, which lessened the demand for them.

Seating

Louis-Philippe chairs and settees are comfortable and solid. They tend to be massive, but their rounded corners prevent them from seeming severe.

Chair backs may be:
• straight and rectangular with a slightly coved top rail; or
• of the gondola type.

Seats proper are rectangular or semicircular.

Legs are often fitted with rollers.
• Forelegs are of the console type with "frog thigh" capitals; straight; turned, with or without fluting.
•Back legs are square in section and flare outward *(en sabre).*

Coverings of the seats, which were stuffed with horsehair or upholstered with springs, varied considerably. Among the most fashionable were black horsehair, printed or solid silk, velvet in solid colors or embossed with a geometric pattern, and tapestry decorated with bouquets of flowers, used either alone or in alternating bands with velvet.

Armchairs were numerous in Louis-Philippe salons.

Straightback armchairs have backs that are basically flat but slightly coved in the center.
• The arms are square in section and terminate in volute console supports; or
•They are round in section and trace serpentine curves culminating in volute supports that rest on podia aligned with the forelegs and are decorated with palmettes.

Gondola armchairs were made in large numbers. Like their Restoration antecedents, they have slightly inclined arched backs that are continuous with the arms.

Voltaire armchairs, introduced under the Restoration, become more widespread. They retain the in-curving backs of the early versions, but their swan or volute arm supports are now replaced by simple consoles.

Crapauds (literally, "toads"), a novelty of the period, are completely upholstered, with no portion of the frame being left visible. Their gondola backs have rounded tops, and their legs are hidden by a thick fringe.

The *high-back armchair* was also introduced during this period. The top rail of its back is arched and shaped to facilitate gripping. Its seat is deep and wide, and its padded arms have sinuous, discreetly carved supports continuous with the forelegs, which are slightly curved.

The Louis-Philippe *bergère* is a variant of the classic or gondola armchair; its full arms and duvet cushion make it extremely comfortable.

Chairs from the period are various and attractive. The primary distinguishing trait of the various types is their back treatment, which can be:
• straight;
• basically straight, but with a slightly coved top rail;
• gondola.

Crapaud *armchair*

Straightback armchair

Ladder-back chair
(chaise à barreaux)

Gondola chair with crossbar back

Settee

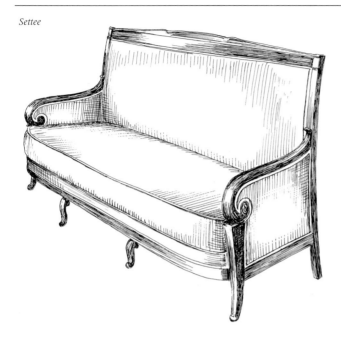

These backs, rarely upholstered, usually have openwork crossbars, ladder slats, or arch designs. Gondola backs sometimes have a flat vertical slat in the center linking that top rail to the seat.

The top rail, whatever its form, sometimes has a grip hole or a shaped grip.

The back legs flare outward *(en sabre)*. The forelegs, which sometimes have turned feet, can be

•straight baluster legs with a collar;
•slightly curved, with or without "frog thigh" capitals.

The *chauffeuse,* very low but with a high upholstered back, has legs like those of other Louis-Philippe chairs.

Note: A variant of the *chauffeuse* without visible frame elements, and thus similar to the *crapaud,* was also produced in this period.

Stools, with X-frames, are heavier and bare of ornament. Less popular than in preceding periods, this type began to disappear.

Settees and **méridiennes** were prominent under Louis-Philippe, figuring in every salon. Produced in every conceivable size, if found today they can be readily integrated into contemporary interiors.

The *classic settee* of the period seats three or four and resembles a widened straightback chair. The top of the back can be straight, serpentine, or broken into three arches.

Louis-Philippe *méridiennes* retain the basic form of their Restoration antecedents but have no inlay decoration. Their feet, rather heavy, are large volutes.

Medievalism

The Cathedral style, which first emerged in delicate Restoration designs, remained current under Louis-Philippe but in a less attractive form. Ébénistes produced pieces made choppy and ponderous by an excess of detail drawn from past styles. This awkward tendency was also taken up by goldsmiths, ceramists, and jewelers. The Cathedral style was followed by fashions for the decorative vocabularies of the Renaissance, Louis XIII, and Louis XIV periods.

The baronne de Rothschild took great pride in her Gothic-Renaissance gallery, as did the writer Eugène Sue in his "Louis XIII" dining room and Marie d'Orléans, daughter of Louis-Philippe, in her "Renaissance" salon. This eclecticism, which prevailed in aristocratic and bourgeois homes, stifled genuine creativity, but it prevailed in decorative-arts production until the end of the century.

Ceramics

Opaline glass

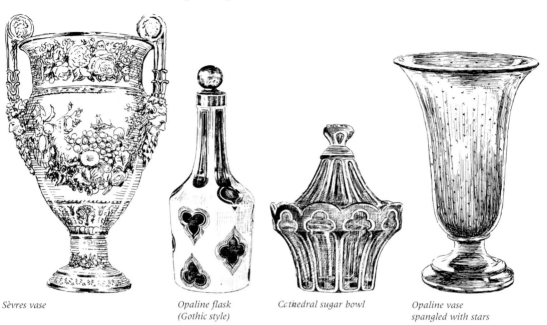

Sèvres vase

*Opaline flask
(Gothic style)*

Cathedral sugar bowl

*Opaline vase
spangled with stars*

Silver

Mother-of-pearl

Teapot

Coffeepot

Perfume case

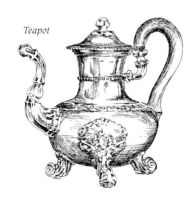

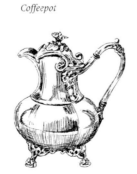

The Second Empire Style
1848-1870

THE SECOND EMPIRE STYLE is a most peculiar phenomenon. None of its materials, forms, or ornamental motifs are characteristic of it in the conventional sense, for all were borrowed from preceding styles, to such an extent that, in many cases, the results could be described as literal copies. And yet, despite this seeming lack of originality, it has its own distinct personality.

Instead of drawing inspiration from a single period, Second Empire furniture-makers, drapers, and decorators drew indiscriminately, with joyous enthusiasm, from all sources. During the twenty-year reign of Napoleon III, Gothic, Renaissance, Louis XV, Louis XVI, English Regency, Chinese, and Japanese models were all fashionable, not successively but more or less simultaneously. The result was a rich, teeming eclecticism that, while sometimes ridiculous, has considerable historicist charm and even inventive appeal.

The style is a rather precise reflection of a feverish period regarded by many contemporaries as the triumph of science, of industry, and even of Western civilization generally. Europe began to treat the rest of the planet as a reservoir of potential colonies. The piercing of the Suez Canal was thought to signify the preeminence of the white man and his commercial needs. The positivist philosophy of Auguste Comte proclaimed the methodical supremacy of reason. The architectural and archaeological research of Viollet-le-Duc had as its ambition the glorification of Christianity.

In England, the reign of Queen Victoria was also considered that of good conscience. In America, the victory of the abolitionists after the long Civil War was likewise understood as a triumph of morality and justice.

As the industrial era unfurled its riches, happiness seemed to be within reach. An entire society danced furiously to the music of Offenbach and laughed uproariously at the comedies of Labiche. Mérimée organized sumptuous entertainments for the court that, while sometimes refined, more often courted vulgarity.

Other artists did not fare so well in this frivolous culture. Flaubert was convicted of obscenity, as was Baudelaire, who died all but unknown. The early work of Claude Monet and the other Impressionists was regarded as scandalous.

Under the supervision of Baron Haussmann, great swaths of Paris were ripped to pieces and the entire city was swept up in a wave of real estate speculation the likes of which it had never seen. Within a few years, Paris had been completely transformed. The furniture-makers of the faubourg Saint-Antoine as well as a few great *ébénistes* made their fortunes furnishing all of the new townhouses and apartments. But they had little time for creative experimentation. So they opted for abundance, piecing together pell-mell furniture of the most heteroclite character imaginable. And yet, without realizing it, they created a style.

ABROAD
England:
the Victorian style
Italy:
the Ottocento and
neo-Gothic styles
Spain:
the end of Isabellin

The furniture

*I know that fruit
falls when shaken
by the wind,
That birds lose their
feathers and flowers
their perfume;
That creation is
a great wheel
Which cannot
move without
crushing someone.*

— VICTOR HUGO

The proliferation of forms, the nonstop imitation of earlier styles, and the incessant development of small pieces intended to satisfy new needs makes an exhaustive survey of Second Empire furniture impossible. Instead, we will describe a few of the most characteristic and popular types.

Initially, it should be noted that little furniture from the period escaped its three most prevalent historicist influences, which are sometimes kept distinct and sometimes combined: the Renaissance, Louis XV (rococo), and Louis XVI styles. The first two were handled rather freely, but the third, thanks in large part to the patronage of Empress Eugénie, who virtually made a cult of Marie-Antoinette, manifested itself in outright pastiches of Louis XVI furniture: the Louis XVI–Empress style.

Materials and techniques. Second Empire *ébénistes* scarcely innovated in these two domains; instead, they consolidated two tendencies introduced in the preceding period: the use of dark woods, and the perfection of machine-assisted production methods.

Woods. Most of the woods previously associated with French luxury furniture were used during this period, but some were more favored than others. Ebony was used for pieces in the Renaissance and Louis XV styles as well as in imitation Boulle marquetry. Pitchpine, a yellow wood with reddish veins that was now being imported from North America in large quantities, was the cheapest of exotic woods; blackened pearwood, walnut, tulipwood, and purple wood were also much appreciated. The fashion was especially long-lived for wood coated with black lacquer, or blackened wood, which was used for small pieces with inlaid or painted decoration.

Papier-mâché. This material, invented and made fashionable by the English at the beginning of the century, was used in France beginning in 1850. As it consists of paper paste with a strong glue binder, it was shaped not by carving or cutting but by molding, which made it compatible with proto-industrial production technologies. Often inset with mother-of-pearl, it was used for seating, gueridons, and other small pieces. But it was fragile, which explains the rarity of such pieces today.

Cuir bouilli (leather that has been softened in boiling water, molded or shaped, and then dried) was used much like papier mâché.

Gilt bronze. The new process of galvanoplasty greatly lowered production costs, with the result that gilt bronze was now used not only as ornament but for frame and case elements (tables, bookcases, beds, etc.). It was often made to resemble bamboo.

Cast iron. This industrial material, which could now be produced quite cheaply, began to appear in furniture. It was used in large formal pieces and, especially, in settees, beds, and gueridon stands.

Ornament

Gueridon with
American Indian
support stand

Imitation Boulle marquetry

Blackamoor
torchère

Polychrome panel

Lacquer tabletop

Ornament

Sèvres porcelain medallion with gilt bronze surround

Imitation cord leg

Imitation bamboo leg

The Louis XVI–Empress style

A native of Germany, Guillaume (or Wilhelm) Grohé settled in France in 1827; he first came to the attention of collectors at the 1834 exposition of French industrial products, where he showed well-crafted furniture of startling eclecticism: mahogany pieces with Gothic inlay designs, neo-Renaissance pieces, and elaborately carved neo-Egyptian pieces. Princess Marie d'Orléans became an enthusiastic client, and Louis-Philippe later acquired some of his neo-Renaissance furniture. But it was during the Second Empire that Grohé became truly famous, as a result of his remarkable imitation Louis XVI work for Empress Eugénie, who was fond of this style and commissioned many pieces in it for the imperial palaces. It was thanks to Grohé that the Louis XVI–Empress style became quite popular, finding its way into many sumptuous interiors.

Techniques. The use of machine tools became widespread in all areas of furniture craft: moldings, veneers, turning, marquetry, etc.

Many components were produced serially in standard formats (support posts, legs, aprons, tops, ornament). Nonetheless, a high level of overall quality was maintained. In addition, a few *ébénistes*, suppliers to the court, maintained the French craft traditions of luxury production. Guillaume Grohé and his brother Jean-Michel as well as Henri Fourdinois, Maxime Charon, Alphonse Giroux, and Jeanselme are among those whose work was most prized.

Ornament

Second Empire ornament, rich and often exuberant, takes many forms and exploits a wide array of materials and techniques: gilt-bronze fittings; copper, pewter, ivory, and mother-of-pearl inlay; carved and gilded wood; applied porcelain plaques; painting on wood; panels of lacquered wood, etc. Only marquetry was relatively out of favor, and it, too, figures on some pieces.

Motifs were drawn from the Renaissance, Louis XV, and Louis XVI styles then so fashionable, but imagery evocative of the Far East, Africa, and Native Americans was also prevalent. Sometimes the quest for fidelity to old models was taken to extreme lengths, as in Louis XVI–Empress pieces.

The decorative vocabulary, then, was quite varied: arabesques for imitation Boulle marquetry; bouquets of flowers (roses and wildflowers) on Louis XVI–Empress pieces; birds, pagodas, fret designs, and figures in oriental pieces, etc.

Doubtless the most original motifs of the period are:
• black caryatids used as legs and support stands on low tables and gueridons;
• neo-rococo porcelain medallions with gilt bronze surrounds;
• imitation cord and bamboo used for seating frames.

Beds

Usually made of ebony, dark wood, or cast iron, these pieces are heavy and imposing. Most have straight or scrolling end boards, with the headboard much higher than the footboard. Their legs, turned or carved, are low. Their ornament is often inspired by Boulle, Louis XV (rococo), and Empire models.

Many neo-Renaissance beds were also produced; made of wild walnut or oak, they have heavy baldaquins supported by serpentine columns or caryatids.

Tables, gueridons, consoles

Large dining-room tables from the period tend to be uninteresting: faithful copies of round Louis XVI or English Regency tables, or, more rarely, of Italian Renaissance *cartibulae*.

On the other hand, there was a marked predilection in the Second Empire period for small multipurpose tables, notably gueridons and consoles.

Most of these pieces were made of blackened wood with polychrome decoration (usually flowers, occasionally chinoiserie designs or Renaissance *rinceaux*).

Some Second Empire table types should be singled out.

Worktables from the period are more like work stands, consisting of a rectangular coffer with a hinged top, decorated with painted or inlay designs, supported by four high, extremely curved legs, often with a stretcher shelf.

Cast-iron bed

This technique was used to produce pieces with extravagant ornament, often inspired by English or Italian rococo models.

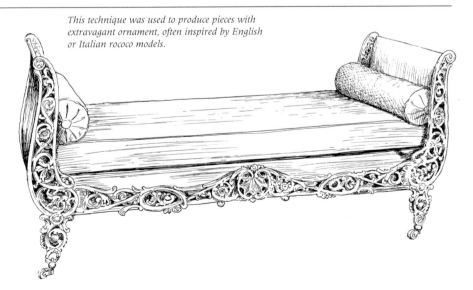

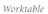

Nesting tables

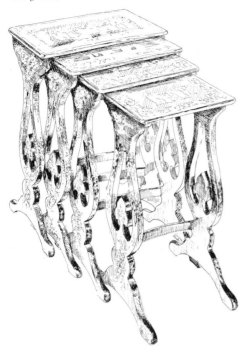

Worktable

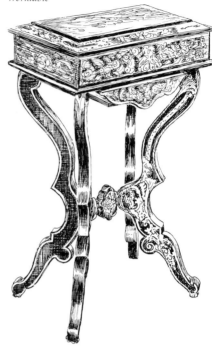

Tilt-top table: top

Tilt-top table: tripod stand

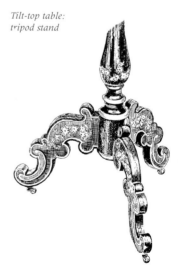

*Originality is a new way of expressing things that
have already been said.* — ABBALAT

*Drop-leaf
night table*

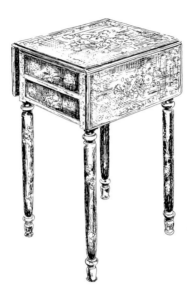

*Three-shelf
gueridon
with imitation
bamboo frame
made of gilt bronze*

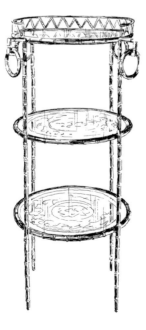

The ***tilt-top table*** has a round or rectangular top, often edged in copper, that is fixed to a delicate tripod stand on which it can pivot into an upright position. These pieces are always richly decorated with inlay or painted ornament.

Nesting tables, whose legs have one or two stretchers, fit into one another for compact storage. They were generally made in sets of four in this period, but ensembles of three or five were also produced.

Their rectangular tops are sometimes identical and sometimes decorated with variations on the same theme: most often, a large medallion surrounded by garlands.

Gaming tables began to resemble today's bridge tables. Their tops, which fold onto themselves down the middle, are rectangular or square and covered with felt, save for a strip around the edge decorated with inlay or painted bouquets.

Their friezes are high and richly decorated, and their legs are Louis XV or Louis XVI.

Gueridons. There are two especially characteristic Second Empire types:
• caryatid gueridons, supported by heavy figures of carved wood (gilt or polychrome), usually an American Indian or a blackamoor who kneels or bends over;
• "bamboo" gueridons, small high tables with four bronze legs fashioned to resemble stalks of bamboo. They have one or more shelves, made of engraved glass or inlaid wood, with bronze edges that resemble bamboo, and their feet can be delicate or gnarled.

Gueridons made of dark wood or inlaid papier-mâché, with round or rectangular tops, were also produced in the period.

The most remarkable Second Empire **consoles** are rather heavy, consisting of long and shallow tops resting on caryatids. Some examples are made entirely of gilt bronze, others of painted cast iron.

Dressing tables from the period tend to be quite ornate, decorated with inlay designs, paintings, or porcelain plaques. The mirrors have carved supports and occasionally culminate in a pediment.

Second Empire **night tables** have spindle or turned legs and are high; they have one drawer, two drawers, or a small storage compartment. Their tops are decorated with inlay work or motifs painted in lacquer. Some examples have one or two drop leaves.

Desks and secretaries

Large desks proliferated in the period but are not very original, being greatly indebted to the Empire models that first made them fashionable. But as storage options had become a higher priority, they have more drawers and compartments than their antecedents.

More interesting are the small "lady's desks" modeled after Louis XV *bonheurs-du-jour,* which always have refined ornament. Bronze imitation bamboo, mother-of-pearl inlay, porcelain plaques, and even pewter inlay are used to decorate the tops, friezes, and compartments, which are sometimes quite numerous. Other small desks, painted or lacquered, were also produced in the Louis XVI–Empress style.

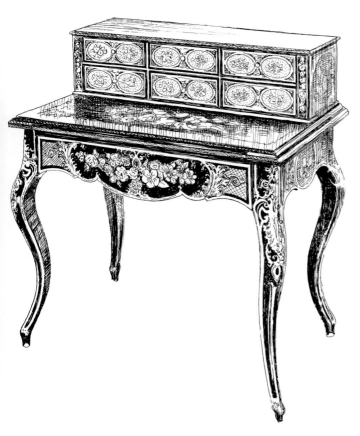

Lady's desk in the Louis XVI style

Bookcase

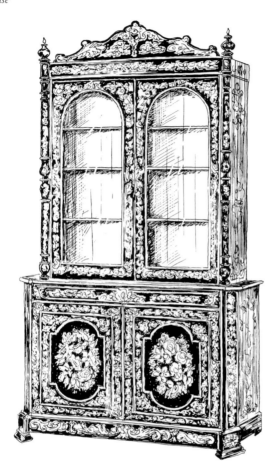

Second Empire *secretaries* all derive from their Louis XVI fall-front antecedents. General forms and interior arrangements change little, but ornament becomes much more prominent: they often have projecting moldings at the top and bottom as well as heavy gilt-bronze fittings. Some examples feature small openwork shelves.

Commodes

Most Second Empire commodes are modeled after Boulle (see page 31) or Louis XVI examples, but a few are more original. Rather high (43–45 inches), these pieces are made of ebony or lacquered wood and have marble tops. Their two hinged doors, richly decorated with inlay and bronze fittings, open to reveal three or four drawers. They have wide straight or bun feet, and their corner supports are richly ornamented.

Armoires

High and narrow, surmounted by large broken pediments, Second Empire armoires often have only a single door fitted with an oval or rectangular mirror. By and large, they are unremarkable, for craftsmen of the period were not interested in this furniture type. Often made of blackened wood with painted or inlaid ornament, they have ball feet and their bases have no drawers.

Bookcases

Although little different from Louis-Philippe examples, bookcases proliferated in the period. Designs in the neo-

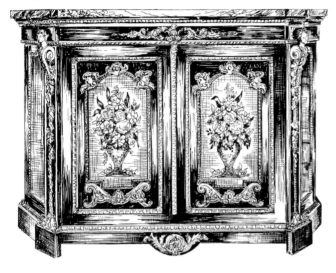

Low cupboard in the Louis XVI style

Gothic Cathedral style remained quite popular, but a new type also made its appearance. Two-part affairs made of blackened wood, their lower parts are closed while their upper parts have two or three glazed doors (sometimes fitted with metal grilles). The ornament (moldings, bronze fittings, inlay and painted designs) is rich and quite heavy.

Low cabinets

Low cabinets were very common. Descendants of the commode and the low buffet, they are often formal pieces intended for reception rooms (entry halls, salons). They are richly decorated, often in the Boulle (see page 25) or Louis XVI style. The decoration of the doors is especially rich.

Buffets

These pieces were rare in luxurious houses of the period, where they were gradually replaced by sideboards and console tables. On the other hand, "Henri II" buffets, as they were called (see page 15), often figured in bourgeois households; they would remain fashionable almost until the end of the century. Serially produced (in oak rather than walnut), their high-relief carved ornament is especially heavy and emphatic.

Drapers were crucial

We are astonished to see how furniture was mixed together pell-mell in this period, without any regard for homogeneity. But we should not forget that these disparate pieces were melded together by oceans of damask, chintz, lampas, and Genoa velvet, by imitation textile wallpaper and precious leathers. Carpets and tapestries also played an important role in these decors. Unity was created by drapers, who coordinated the whole and set the tone. Their contribution was crucial to the effect of the Second Empire style.

Cabinets

Neo-Renaissance cabinets (styled after French, Italian, and Spanish models) from the period can be quite handsome. Most of these pieces are quite large and well crafted. In their general lines and

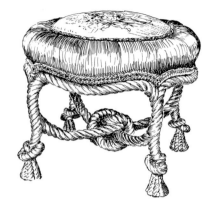

*Pouf (ottoman)
with imitation
cord frame*

*Stool of
Venetian inspiration
with blackamoor
acrobat support*

Rattan furniture

Princess Mathilde initiated this craze with the furniture for her "greenhouse salon" on the rue de Courcelles. Made of plaited and woven rattan, it was ideal for this interior garden — glazed on one side — of palms, flowers, and exotic plants in large vases and planters. Toward the end of the century, the introduction of central heating placed this caprice within the reach of many members of the middle class.

proportions, they are rather faithful to their distant antecedents. By contrast, their ornament is quite eccentric (religious themes, for example, or lacquer plaques of Far Eastern inspiration). Many examples were made of ebony, as opposed to the walnut or oak of authentic Renaissance cabinets.

Seating

Second Empire furniture production was dominated by seating. Never have so many chairs, armchairs, settees, stools, and ottomans of various kinds been produced. Some pieces are straightforward reproductions — of high quality — of Louis XV and Louis XVI pieces. Some *ébénistes,* working for the court and rich dignitaries, specialized in such work, which can still fool collectors.

Note: Around 1860, furniture began to be produced in rattan, but this material only became widely popular later, early in the Third Republic (the 1870s).

Poufs (ottomans) were extremely fashionable. Two types were especially prevalent:
• entirely stuffed, with a skirt hiding the legs;
• with an upholstered seat supported by four short wooden legs, reinforced by an X-stretcher, carved to resemble cord, bamboo, or rockwork.

Stools continued to be made in the traditional X or curule format, but the most prized examples consisted of a large padded seat supported by a carved figure, usually a blackamoor or a mythological figure.

Confidantes and **indiscrets,** often generously upholstered or padded, were introduced under the Second Empire. Occasionally, these pieces have carved and gilded backs and legs.

The Second Empire *confidante,* also known as

Confidante

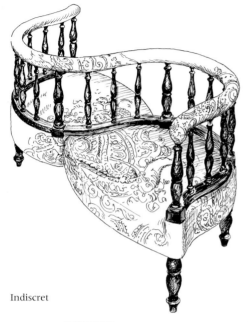

Medallion-back chair

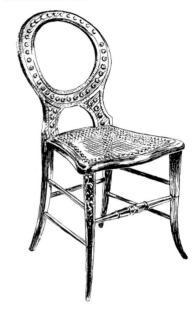

Indiscret

Bamboo chair

Cord chair

Chinese chair (chinoise)

a *vis-à-vis* (to be distinguished from the eighteenth-century design of the same name; see page 79), is a composite design consisting of two armchairs placed side by side but facing in opposite directions and linked by a common serpentine back, whose top rail traces an S. They are not always upholstered.

The *indiscret* (known as a roundabout in English) is an analogous composite design consisting of three contiguous armchairs disposed such that the top rail of the back traces a helix with three arms.

Settees from the period are various. Capable of seating two or three, they were produced in a wide array of styles: Louis XVI, Louis-Philippe, etc. A few were even inspired by *crapaud* armchairs (see page 136).

The *borne* (island seat) is the most characteristic type. Round or oval in plan, it consists of three two-place settees placed against a common triangular core that is sometimes adorned with a decorative sculpture made of bronze, ceramic, or gilded wood. The multiple contiguous backs often have a pronounced outward flair, and the frame is often obscured by the upholstery.

Chairs. It is difficult to isolate characteristic features of Second Empire chairs, save, perhaps, for a preference for thinner chair rails than in previous periods. Nonetheless, a few especially pervasive types should be singled out.

Classic Second Empire *medallion-back chairs* have caned seats supported by four slightly flared legs. Their backs consist of simple medallions supported by two posts.

Bamboo chairs have legs and back supports — usually wood, but occasionally made of patinated bronze — fashioned to resemble bamboo. The seats and backs are rectangular.

Chauffeuse

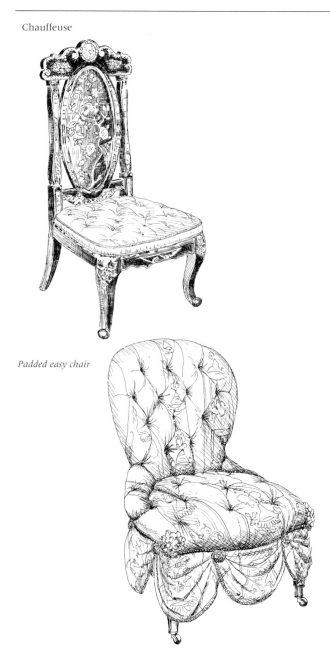

Padded easy chair

Generally speaking, Second Empire *cord chairs* have Louis XV and Louis XVI lines, but the legs, stretchers, chair rails, and backs are of dark or blackened wood that has been carved to resemble plaited and knotted cord. The seats are generally covered with silk.

Chinese chairs, made of blackened wood with mother-of-pearl or ivory inlay, were made in a wide variety of designs. They are most often low and rectangular, but occasionally they are rather high and have Louis XV lines.

Chauffeuses (fireside chairs) have low seats and rather low rectangular backs. They were made of blackened wood, papier-mâché, or gilded wood, and sometimes their frames were fashioned to resemble bamboo. The seats are padded and occasionally have floor-length fringe or tassels around the edges that mask the legs.

Padded easy chairs from the period are likewise low but integrally upholstered (their frames are invisible), and their legs are often hidden by swags of fabric.

Charivari chairs have padded seats and wooden ladder backs with turned struts.

Armchairs. Generally speaking, Second Empire armchairs imitate those of preceding periods, but in some cases they are lower and have set-back arms (to accommodate crinolines).
• Padding was quite common, with the *crapaud* armchair (introduced under Louis-Philippe) remaining quite popular.
• Empire gondola armchairs remained fashionable.
• Curiously exaggerated versions of Louis XV or English Regency armchairs, made of painted papier mâché and often inlaid with mother-of-pearl, were also in vogue.

Porcelain . . . an admirable material for description in Latin verse. — ALFRED DE MUSSET

Ceramics

Polychrome biscuit statuette

Opaline vase

Mother-of-pearl perfume case

Polychrome biscuit tobacco jar

Papier-mâché casket

Silver

Tea fountain

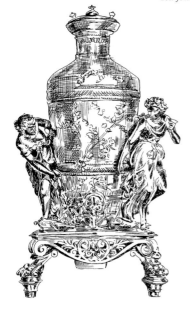

Egg cup

Carafe stand

Coffee pitcher

Vegetable dish

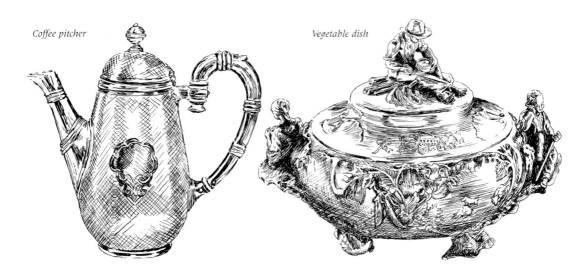

Styles around 1900

THE YEAR 1900 IS A SYMBOLIC yet ambiguous date. The inaugural year of the twentieth century, it is also widely used by the French to designate a period that, from the fall of the Second Empire in 1870–71 to World War I, belongs more to the preceding period than to the subsequent one. It is an era of debonair presidents and jingoistic bourgeois, of the first automobiles and the last carriages, of elegantly corseted women and industrial parvenus. France seemed prosperous and content, becalmed and industrious. A nation of liberty, progress, and artistic achievement, it illuminated the world much as Bartholdi's Statue of Liberty did New York harbor. The prince de Galles brazenly appeared in public with Cléo de Mérode. The comedies of Feydeau and the speeches of the anti-Dreyfusard Paul Déroulède met with equal applause, as did (eventually) Gustave Eiffel's tower and the revivalist grandeur of Boni de Castellane's Palais Rose, the exploits of early aviators, the provocative banter of Mistinguette, and the eccentricities of Sarah Bernhardt.

Interior decoration, too, was marked by influences that were contradictory and often short-lived, as well as by superficial curiosity about new techniques and avant-garde art. But it also, and above all, embraced France's venerable craft traditions, then believed to be unshakable. All furniture from the past was admired, including, perhaps contrary to expectation, the style of the immediately preceding period, which remained popular until 1900. Specialists as well as the general public felt that this moment was the end result of a harmonious evolutionary process; that everything had already been said; that style, like civilization itself, had entered a culminating phase.

But this glib self-confidence did not go unchallenged. Many intellectuals and artists were alert to portents of imminent upheaval. Generally ignored, ridiculed, or regarded with contempt, the productions of adventurous craftsmen rarely met with success, and then usually for lesser works (objets d'art, jewelry, knickknacks). Incomprehension of this kind was certainly not limited to the decorative arts. It characterized the response to innovative cultural productions of all kinds: Van Gogh and Gauguin were no more appreciated than were Mallarmé and Proust, not to mention the Curies, Clément Ader, and the filmmaker Georges Méliès. The period rejected its avant-garde as though afraid to learn what the future held in store for it. In interior decoration, the most prominent avant-garde tendency was the *style moderne,* variants of which were present in all European countries under different names. While still very far from the prodigious revolution that would follow World War I, it was the only French style, in this period of complacent self-satisfaction, to strive for invention and creative renewal. Virtually unconnected to the historicist eclecticism that was prevalent at the time, it now seems much more important. That is because it was, in addition to the last nineteenth-century style, the first characteristic style of the twentieth century.

The furniture

In the years around 1900, there was a gigantic recapitulation of the styles of all countries in all preceding periods. Everything from Chinese to Spanish models, from Boulle to Gothic, found its way into furniture production, but some styles were more appreciated than others.

The High Middle Ages and the early Renaissance were especially prized: everything redolent of medievalism and Christianity was considered fashionable. Exoticism of every stripe as well as the most exuberant rococo models were likewise favored. But Spanish, Italian, and English influences are also apparent in furniture from this period, which manifests little in the way of originality, accepting only with considerable reluctance the sole attempt at renewal to emerge in these years: the *style moderne*.

In any case, the tendency toward synthesis was so strong that the *style moderne* itself sometimes incorporated elements drawn from earlier furniture, employing not so much its shapes as its ornamental vocabulary, if only in altered or caricatural form. The results are surprisingly heterogeneous, marking furniture produced in the years around 1900 as a crossroads of contradictory tendencies.

In many respects, the **style moderne** — which encompasses Art Nouveau — remained experimental, a style of theorists. If it had a profound impact on its period, that is because it was the only original development in the domain of furniture design. But it proposed too radical a break with indigenous traditions to enjoy rapid success, and historical circumstances precluded its being widely disseminated. Emerging between 1885 and 1900 in the workshops of a few great furniture-makers (Majorelle, Vallin, Gallé, Gaillard, Cona), many of whom were also ceramists, metalworkers, and glassmakers, it was swept away by World War I (1914–18), which brought the Belle Époque — that period of prosperity and gaiety surrounding the turn of the century — brutally to a close. This explains both the rarity of beautiful characteristic pieces and, especially, the absence of certain important furniture types in the style, for example secretaries and commodes. As a result, it is now impossible to imagine an entire house or apartment furnished with authentic *style moderne* pieces.

Materials and techniques

1900 style. All materials and techniques were used by furniture-makers of the day, who produced, in series or as unique pieces, furniture inspired by every conceivable stylistic model, from ancient Egypt to Celtic England, made fashionable in England by the critic John Ruskin as well as by artists such as Edward Burne-Jones.

Craftsmen went so far as to revive certain forgotten techniques, for example those of iridescent glass, current among the ancient Jews and the navigators of ancient Tyre, and of chryselephantine sculpture, dear to the Greeks of the fifth century B.C.

Craftsmen became adept at producing imitation Gothic, Renaissance, and Louis XV work, often on an industrial scale. An interest developed in techniques for aging

wood artificially and for reproducing in mass-produced furniture some of the appealing irregularities of handcrafted work. Contrary to widespread belief, metal was often used functionally in this period, especially in folding and metamorphic pieces.

The style moderne has its own characteristic materials and techniques.

It is marked by two contradictory tendencies: on the one hand, *ébénistes* like Louis Majorelle and Eugène Vallin produced luxurious pieces in costly materials; on the other hand, workshops in the faubourg Saint-Antoine turned out inexpensive, serially produced furniture — usually, copies of French and English designer work — for the Parisian department stores (Samaritaine, Printemps, Galeries Lafayette, Innovation). These pieces were of mediocre workmanship, and few survive.

Wood. The *style moderne* fostered the return of a wood that, while greatly neglected under the Second Empire, had been quite fashionable in the eighteenth century and under Napoleon: Brazilian mahogany.

In addition to mahogany, used in solid pieces or as veneer, *ébénistes* employed oak, walnut, and pearwood. Ebony, sycamore, and walnut were used for marquetry.

Furniture produced with the aid of machine tools was made of less costly woods, primarily resinous species, which were always lacquered or painted bright colors, occasionally even white.

Metal. Ongoing technical advances in industrial metalworking, a marked preference among designers for "modern" materials, and the triumph of these materials in new architectural applications — epitomized by construction of the Eiffel Tower (1889) — prompted many artists, decorators, and producers to use iron, steel, bronze, and cast iron. By doing so, they were flying in the face of the widespread view that such materials were vulgar. Metal was often fashioned into ribbons, serpentine columns, volutes, and *rinceaux*. It was used to underscore and even exaggerate a piece's sinuous lines. Easily manipulable, it could be made to resemble creeping vines or to assume all manner of extravagant forms. It was also employed in utilitarian pieces, notably bathtubs and stoves, but in ways that rejected a purely functionalist approach, allowing for inclusion of the same twisted and organic forms characteristic of other *style moderne* work.

Metal was usually left untreated. Gilt bronze and painted iron tended to disappear, but cast iron coated with enamel was used in kitchens and bathrooms. Noble and costly metals were somewhat out of favor: copper, pewter, and silver, so prominent in late Second Empire ornament, now became rare. On the other hand, these materials were widely used in decorative accessories, although in a spirit quite different from the one prevailing in true *style moderne* work.

Note: A few attempts were made to employ:
- tapestry, placed in the center of panels with low moldings (bed headboards, buffets);
- stained, tinted, and oxidized glass, used for glazing bookcases.

Ornament

1900 style: roses

1900 style: flowers

Style moderne: *seaweed, chair back designed by Gaudí*

Style moderne: *stylized orchids*

Style moderne: *branches and birds*

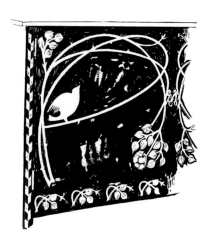

Materials and techniques

Style moderne:
ribbons and volutes

Style moderne:
supple lines

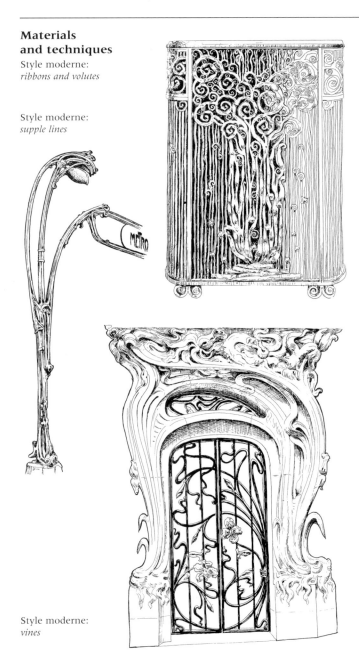

Style moderne:
vines

Ornament

1900 style appropriated ornament from earlier styles, which it exaggerated and amplified. It usually treated its models freely, but, at least in luxury production, its materials and craftsmanship are of high quality. Two themes are especially prominent in these productions: Christian imagery, in all manner of furniture incorporating Gothic and Renaissance elements; and the nude, which figures in work drawing upon models from all later periods. One motif is so prevalent that it should be singled out: the rose.

The style moderne was considerably more innovative in the domain of ornament, which in its productions is not decorative sculpture added after the fact but, rather, is fully integrated into the formal and structural matrix.

In extreme cases, for example designs by Émile Gallé and Hector Guimard, whole pieces of furniture become ornamental, utilitarian considerations having been disregarded almost completely. This revolutionary approach is not always in evidence; more or less traditional ornament figures in many *style moderne* pieces. But even in these instances, high-relief sculpture, rockwork, and applied ornament inspired by furniture from earlier periods remain subsidiary to linear arabesques that provide the piece's basic formal armature.

Ornamental marquetry sometimes appears on furniture from this period, but it, too, takes the form of long curves, sinuous tendrils, and pliant branches executed in precious woods, ivory, or, occasionally, copper.

Ornament

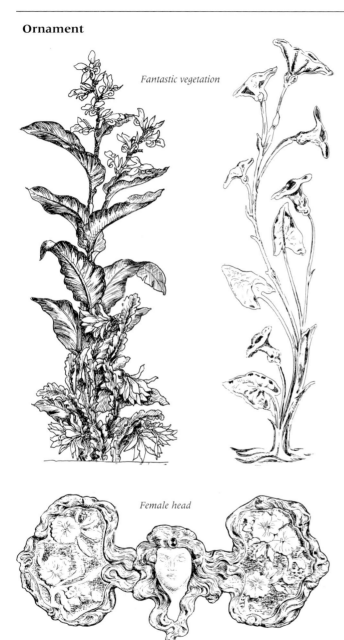

Fantastic vegetation

Female head

Motifs. Style moderne ornament is almost exclusively botanical in inspiration, with marine plants (water lilies and seaweeds), tropical vines, and branches virtually bare of leaves being especially prominent. Roses are virtually absent, as are other familiar garden flowers with the exception of tulips. By contrast, orchids and other exotic plants appear frequently, always treated with considerable imaginative freedom.

Before long, these botanical designs became completely fantastic; simultaneously dense and evanescent, their patterns often evoke loose and flowing women's hair.

Other ornamental themes are rare: birds, sometimes found on imitations of painted Japanese silk; snakes; the heads of women whose features all but disappear in their long flowing hair.

Geometric ornament disappears completely. Twists, volutes, and curves, although sometimes close to fragmentary working drawings, are by no means abstract. On the contrary, they are always meant to function as spurs to poetic revery.

Beds

1900 style beds are reproductions, often fantastic, of Gothic, Renaissance, and Louis XV beds, replete with canopies and columnar bedposts. Examples produced by the great *ébénistes* of the period are well crafted, but historical fidelity is not their strong suit. Models from the past are interpreted in ways consistent with prevailing tastes: neomedieval headboards are decorated with niches containing statuettes of saints, female nudes, and ephebes; bedposts serve as pretexts for aquatic and/or exotic vegetal motifs; mattresses can be quite high

What now seems oldest is what initially seemed most modern.
— ANDRÉ GIDE

or quite low, depending on the preference of the patron or purchaser.

The style moderne sought to impose a new type of bed. Its mattress is low, and its end boards, of markedly different heights, have slightly sinuous profiles, accentuated by simple oak or mahogany moldings that run continuously from one leg to the other. These moldings serve as a frame for blond or *satiné* wood panels, often decorated with marquetry (flowers or "Japanese" landscapes).

The movement of this outer molding is almost always underscored by additional ones — thin, dark, sometimes multiple — whose curves are more emphatic, sometimes suggesting butterfly wings.

Tables

1900 style. Some of its most characteristic tables are heavy neo-Renaissance pieces with marble, mahogany, or oak tops and ornately carved legs and bases. But the period also saw a proliferation of low tables of Far Eastern inspiration with richly decorated marquetry or inlaid tops (ivory, mother-of-pearl, and exotic woods as well as, occasionally, colored glass and semiprecious stones).

1900 style: console table with patinated bronze base and marble top.
The caryatids and garlands are neo-Renaissance,
but the overall sense of movement derives from Baroque models.

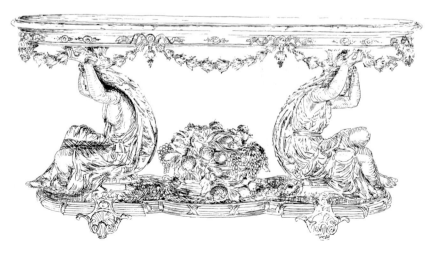

Style moderne:
gueridon

Style moderne:
armoire

The style moderne, by exception, produced a rather large number of tables of very different sizes and forms. All of them, however, share certain striking characteristics:

• The tops avoid the traditional geometric forms (rectangle, circle, oval) in favor of more eccentric shapes with curvilinear profiles, often suggestive of flowers or waves.

• The legs or stands are dominated by curved lines. Generally thick and without ornament, they avoid traditional symmetrical formats.

• The tops and legs are often made of different woods.

Armoires

1900 style continued to favor Boulle and Louis XV armoires, as well as mirrored armoires of the Louis-Philippe and Second Empire type and "Chinese" examples made of black lacquered wood with mother-of-pearl inlay decoration.

The style moderne produced a few high, unpedimented armoires with one or two doors of curving outline and decorated with sinuous moldings. Their legs are high, slender, and slightly curved.

Their sides also feature moldings, while their aprons and support posts are sometimes decorated with vegetal motifs in low relief.

Some of these pieces have one or even two drawers. Others have small, eccentrically shaped shelves on their sides.

Buffets

1900 style. "Henri II" buffets, produced since the mid-nineteenth century, were still in favor. These pieces are sometimes smaller than their Renaissance models, with which they take many liberties.

163

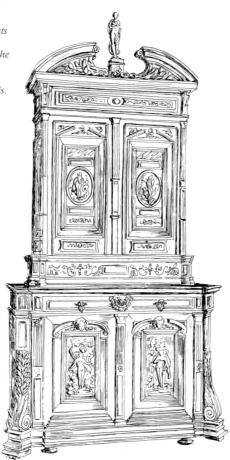

1900 style: "Henri II" buffet made of ebony with gilt bronze mounts and lapis lazuli inlay. This piece, owned by the marquise de Païva, is now in the Musée des Arts Décoratifs in Paris.

Increasingly, the ornament diverged from that of the Renaissance models: sculpture in high relief was replaced by low-relief elements; classical iconography disappeared in favor of Christian and pseudo-historical imagery. The pediments, often broken, became large and overelaborate. Produced on a quasi-industrial scale, these pieces were sold with fantastic "dining-room ensembles" that had nothing to do with their putative Renaissance sources. They are now of little interest.

Style moderne buffets, imposing and a bit ponderous, are made of pearwood or, on occasion, of walnut. The lower parts, which can have two or four doors, are surmounted by rather high, armoire-like units whose doors are fitted with tinted or frosted glass, sometimes protected by grilles. The upper units' support posts and cornices are rather emphatically curved. Ornament is kept to a minimum, usually consisting only of sinuous moldings that frame the doors and run along the top edge of the lower part. The doors are sometimes decorated with marquetry executed in wood or other more precious materials.

These buffets are often conceived as parts of an ensemble, their curves and moldings having been devised to harmonize with those of other pieces — even, on occasion, in the best eighteenth-century tradition, with a room's woodwork and decorative accessories, as in a dining room in Nancy designed by Eugène Vallin.

The first antique dealers

They appeared shortly after 1870. Previously, little attention had been paid to the authenticity of old furniture; indeed, copies were often preferred because they were sturdier than originals. From this point forward, period furniture became the object of both collectors' passion and monetary speculation. But experts were still rare, and the first forgers set to work around 1880. They were abetted in their dubious enterprise by new techniques (for the rapid aging of wood, for example), as well as by the still vibrant traditions of French furniture craftsmanship. In effect, many craftsmen still worked much like those of the eighteenth century. What's more, the results were often only "half-fake": parts of authentic pieces were sometimes incorporated into new ones. However, forged signatures dating from the period tend to be readily identifiable as such and now rarely fool specialists.

Commodes

1900 style. Louis XV and Louis XVI commodes seem to have been the clear favorite in 1900.

Style moderne designers do not seem to have been much interested in this furniture type, despite its unquestionable popularity since Louis XIV. Nonetheless, a few rare examples designed by Vallin and Gallé make it possible for us to describe a typical *style moderne* commode. A chest of drawers made of blond wood and supported by high legs, it has thin transverse rails decorated by slender, sinuous moldings. Ornament is limited to a few twists and interlace patterns. The panels are sometimes decorated with marquetry (landscapes, flowers, seaweed).

Desks

1900 style. The fashion was for Italian Renaissance or Baroque desks. In private residences, minister's desks were out of favor; although the word had yet to enter general currency, they were effectively deemed too "functional." The eclectic spirit of the age preferred Louis XV and English Regency models.

Style moderne desks have long interested collectors, for the emphatically functional character of this furniture type is at odds with the taste for "irrational" and irregular forms that otherwise prevailed in the style. The solutions to this dilemma proposed by designers are not always happy. As with the analogous tabletops, *style moderne* desktops never have simple geometric shapes; forms with eccentrically curved outlines are the rule. Sometimes a small drawer cabinet rests on its surface, and often the edges have molded rims. The top is supported by two asymmetrical drawer units with swelling edges, often supported by four stubby feet of organic form. Sometimes there are irregularly shaped, fixed shelves on either side.

Ornament is sparing; sometimes undulating moldings and/or detached, branch-like support posts imbue the drawer units with sinuous rhythms.

Style moderne: *large asymmetrical desk designed by the architect Hector Guimard. Its molded ornament evokes water lily leaves. This piece is now in the Museum of Modern Art, New York.*

Style moderne:
chair by Hector Guimard

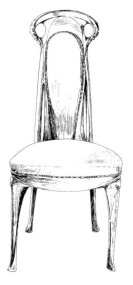

Style moderne:
chair by Eugène Gaillard

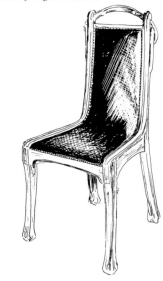

Seating

1900 style. The taste that emerged under the Second Empire for historicist variety in seating design remained current. Producers continued to turn out high chairs and armchairs in neo-Gothic style, stools, ottomans, fireside chairs. armchairs (primarily Louis XV), easy chairs, and dining-room chairs without the slightest concern for unity, always interpreting past styles quite freely.

The coverings of these pieces compensated somewhat, functioning as a common, harmonizing element. There was a marked preference for silks and satins in dark colors printed or embroidered with botanical or animal motifs, often vaguely suggestive of Far Eastern models.

The style moderne was resolutely opposed to this polyglot historicist approach. *Style moderne* chairs have clean lines that strike an entirely new note. In general, they lack carved, marquetry, or inlay decoration, for the style's advocates maintained that form itself should be ornament enough.

Chairs and armchairs almost always adhere to the same guidelines:
• The lines of the legs, rails, arms, and back are as continuous as possible, judicious curves being used to create visual interest.
• Backs tend to be rather high; their straight, slightly inclined side rails culminate in a gently curved top rail, often underscored by a botanical molding.
• Often there is no break between the back and the seat, making it possible for patterns on the covering to be continuous between them. The overall effect produced by these pieces is one of attenuation, even fragility, imbued with a sinuous or aerial grace.

1900 style: chair of Gothic inspiration

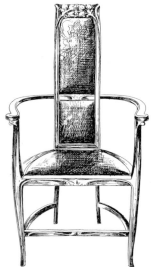

1900 style: armchair of Louis XV inspiration

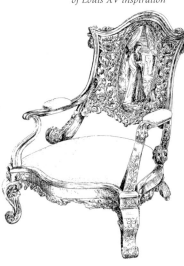

Style moderne: *night table*

Style moderne: *worktable by Émile Gallé*

Style moderne: *firescreen by Émile Gallé*

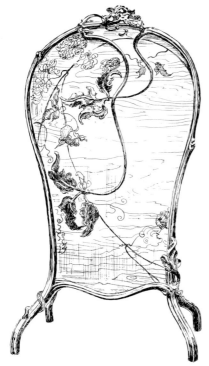

Style moderne: *small table by Louis Majorelle*

Note: Style moderne designers also produced medallion chairs, settees, and matching dining-room ensembles in the same spirit.

Small furniture

1900 style. The Second Empire craze for small pieces continued, but the array of possible historicist styles was enlarged, with the result that rooms from the period can be hodgepodges of diminutive furniture whose sole claim to originality is their very heterogeneity. It is worth noting, however, that there was a marked predilection for church furnishings (prayer stools, music lecterns) and *turqueries* (copper tabletops, leather ottomans).

Style moderne. Small pieces in the style are too various to be exhaustively inventoried. We list a few of the most characteristic types.

Bedside tables. These tables are quite low, and their lines harmonize with those of the bed's headboard. Their tops often resemble stylized butterfly wings and are sometimes asymmetrical. They often have a storage compartment behind a hinged door, below which are one or two open shelves. Their legs are short, slender, and often extremely curved.

Gueridons and other small tables have exceptionally "irrational" — organic and asymmetrical — forms. Some gueridons are purely ornamental pieces.

Corner pieces. These take the form of low display cases or consoles. Bare of ornament, they are willfully asymmetrical and rest on short, curved legs. Sometimes the glass in the doors is tinted.

Plant stands. High and supported by splayed, straight, or curved legs, these pieces have irregularly shaped tops designed to harmonize with matching vases. Sometimes the legs rest on a low base decorated with an ornamental element, occasionally quite elaborate.

Worktables. These small pieces often have exaggeratedly sinuous profiles. Their small tops rest on emphatically in-curved supports, between which is a small shelf that is sometimes decorated with an unassertive molding. Just below the top is a delicately carved apron or transom.

Firescreens. Their oval frames consist of sinuous double moldings that run without interruption from one biped leg to the other. Within these frames is a sliding panel of marquetry or, more rarely, tapestry decorated with botanical or animal motifs, often of Japanese inspiration.

Hector Guimard

The architect Hector Guimard (1867–1942), one of the form-givers of Art Nouveau, is probably the most remarkable of all style moderne *designers. The Paris métro entrances that he designed shortly before 1900 — shaped like tulips, flowing seaweeds, and sinuous tendrils — made him famous. The apartment buildings and townhouses that he built in the same city reveal the prodigality of his invention. But many found them scandalous. An advocate of curved lines and asymmetrical compositions, Guimard sought to create integrated environments, lavishing his attention on everything from fireplaces to service entrances, from cottages for concierges to kitchen stoves. He also designed a great deal of furniture.*

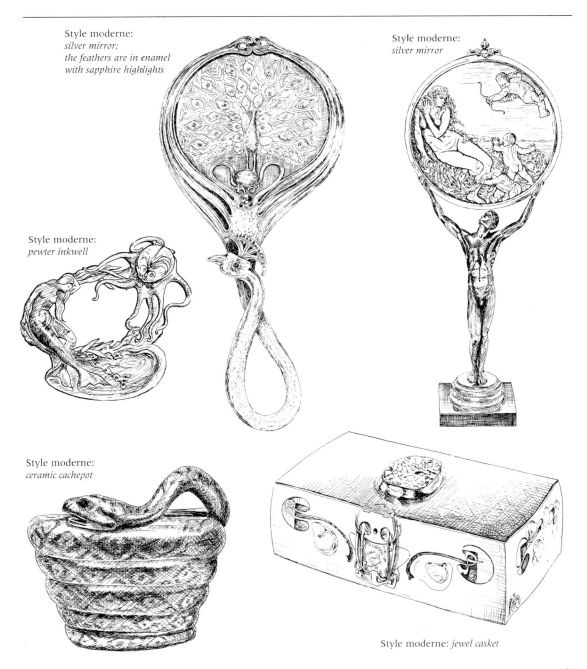

Style moderne:
silver mirror;
the feathers are in enamel
with sapphire highlights

Style moderne:
silver mirror

Style moderne:
pewter inkwell

Style moderne:
ceramic cachepot

Style moderne: *jewel casket*

Styles around 1925
1918-1939

THE ERUPTION OF LICENSE, anarchy, and disorder throughout the West after World War I is consistent with an age-old pattern. To cite a single precedent, the Directoire dandies known as *merveilleuses* and *incroyables* have much in common with the gender-bending provocations of the French *garçonnes* of the 1920s. It is not unusual for societies to succumb to the temptation of extravagance and libertinage after prolonged periods of crisis. Deprivation gives way to a collective surrender to sensuality that unsettles, more or less durably, art, fashion, taste, and mores. In the present instance, the paroxysm climaxed with the 1925 Exposition des arts décoratifs in Paris and faded away around 1933, when Hitler came to power. It was, then, quite brief, which makes the richness of its intellectual and cultural production all the more striking. Within the space of a dozen years, the Western world discovered the theory of relativity (Einstein), the nature of atomic structure (Joliot-Curie), intercontinental aviation (Lindbergh), and penicillin (Fleming). Proust, Joyce, Hemingway, and Faulkner produced groundbreaking works of fiction. Picasso and Matisse gave art entirely new dimensions.

In Paris, between the cafés Dôme and La Coupole, a small circle of determined men and feverish women set a fashionable tone that still fascinates. Against a background of jazz and rumbas, Cocteau wrote his ambiguous poems for an audience of dancers, actors, painters, and couturiers whose names remain familiar to all francophiles. Here Nijinsky walked side by side with the likes of Marguerite Moréno, Raoul Dufy, Paul Poiret, Coco Chanel, and Colette. Henry de Montherlant discovered sports. André Breton reigned over the kingdom of Surrealism. And yet, in many respects, the French decorative arts of the period disappoint. Their novelty is more apparent than real. The great revolution that would soon transform domestic interior decoration, as it had already begun, especially in Germany and America, to transform architecture, was a phenomenon very much apart from the celebrities and scandals of what is known in France as the "crazy" 1920s. It developed separately, in a few schools and little-known ateliers. The prophets of contemporary style were iconoclasts who sought to invent a new private world of beauty, warmth, and fantasy.

Nothing could be farther from the work of Walter Gropius, Marcel Breuer, and Gio Ponti than the designs of Émile-Jacques Ruhlmann, Jules Leleu, and Paul Iribe. The advocates of functionalism were all but unknown to the bourgeoisie and fashionable artists alike. Their designs and prototypes were relegated to the domain of social theory, as projects relating to mass-produced furniture and purely utilitarian objects. In the end, however, it was they who would determine the forms, lines, and volumes of contemporary furniture. Their work still seems incredibly fresh, whereas the most beautiful Art Deco furniture, the final offspring of a long tradition, strikes us as outmoded, if deliciously so.

The Art Deco style

This style lacks unity, being a reflection of quite various historical influences. Most of the great *ébénistes* and decorators of the 1925 exhibition were striving to rejuvenate the great tradition of French furniture by breaking away from the paucity of imagination that had prevailed since Louis-Philippe. But they took as their models either Louis XV and Louis XVI (Émile-Jacques Ruhlmann, Paul Iribe) or Restoration work (Louis Süe, André Groult). Still others tried to synthesize admired past styles (Jules Leleu) or sought to emulate Far Eastern and Spanish models (Armand-Albert Râteau). The spirit and taste of the age were on their side. The *style moderne* had produced some excellent craftsmen who remained under its influence. The weakness for tinsel and flash characteristic of all societies emerging from prolonged crisis gave issue to a mode of ornament that was a bit gaudy but, in the end, quite novel.

The influence of black Africa, American civilization, rapid maritime travel, and the Mediterranean sun left its mark in diverse ways on the ornamental vocabulary of stylists and furniture-makers. The result was a heteroclite style, encompassing both a Riesener-like refinement and a return to archaic sources, that did not always manage successfully to reconcile past traditions with the new ideas and impressions characteristic of this volatile period. But this style may still be too close for us to discern its true character.

However, when we compare it to functionalism, which emerged in the same period, what is most striking about Art Deco is the richness and proliferation of its ornament. Whereas the Bauhaus, which planted the seeds of contemporary style, strove to do away with ornament, Art Deco exploited every available ornamental resource, deploying them all with imagination, invention, and refinement. Marquetry, inlay work, bronze fittings, wrought iron, lacquer, painting, etc. were used lavishly in ways consistent with period tastes and predilections.

Metalwork, ceramics, textiles, tapestry, and glassware were treated as supports for decoration that was responsive to prevailing taste — and that often seems rather carelessly and pointlessly added on, such that in the course of this short period ornamental fashions supplanted one another with startling rapidity. In 1935, even before an alternative had emerged, Art Deco began to seem dated. Historical-revival styles came to be preferred, especially Empire, which remained fashionable into the 1950s. Given the expensive volatility of modern taste, many buyers preferred more stable values. The resulting suspicion of a production deemed too volatile tended to sterilize designers' imaginations.

The furniture

In this period, furniture had not yet entirely renounced the Belle Époque taste for curves and sinuous lines. But neither was it immune to the influence of Cubist and abstract painters and functionalist architects, who accorded a new importance to geometric volume. These discordant allegiances explain the occasional inconsistency of their ornament. The period's finest productions are those most clearly inspired by the eighteenth-century French tradition.

Materials and techniques. The Art Deco style, being oriented toward the luxury market, paid little attention to production costs and retail prices. It delighted in costly materials.

Wood. Exotic woods were preferred to European ones. All dark woods were in favor, especially ebony and macassar. Palisander, yellow and rose amboine, and mahogany were also in vogue.

Sycamore, citronnier, and tulipwood were reserved for veneers and marquetry. Lacquered wood was often used.

Metal. The metals traditionally used in ornament (gilt bronze, copper) were generously employed. Silver was also used, notably for drawer handles, lock plates, and *sabots.*

Cast iron was much favored, sometimes being used for the bases of tables and consoles as well as in the form of grilles in bookcases and buffets. Whether untreated or lacquered, it is always carefully worked.

Leather and textiles. Leather (especially tan leather) slowly became as pervasive as fabric as a cover material for chairs and settees. Often tooled, it was also used in the center of panels, on the tops of tables and desks, and even on the tapered legs of many pieces.

• *Galuchat* (treated and dyed sharkskin), introduced toward the end of the eighteenth century, returned to favor. Fur (ocelot, for example) was sometimes used on chairs and divans.

• *Pony skin* was often used on the seats and backs of chairs and armchairs.

• Textiles presented opportunities for experiment with form and color. Gifted painters like Raoul Dufy designed fabric patterns. Luxurious silks were also fashionable. Embroidery disappeared. Contrary to the tendency of functionalism, technical experiment was abandoned; tapestry is all but absent from Art Deco pieces, despite interest in the medium among contemporary painters.

Ivory was much in favor, being used in marquetry, inlay ornament, and in the form of large plaques. It was even used to sheathe the tapered feet of some small ebony pieces.

Materials
*Gilt bronze
lock plate
and handle*

Materials

Tooled leather panel

Cast-iron firescreen

Gilt bronze ornament

Chased and gilded bronze handle

The 1925 Exposition des arts décoratifs

Immediately dubbed Expo 25, it spurred a virtual obsession with decoration for two or three years. Le Corbusier, who contributed a maverick exhibition that was more remarked upon than admired, observed that it encompassed everything "from hat boxes to master plans for Paris, Moscow, and London," adding that sumptuous palaces had been erected to house displays tracing "the adventures of a flower bud passing from an umbrella handle to a chair back." In fact, the exhibition was a gigantic crossroads of contradictory tendencies where the great trends of contemporary aesthetics were drowned in a kind of ornamental frenzy. Only the Russian and Austrian pavilions, as well as the one built by the French architect Robert Mallet-Stevens, gave any hint of the profound renewal that some designers were striving to effect in interior decoration. The whitewashed walls of Le Corbusier's Pavillon de l'Esprit Nouveau occasioned scandal.

Ornament

Fruit

Vegetation

Flowers

Low table

Marble replaced wood as the preferred material for tabletops (consoles, gueridons, low tables), where it was often used in tandem with cast iron.

Ornament

Most ornamental techniques were used (marquetry, inlay, decorative panels). Only carved wood sculpture was relatively downplayed. On the other hand, new decorative motifs consistent with contemporary tastes were introduced.

The influence of **Cubism and abstraction** is apparent on some pieces in the guise of marquetry or tapestry panels, tooled or repoussé leather, or metal or ivory inlay of geometric motifs or nonrepresentational shapes.

Ornament in the **style moderne** tradition, enriched by elements drawn from African art, tended to be vegetal, floral, or maritime motifs (waves). Curved lines, contrasting colors, and precious or richly worked materials (ivory and silver; cast iron and bronze) were especially prevalent.

Tables

Tables were made of ebony and palisander as well as of walnut and even mahogany. Round, rectangular, oval, or, more rarely, square, they are crisply geometric in profile and light in appearance. Their legs are gracious, often vertical or splayed, occasionally curved, and bare of ornament. Their friezes are wide, and their tops sometimes have leather insets.

Events wipe away events; inscriptions engraved on other inscriptions, they are pages in a historical palimpsest.

R. DE CHATEAUBRIAND

Desk

Console table

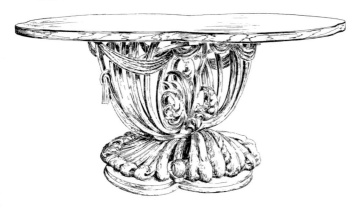

Large tables from the period have simple stretchers enriched with a central motif made of metal.

Console tables sometimes have richly worked cast-iron legs and friezes and a marble top. Alternatively, they imitate eighteenth-century styles and are made of ebony or palisander.

Low tables were much in vogue; their legs and friezes are often made of cast iron or gilded wood, and they have marble tops.

Desks

Desks tend to be large. Their legs are straight or curved without stretchers, and their tops are covered with leather or galuchat (sharkskin); their friezes are veneered, often with dark wood. The banks of drawers flanking the kneehole are of ample dimensions, and their panels are sometimes covered with leather. Shelf or storage units no longer rest on the top. Ornament is restrained and sometimes geometric. The lock plates and handles, often richly worked, are made of copper, bronze, or silver. Desks were made of every conceivable rare wood, but there was a marked predilection for ebony.

Bookcases

Despite the growing popularity in offices and studies of open shelves and even filing cabinets, bookcases proliferated. Most often large, they usually were made of palisander or ebony. Composed of one or two small armoires, their doors tend to be decorated with marquetry or a central inlay motif, but occasionally they are glazed. They either have short legs or rise directly from a full base.

*Bookcase designed
by Eugène Gaillard
(Musée des Arts
Décoratifs, Paris)*

*Bed made of burled walnut,
designed by Paul Follot*

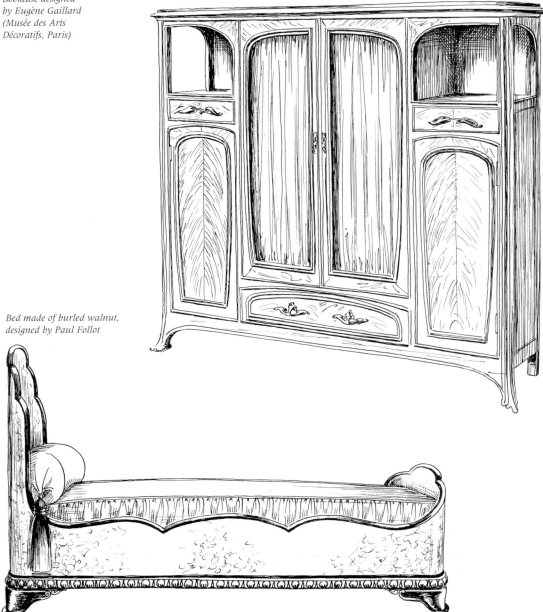

Armoires

Art Deco armoires are often made of sumptuous materials (ebony, tulipwood) and tend to be richly decorated. Usually based on Louis XV or Restoration models, they have rather large pediments enriched with marquetry, gilt bronze, or silver; their door panels, often clad in leather or decorated with marquetry or ivory inlay, are fielded by assertive half-round moldings. Their support posts are also richly decorated.

Their interiors are refined:

• The upper half is occupied by shelves and drawers of various sizes, the latter sometimes clad in leather; the inner surfaces of the doors are fitted with large mirrors.

• The lower part often has a large drawer.

Psyché mirrors

Art Deco Psyché mirrors often double as dressers. Their tall oval mirrors, framed in the same wood as the rest of the piece, are flanked by two small, low chests of drawers that support a central shelf. They have short, straight, tapered legs; their ornament is discreet, sometimes consisting only of a simple marquetry panel or a carved mirror frame. True Art Deco dressing tables, which were also made, have longer legs but are otherwise conceived along similar lines.

Beds

Typically, the end boards of Art Deco beds, of unequal height, are rounded or scroll outward and lack moldings. Their legs (spindle or twisted) are sometimes sheathed in leather. Their bases are large and made of ebony, palisander, or burled walnut (never of mahogany); the

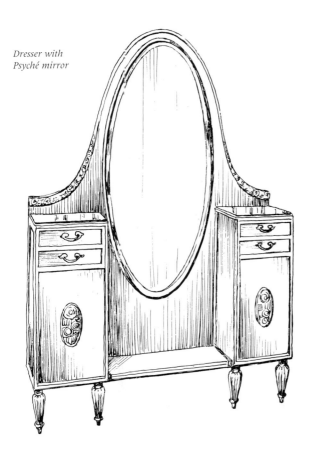

Dresser with Psyché mirror

Commode

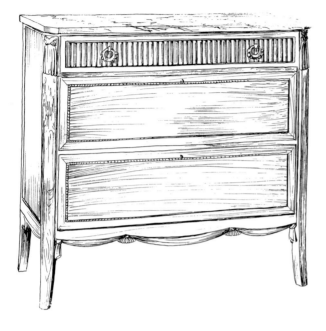

footboards are often richly decorated with wood marquetry, ivory inlay, gilt bronze fittings, or tooled leather.

Divans were quite popular. Lacking end boards, they were designed to disappear below fur throws and silk cushions.

Commodes

Art Deco commodes are among the period's most attractive productions. In terms of form, size, and ornament, they derive from Louis XVI models or, on occasion, from nineteenth-century English ones. Their legs tend to be straight but are sometimes flared or curved, and they have two or three drawers, the uppermost of which is sometimes divided into two smaller ones. Their tops project slightly, and their support posts are straight or, on occasion, slightly bulbous.

Their refined ornament can be flat (marquetry, inlay, veneer) or in low relief (gilt bronze or silver fittings). Lacquered wood, tulipwood, and ebony were all used frequently to make these pieces. The interiors of their drawers are often lined with leather or fabric.

Note: Some commodes have simpler, almost straight lines and are fitted with sliding tambour panels instead of drawers.

Cushions

Tapestry was in a slump; the quality of its workmanship had declined, and its decorative vocabulary had not much changed since the middle of the preceding century. Despite the interest of such artists as Raoul Dufy and Cappiello in the medium, it was disappearing from interiors and was used only rarely as a covering for chairs and settees. Cushions, however, were quite fashionable. Prominent artists like Dufy, Paul Iribe, Leon Bakst (who designed sets for the Ballets Russes), and the couturier Paul Poiret devised embroidery patterns for them: pierrots, goldfish, flowers, parakeets, etc. Cushions in black and white checkered patterns, Cubist compositions, and brilliant floral bouquets proliferated as well. They were placed on settees, beds, banquettes, and leather armchairs, sometimes even on chairs.

Seating

The late-nineteenth-century tendency to produce seating in a broad array of formats and after an eclectic array of historical models continued. A growing interest in maximizing comfort manifested itself in design experiments — with back heights, padding, coverings — that were not always successful.

Chairs. Backs tend to be rather low and quite open, sometimes consisting only of an empty frame. Padding is not necessarily limited to the seat proper and is often covered with leather. The legs — tapered, curved, or splayed — are quite thin.

Art Deco chairs can be a bit overloaded with ivory, copper, bronze, and mother-of-pearl decoration, but simpler designs were also produced. Made of waxed oak, they have caned seats and straight, sometimes turned legs reinforced by four or six stretchers; they occasionally evoke regional models, notably those of Alsace and the Basque country, in which case the top rails and center splats of their backs can feature heavy carved motifs.

Regardless of their stylistic sources, Art Deco **armchairs** tend to be low and somewhat heavy in effect. Their legs are thick and sometimes curved, sometimes straight and splayed. Typically, they have low, markedly inclined backs and are richly decorated (lacquered with bronze fittings and moldings).

Many armchairs from the period have caned seats, in which case they resemble garden chairs and have frames made of waxed oak. They have wide, flat arms and short, turned legs.

Fully upholstered club chairs, inspired by English models, were quite popular. Covered entirely in leather or fur, they have large, slightly inclined seats and thick leather seat cushions. The legs are very short, the backs low and inclined, the arms rounded and ample.

Settees became increasingly prominent as the period advanced. Most Art Deco examples are conceived along English lines, being integrally padded and short, with thick arms and a markedly inclined back. Settees in historical styles were also produced (Louis XV, English Regency, French Restoration), and these pieces are more richly decorated. Textile coverings are often influenced by contemporary advanced painting, featuring geometric patterns in bright, contrasting colors (sky blue, pure white, yellow).

Art Deco **stools,** often inspired by English Regency models, have thick cushions and ornament of great refinement. The legs are long and the friezes are decorated with elegant marquetry or inlay designs.

Creators of the 1925 style

They included the writer Cocteau, the painters Modigliani and Picabia, and the composer Francis Poulenc. Many couturiers, notably Coco Chanel and Paul Poiret, also took a strong interest in decoration. Colette, in a series of articles for Vogue, *was a tireless chronicler of current trends. The great ébénistes of the period, influenced by these celebrities, produced work of considerable variety; each of them cultivated a distinct manner, with the result that it is now difficult to discern a coherent period style. But three of these furniture-makers produced especially characteristic work and should be mentioned here:*

- *Jacques-Émile Ruhlmann (1879–1933) was heir to the great French tradition. His pieces are superbly crafted, luxurious, tasteful, and remarkable for their purity of line. They now command high prices. He made lavish use of precious woods, ivory, leather, and mother-of-pearl.*
- *Paul Iribe (1883–1935). Although above all a draftsman, he took an interest in many of the arts: cinema, the theater, metalworking, painting. He was on friendly terms with Poiret, Cocteau, and the composer Georges Auric. Pieces designed by him have neoclassical lines, but their ornament, sinuous and heavy, gives them a style moderne flavor.*
- *Jules Leleu was aligned in sensibility with Ruhlmann, but Leleu was open to a wider array of period tendencies. His pieces, beautifully crafted, are restrained and sparely decorated. He worked on the interiors of several ocean liners, including the* Normandie.

Chairs

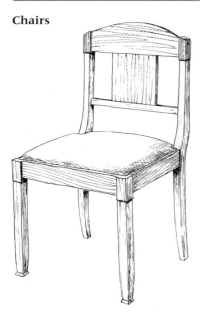

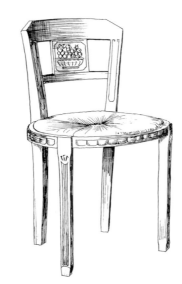

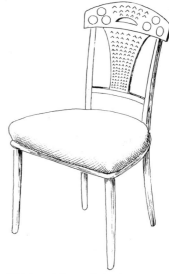

Rustic in inspiration

With a relief motif on the back

With ivory inlay on the back

Armchair

Club chair

Lalique glassware

Vase with birds in relief

Cut-glass decanter

*Frosted glass bottle
(Musée des Arts Décoratifs)*

Glassware

Art Deco glassware extended *style moderne* trends while dispensing with some of its excesses. More stylized and less ornate, it remained committed to technical experimentation. Its preeminent figures are Lalique and Daum.

Opaline was much favored, especially in bluish or cream tints, less often in pink.

Blown glass was also popular, being used notably in pieces evocative of Far Eastern jade and celadon work.

The Baccarat and Saint-Louis glassworks produced much Art Deco crystal ware with enamel decoration: plates, vials, and vases, even complete cut-glass table services.

Some great metalworkers, for example Christofle, made toiletry sets out of enameled crystal.

Art Deco **vases,** made of crystal, glass, or cut glass, are thick and heavy. When their material is glass, it is often opaque and decorated with impressed relief compositions. Crystal vases are cut with geometric designs, occasionally with stylized flowers or sea horses. Typically, they are large in size, with the rounded forms of earlier styles being rejected in favor of shapes that are irregular or rectangular.

Art Deco **lamp bases** were produced in large numbers, those made of opaline being especially handsome.

Glass tableware. The Saint-Gobain and Portieux glassworks produced beautiful goblet-like glasses. Although simple in design, in some cases totally without decoration, their glass is heavy and thick.

Carafes, usually potbellied or very tall, are always decorated and equipped with stoppers.

Ceramics

Although individual ceramists produced work of considerable distinction (Daum, Lenoble, Laherche, Serré), the Sèvres and Limoges manufactories entered a period of decline. There was a new interest in rustic ware and local crafts traditions, especially in Lunéville, Quimper, Montereau, and Angoulême. Much fine work was produced in soapstone and enameled soapstone.

Collectors developed a taste for platters and plates with patriotic motifs and mottos (*on les aura,* "we'll get them yet"; *les oreilles ennemies vous écoutent,* "enemy ears are listening"), which proliferated during the war.

Materials. Regardless of the materials and firing methods they used, ceramists sought to produce an archaic, primitivist effect. Decorative ceramics from the period tend to be heavy and have rough surfaces. Earthenware, too, often has a coarse texture, the enamel having been thickly applied.

Colors. Three pervasive tendencies should be noted:
• a preference for earth colors (browns, beiges, bisters), often used in subtle combinations;
• a preference for bright, clashing colors (white, sky blue, intense red, green, black);
• a vogue for tableware that is pure white, without decoration of any kind.

Forms become simpler. Plates and serving containers tend to be rectangular, for emphatic curves are out of fashion. Vases are often given intentionally awkward shapes.

Metalwork

Like all of the luxury crafts in this period, silversmithing flourished. The medium also experienced a formal renewal, as proportions, volumes, and plans were all subject to experimentation, especially in flatware, whose lines were simplified. Ornament was less important than in the preceding period, being used to emphasize curves or profiles or to punctuate an object's center. Quite often, it consists only of a few volutes, fillets, arabesques, friezes, or, more rarely, medallions.

Tableware often incorporated ivory, mother-of-pearl, or semiprecious stones: lapis lazuli, onyx, jasper, agate, etc. Even exotic woods and tortoiseshell were occasionally used in platters. The most accomplished work of the period is by Jean Puiforçat and Gérard Sandoz.

Wrought iron and cast iron

The ironworking crafts experienced a full-blooded revival, manifest in multiple architectural applications (doors, grilles, pediments, window frames, rose windows) as well as in interior appointments.

Cast iron was widely used for radiator boxes, some of which, for example those produced by Subes, are true works of art whose ornament is rich yet refined. Cast iron was also widely used for lighting fixtures (sconces, lamps, candelabra), small pieces of furniture, and interior grilles separating entry halls from reception rooms. Many ironworkers of the period eschewed industrial procedures (stamping, oxyacetylene welding) in favor of the hammer, with the result that their work has an appealing archaic quality.

Ceramics

*Enamel
faïence
vase*

Stoneware bowl

Silver

Silver pitcher with ivory handle

*Tray made of precious woods with silver
rim and mother-of-pearl inlay*

*Pillbox in
silver repoussé
(Christofle)*

*Silver teapot by Gérard Sandoz
with ebony handle and lid knob*

Soup tureen by Jean Puiforçat

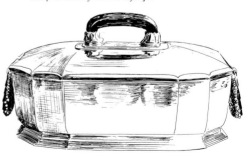